FREDERIC REMINGTON

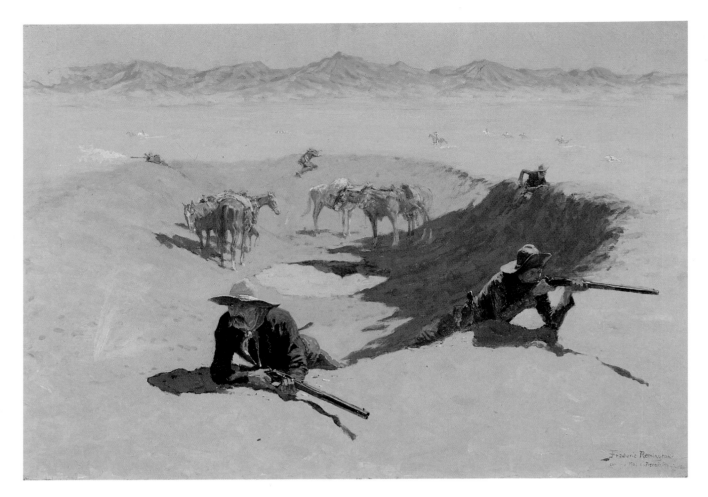

Fight for the Waterhole

Frederic Remington

JAMES K. BALLINGER

Harry N. Abrams, Inc., Publishers

IN ASSOCIATION WITH

The National Museum of American Art, Smithsonian Institution

Series Editor: Margaret L. Kaplan
Editor: Mark D. Greenberg
Designer: Ellen Nygaard Ford
Photo Research: Lauren Boucher

Library of Congress Cataloging-in-Publication Data

Ballinger, James K.
 Frederic Remington / James K. Ballinger.
 p. cm.—(Library of American art)
 Bibliography: p.
 Includes index.
 ISBN 0–8109–1573–1
 1. Remington, Frederic, 1861–1909—Criticism and
 interpretation. I. Title. II. Series.
N6537.R4B26 1989
709'.2'4—dc19 89–43

Frontispiece: *Fight for the Waterhole*
 1901. Oil on canvas, 27 x 40"
 The Hogg Brothers Collection,
 Gift of Miss Ima Hogg,
 The Museum of Fine Arts, Houston

Text copyright © 1989 James K. Ballinger
Illustrations copyright © 1989 Harry N. Abrams, Inc.

A Times Mirror Company

Printed and bound in Japan

Contents

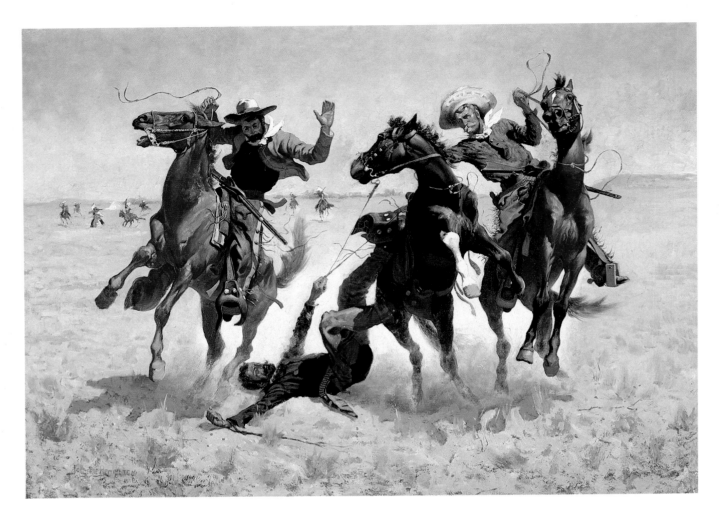

Aiding a Comrade

Acknowledgments

IT IS A WELCOME OPPORTUNITY to be asked to write a volume on Frederic Remington for the Abrams Library of American Art. I am grateful to those involved, Margaret Kaplan and Mark Greenberg at Harry N. Abrams, Inc., and Charles Eldredge and Elizabeth Broun at the National Museum of American Art, but to produce the work required the cooperation and support of many individuals. I would like to thank especially the Phoenix Art Museum Board of Trustees for granting a sabbatical leave from my duties as Director to complete this book.

As outlined in the study, many individuals have preceded me in my work on Remington, and without their assistance this work could not have been completed. Peter Hassrick, the leading scholar on Remington, shared his files and, more important, allowed me access to the Remington catalogue raisonné he is preparing at the Buffalo Bill Historical Center. Melissa Webster of Hassrick's staff efficiently responded to every inquiry. The published works of Harold and Peggy Samuels and of Michael Shapiro were a great guide, as were the individuals.

I could not have gathered the information for this study without the assistance of many people. Chief among them is Linda Marrie, who served as research assistant, keeping the information flowing and offering a lot of encouragement. Clayton Kirking, Phoenix Art Museum Librarian, likewise provided much help, as did Barbara Gutierrez of the Museum staff. The holdings of the Frederic Remington Art Museum were placed at our disposal. The Museum's Director, Lowell McAllister, as well as Mark Van Benschoten and Melodie Ward are all to be thanked. Others who responded to special inquiries were: Nan Bowers, Arizona State Archives and Library; Emmet Chisum, University of Wyoming, American Heritage Center; Martha Clevenger, Missouri Historical Society, Saint Louis; James Forrest, Bradford Brinton Museum; Michael Frost, Bartfield Galleries; Abe Hays, Arizona West Galleries; David Karpelis, David Karpelis Manuscript Collection; Chuck Kelly, Library of Congress; Robert Knecht, Kansas State Historical Society; Linda Laws, Woolarac Museum; Alex Nemerov, intern, National Museum of American Art; William Reece; Joan Carpenter Tracolli; and Rudolf Wunderlich, Wunderlich-Morgerson Gallery. In addition, the collectors and institutions whose holdings are represented in this volume supplied photographs and other basic research information. C. Peter Goplerud read the manuscript and made editorial suggestions.

Removing myself from the daily activities of the Phoenix Art Museum required the entire staff of the institution to willingly pick up loose ends. Likewise, the support of my family was appreciated during the time I could not be at home. Finally, special credit goes to Roy Papp and his colleagues for providing me with a quiet place to work, encouraging my efforts, and never giving away our secret.

JAMES K. BALLINGER

Aiding a Comrade

c. 1890. Oil on canvas, 34⅜ x 48⅛"
The Hogg Brothers Collection, Gift of Miss Ima Hogg, The Museum of Fine Arts, Houston

It is the action in Remington's art that has sustained his popularity throughout this century. What enabled him to re-create such believable action was his thorough understanding of horses and his ability to group them without the repetition most artists employed.

Preface

FREDERIC REMINGTON'S LIFE, the period in which he lived, and his acquaintances and friends have interested writers and scholars throughout this century. In fact, his larger-than-life existence has in some cases prevented a faithful examination of his efforts as painter and sculptor, the prime concern of this publication.

During the 1940s and 1950s Harold McCracken first considered who Remington was and what he produced. McCracken's efforts and those of New York art dealer Helen Card brought together Remington's illustrations and writings and, what is most important, provided the basic bibliography from which we work today. More recently, Harold and Peggy Samuels have produced a thoroughly documented biography that is invaluable to Remington studies. In their years of research they compiled a mass of information, and the biography records the chronology of the artist in detail. In addition, they have edited Remington's writings into one volume.

Since World War II numerous exhibitions of Remington's works have been held, usually based more on Remington's view of American history than on his development as an artist. This deficiency was rectified with the exhibition of Remington's greatest works, organized by Peter Hassrick, director of the Buffalo Bill Historical Center, Cody, Wyoming, and Michael Shapiro, chief curator at the Saint Louis Art Museum. This exhibition, and the catalogue accompanying it, is the first successful examination of Remington's career focusing purely on his art. The effort brings to realization years of study by Hassrick, whose knowledge of Remington is unequaled. He is currently preparing a catalogue raisonné of Remington's works, the data in which has been invaluable to numerous researchers. A forthcoming volume edited by Allen Splete will contain Remington's known letters, which number in the hundreds.

Given the extensive Remington bibliography that can be developed, the reader of this volume might legitimately inquire, "Why another examination?" The answer to this question is twofold. First, the intention here is to complement the efforts of the scholars previously mentioned. Only basic biographical information will be used since the books mentioned are all readily available. The efforts of Remington as an author will be cited only where they are appropriate to the works of art discussed. Likewise, no effort is made to replicate the superb analysis Shapiro has conducted regarding Remington's sculpture. Because so many of Remington's greatest works are held in collections that do not lend to exhibitions, we will focus on works that were not available to the Saint Louis-Cody exhibition and thus were not included in its catalogue. We shall provide special insight into three areas: Remington's earliest illustrations and the influences on

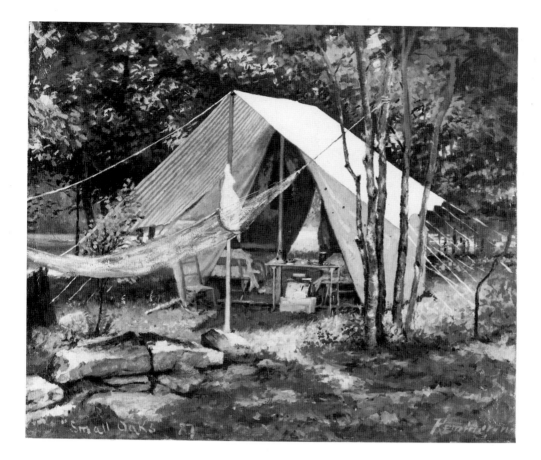

Small Oaks

1887. Oil on canvas, 12 x 14″
Courtesy Frederic Remington Art Museum,
Ogdensburg, New York

Remington always spent his summers in his home region of northern New York if he was not on an expedition. Small Oaks is one of the Thousand Islands of the Saint Lawrence River near Ogdensburg. This 1887 painting is the same composition as an ink sketch Remington drew in a letter to his friend Powhatan Clarke, dated August 6, 1889, describing his camp quarters.

him at that time, his ongoing frustration with being only "a black and white man," and finally, the artist's success in his striving to be a "fine," rather than commercial, artist.

The second reason for this book's inclusion in the Abrams Library of American Art is that, interestingly, no previous publication has tried to assemble what its author regarded as the greatest and most important Remington works. Each cited study has had a specific thesis concerning the artist's endeavors. It is hoped that a broader approach will enhance Remington's position and ensure, finally, his proper place in the history of American art.

It is odd that an artist whose work gained such renown during his lifetime, and whose popularity has remained strong since his death, should require a long-overdue plea for proper evaluation. It is equally odd that this plea takes on an apologetic tone at times. Here is an artist who, at his best, felt comfortable as a draughtsman, a watercolorist, a sculptor, a painter, a reporter, and a novelist. Here is an artist who has had more publications devoted to his work than almost any other American artist. Here is an artist who not only has a museum dedicated to his efforts, the Frederic Remington Art Museum in Ogdensburg, New York, but also has his studio and late paintings housed in another institution. Finally, here is an artist whose works command prices equal to those of almost any other artist in this nation's history.

Introduction

WE ALL LONG TO LIVE in interesting times. Yet it is the rare individual who recognizes the true significance of an era, capitalizes on it, and leaves a lasting contribution to society. Frederic Remington was such a man. Born into a comfortable family in Canton, New York, on October 4, 1861, he lived a very full forty-eight years until his death the day after Christmas 1909. He died of complications from an emergency appendectomy performed by a doctor on Remington's own kitchen table in his new home on a 50-acre estate in Ridgefield, Connecticut, a then burgeoning commuter community near New York City.

One hundred years ago Americans were experiencing the culmination of the first era in the Republic's history. America's democratic society had long exemplified Thomas Jefferson's agrarian ideals. His Louisiana Purchase in 1803 had provided the opportunity for many more people to hold land privately and provide for their own sustenance. The nation remained agricultural and domestic, and it was able to conform to a generally recognized set of moral, economic, and political principles. In short, a self-contained, self-confident, and self-reliant America had been created. By the end of the century, America had expanded to fill its present geographic and political boundaries. This development, coupled with tremendous population growth through immigration, brought on a rapid urbanization and industrialization of the nation, which was also forced into the global arena. At the same time, the government was becoming increasingly centralized and a small number of families were gaining great wealth.

The genteel society that had spawned most American artists and writers throughout its history was now confronted with new thinkers who claimed that the heroes of the Revolution and the Civil War were not as relevant to our future as were the great capitalists who represented the hope of the middle class. On the one hand, memoirs were being written and great monuments to the past were being built, while on the other, rails were being laid at an unprecedented pace and American goods were being harvested and manufactured for worldwide consumption.

Artists had to choose how to address these new aspects of American life. Many well-known artists preferred to view life looking back over their shoulder. Theirs was a view steeped in traditions quite often learned in the art academies of Europe. This attitude, which called for a reflective art, is best exemplified by the Impressionists' pictures and realist academic depictions of peasant life in Europe. The ugliness of urbanization was to be avoided, not championed.

There was nothing in his early career to indicate that the life and art of Frederic Remington would be helpful in understanding American culture during these watershed years. But American history is full of people who demonstrated that intellect, talent, and ambition, combined with being at the "right place at the right time," can bring about wide recognition.

To say that Remington was ambitious is an understatement. Writing to his uncle from the Highland Military Academy in Worcester, Massachusetts, on May 27, 1878, the seventeen-year-old weighed his options upon completion of a bookkeeping course: "The pathes [sic] of glory lead but to the grave. As bookkeeping would not tend to extend my chances in the one direction (fame) and seeing that he seldom reaches further in the other direction I have concluded not to hire out in that capacity." Writing over a year later in response to his aunt's warning to recognize a "Christmas God," Remington expanded on his desire: "I want a situation as son-in-law of a first class family—no objections to going a few miles in the country. I want an English walking jacket—fur collar and cuffs. I want 'L'Art' for a year. I want De Neuville's last autotype. I want some half hundred books. I want about 1,000,000 Henry Clay cigars. I want a smoking set—not the common kind—but the uncommon kind. I want a board bill paid in advance for 4 weeks at Fire Island. Oh laws I want everything—anything and nothing at all. Guess I wouldn't buy anything for such a feller as I am."

Throughout his life Remington was an overly active, physical, and aggressive individual. During his high school days he broke a friend's shoulder while wrestling. When studying art at Yale in 1878 and 1879 Remington was well respected as the burly rusher of the football team that featured Walter Camp, its captain and coach, who later revolutionized the sport. Thus, Remington was quite prepared for the physical demands of the American frontier. Throughout his later years he fought a constant battle with obesity brought on by a penchant for drink and living the so-called high life. He was always one to go straight at life to accomplish what he wanted, with little consideration of the consequences. Among men he was well liked, counting good friends by the dozens. His conviviality enabled him to travel easily among the ranchers, cowboys, and cavalrymen of the frontier, gathering information and material for his art, and to work closely with the craftsmen of the publishing world and the bronze-foundry men, all of whom enabled Remington to present his art to the American public. It is fascinating that Remington's art championed the little guy, while his craving for fame and success drove him to live an exceedingly overindulgent Victorian life.

The best description of Remington during his early career was drafted by Lieutenant Alvin H. Sydenham, an amateur writer and artist who met the artist in Montana in 1890. Remington had been invited by General Nelson A. Miles, the famous Indian fighter, to observe his troops' activities during the Sioux uprisings, an action that resulted in the infamous slaughter of Indians at Wounded Knee on December 29, 1890. Sydenham naturally knew of Remington due to his vast exposure in *Harper's Weekly* and in other publications. Sydenham would have been keen to have such a star in camp with whom he could share his interests, and his journal provides an insight into Remington's personal appeal.

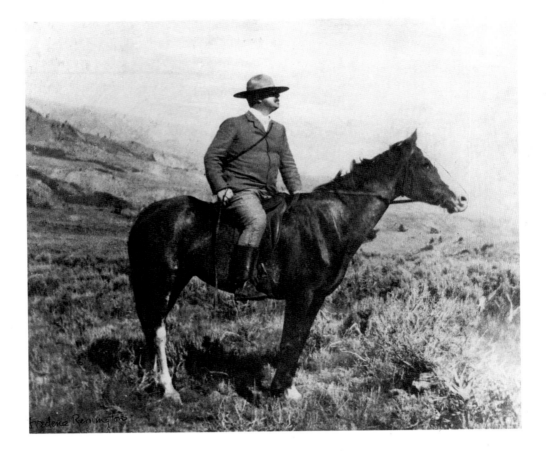

*We first became aware of his existence in camp by the unusual spectacle of a fat citizen
dismounting from a tall troop horse at the head of a column of cavalry. . . . As he ambled
toward camp, his gait was an easy graceful waddle that conveyed a general idea of
comfortable indifference to appearances and [of] abundant leisure. But his face, al-
though hidden for the time behind the smoking remainder of an ample cigar, was his
reassuring and fetching feature. Fair complexion, blue eyes, light hair, smooth face. . . .
a big, good-natured, overgrown boy—a fellow you could not fail to like the first time
you saw him. . . .and thus we met. Not withstanding his acknowledged predilection for
captains, commissioners, and generals, we occupied the dust at the rear of the column
in company several times after that.*

Remington's intelligence was more practical and intuitive than intellectual. Re-
search and study were not activities that attracted the attention of this hyperac-
tive young man. He always paid close attention to the business side of his career,
and addressed technical progress in making art as on-the-job training. Aside
from eighteen months at the relatively new School of Art at Yale beginning in
1878, and three months of study at New York City's Art Students League in the
spring of 1886, Remington's twenty-five-year career progressed by the artist's
recognizing his weaknesses and ambitions, then approaching them head-on with
an unreasonable amount of self-confidence.

His optimism did not result from being naturally blessed with technical genius, as was Remington's contemporary John Singer Sargent. Rather, his success resulted from methods developed by long practice and the continual deadline demands of the publishing world. Remington was prolific, completing almost 3000 works during his relatively short career. His early drawings were somewhat awkward and *Harper's* editors had them redrawn by staff artists, such as William Rogers and Thure de Thulstrup, before having them engraved for publication. Remington's struggle with color and the use of oil paints is well documented in his letters and late diaries. Whatever genius existed was manifested in the artist's sculptures—because once he began "playing with mud," as he called the modeling process, he seemed to grasp it immediately. Simply put, beginning at a very young age, Frederic Remington yearned to be a famous artist, and he never stopped working toward that goal until his death.

Remington had another asset—he was there! The incredible acceleration of the magazine and newspaper industry during the latter years of the nineteenth century gave Remington a vehicle that few artists had ever had: access to the public. Public education had increased the literacy rate, and the technological advances of the printing industry satisfied the public's insatiable appetite for information. Finally, as the transcontinental rail system continued its expansion, affordable, timely travel made the West itself quite accessible. A brief listing of Remington's activities will provide an understanding of this aspect of his career: The last great buffalo slaughter occurred on the northern plains during 1881, the year of the artist's first travels west to Montana. He was commissioned to record the capture of the Apache chief Geronimo in Arizona; he was invited to Montana to observe Miles's handling of the Sioux uprisings of 1890, during which Sitting Bull was killed; he attended the 1893 World's Columbian Exposition in Chicago; and he returned the following year to document the government's handling of the Pullman strike. Always longing for the war his generation never had, Remington accompanied American troops to record their invasion of Cuba during the Spanish-American War. And finally, important friends, such as Theodore Roosevelt and the popular writer Owen Wister, believed in Remington's importance to America and gave the final seal of approval to his talents.

In looking more closely at Remington's background, ambitions, and activities, it becomes clear that he kept his feet firmly on either side of America's social and historical watershed. Always aspiring to live among and be recognized by the genteel society of his day, he attended private schools, participated in popular club life, lived in the stylish surroundings of New Rochelle, New York, and his estate in Ridgefield, Connecticut. His homes reflected every aspect of a typical, upper-class Victorian life, except his own space, the studio, which was cluttered with artifacts of the West that he had accumulated during his travels and had had sent to him by friends in the cavalry. He followed closely Theodore Roosevelt's call to the "strenuous life," which to the genteel generation really meant maintaining the illusion of ruggedness through travel, hard drinking, and being a "real man."

His migration from his rural hometown to New York City was typical of millions of Americans during his lifetime. It was the publishing houses of the metropolis that created his fame and provided for his opulent living. Yet throughout his career he longed for the north woods and for several years kept a summer home and studio on Ingleneuk, his own island in the Saint Lawrence River, near his boyhood home of Canton.

Remington drew his artistic inspiration predominantly from the hardworking, low-paid cavalryman and cowboy who worked on the plains and in the Southwest. His contacts with these people led to many of his lifelong friendships. The urban worker became his patron through publications such as *Harper's*, *Collier's*, and *Outing* magazines. Ultimately, it was the rapidly growing middle class that became his audience. As the era of the West waned, Remington was drawn to the world of the "fine artist," a creator who was championed by the upper class. His attention shifted from the action-oriented realists toward the Impressionist painters of his day, such as Childe Hassam and Willard Metcalf, friends from his club life in New York. It was their presence in Connecticut that drew Remington to Ridgefield near the end of his life.

The ultimate success of an artist is created by the critic, the collector (private and public), and the art historian. Remington was never able to acquire a strong position in the established art community. During most of his lifetime critics belittled him by calling him an illustrator, which is the curse of any realist. Only in the last year of his life could he write to a friend, "I am no longer an illustrator." Though he sold many works during his life, and though today his works command tremendous prices among collectors, Remington's patrons were never the "serious" collectors. Amon Carter and Sid Richardson, both legendary Texas oilmen, built great collections of Remington's works, which are on view in Fort Worth. R. W. Norton of Shreveport built an important, but lesser collection. Many other men of business and industry have always been drawn to the strength of Remington's work and have viewed him as a symbol of the American West, where freedom reigned.

Unfortunately, Remington's works found their way into collections devoted to Western subject matter; they were rarely purchased for American painting collections. Only Williams T. Evans, whose Tonalist and Impressionist collection forms the core of the Smithsonian's National Museum of American Art, was adventurous enough to acquire *Fired On* in 1909, adding it to a collection that included Hassam, Metcalf, and Julian Alden Weir. Prior to Remington's death, the Metropolitan Museum of Art in New York City overlooked his paintings, choosing only to acquire four examples of his sculpture. Finally, historians of American art, a field of study that began after World War II, have never embraced Remington's finest works, choosing either to regard him as an illustrator or to group him with other artists who depicted the American West. This was the result of a cultural bifurcation that began during the artist's lifetime. The layman, who had been part of many cultural events throughout the nineteenth century, was gradually excluded during the 1880s and 1890s, and by World War I his exclusion was virtually complete. Art was increasingly made only for the "cogno-

scenti," and the belief grew that one must study art in order to understand it. Thus, Remington's literalism banished him from the "fine arts."

Remington's career exactly parallels this period, and so we must address his career carefully avoiding simple suppositions. Many recent writers think he saw little of the West and that he extolled invented frontier values in order to sell work to industrialist patrons. In truth, Remington spent a total of almost four years west of the Mississippi—from 1883 to 1900. In addition, he was in constant correspondence for years with friends in the cavalry, collecting from them hundreds of photographs and artifacts, which he sometimes used in the studio. In many ways the "available" West he experienced by train, army camp, and hotel was similar to the Hudson River Valley and more exotic locations visited by landscape painters in the early years of the century. The artists of the Hudson River School sold their works to wealthy urban patrons as did Remington years later. The entire issue of American artist patronage and its impact certainly deserve greater study.

Because his personal interaction with the West was primarily through the cavalry, Remington never developed a true understanding of Native Americans, which is why as subject they appeared only infrequently in the artist's works. He chose instead to place them as "off-the-canvas" antagonists of the cavalryman with whom the artist did identify. It can be said that Remington thoroughly documented late nineteenth-century life, with his greatest works being successful genre pictures.

A fine line exists between what is accepted as genre painting and what is dismissed as illustration. Most illustrations produced on deadline lack an inherent sense of the human condition. At their best, however, illustrators transcend their stated subject, and their efforts should be recognized accordingly. This is certainly true of Remington, who understood this difference and, even when painting his early exhibition works, moved away from the absolutely literal. The artist's own struggle must be properly examined and his works put into perspective before the final assessment of his career can be made.

HARPER'S WEEKLY.

JOURNAL OF CIVILIZATION.

VOL. XXX.—No. 1516.
Copyright, 1886, by HARPER & BROTHERS.

NEW YORK, SATURDAY, JANUARY 9, 1886.

TEN CENTS A COPY.
$4.00 PER YEAR, IN ADVANCE.

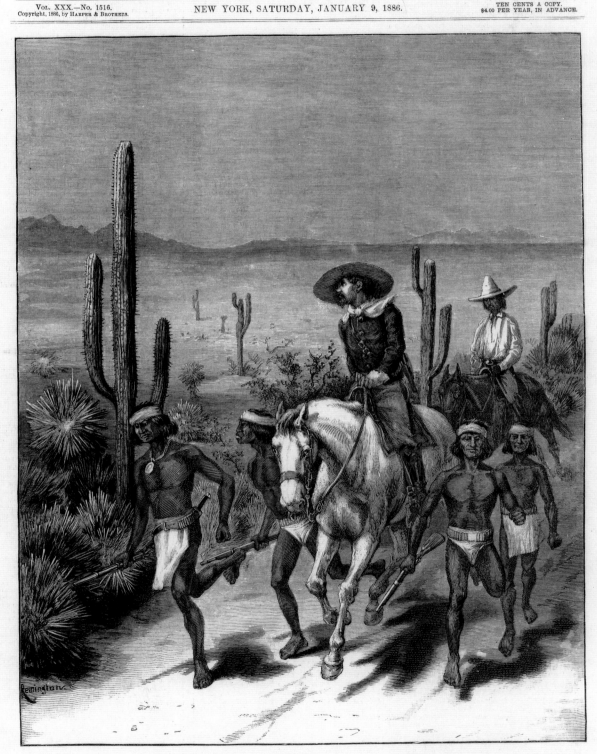

THE APACHE WAR—INDIAN SCOUTS ON GERONIMO'S TRAIL.—DRAWN BY FREDERIC REMINGTON.—[SEE PAGE 23.]

The Apáche War—Indian Scouts on Geronimo's Trail

I. Seeking a Career in the West

DURING THE WEEK OF MARCH 18, 1905, hundreds of thousands of American households received their edition of *Collier's: The National Weekly*, which carried on its cover the image of a northern plains Indian, mounted on his pony, making a gesture of welcome as he looked out at the reader. Below the horse was printed the issue's subtitle, *Remington Number*, an honor few, if any, artists had ever received. The original of the cover design was a pastel drawing by the most renowned artist of the American West, Frederic Remington, more of whose work had been seen in the nation's leading periodicals than that of any other artist. In May 1903, Robert Collier had signed Remington to an unprecedented contract providing for the exclusive reproduction rights to twelve paintings a year, for four years, for the monthly sum of $1000, which was twice the average employee's annual salary. Collier's scheme had been twofold: first, Remington's fame would help sell magazines in an extremely competitive market, and second, each painting would be made into a print, which would be available for one dollar from the magazine.

On opening the issue, the reader discovered full-page reproductions of Remington's best paintings: *Amateur Rocky Mountain Stage Driving, The Map in the Sand, An Apache Scout,* and a double-page color illustration of his most recent effort, *Evening on a Canadian Lake.* The lead article was by the well-known writer Charles B. Davis; "An Appreciation" of the artist was drafted by America's leading Western writer, Owen Wister; and an article highlighting Remington's sculptural efforts was penned by James Barnes. Remington was basking in his fame. Throughout his twenty-year career the artist had been promoted by magazines, but to have an entire issue dedicated to his art was an achievement indeed. Interestingly, at the very moment that *Collier's* was touting its artist, Remington was strengthening his efforts to throw off the "illustrator" label and to gain acceptance as a painter. This proved to be difficult partly because of the comfort created by financial security and the years of producing black-and-white works for illustrations. One must never lose sight of Remington's desire to be a famous painter, as it always affected his career decisions.

The March 18 issue of *Collier's* also carried an article titled "A Few Words From Mr. Remington," an autobiographical exercise that perpetuated many of Remington's personal myths while rather awkwardly stating how it all began during a brief trip to Montana in the fall of 1881. "I had brought more than ordinary schoolboy enthusiasm to Catlin, Irving, Gregg, Lewis and Clark, and others on their shelf, and youth found me sweating along their tracks. I was in the grand

The Apache War—Indian Scouts on Geronimo's Trail

Wood engraving for *Harper's Weekly*, January 9, 1886

This was Remington's first published illustration that was not redrawn by a Harper's artist. Based on his brief trip to the Southwest in 1885, it was reproduced on the cover of Harper's Weekly *on January 9, 1886. At that time the search for Geronimo occupied much space in the newspapers and magazines. The artist was paid the standard fee of $75.*

silent country following my own inclinations, but there was a heavy feel in the atmosphere. I did not immediately see what it portended, but it gradually obtruded itself. The times had changed." He then described his chance meeting with an old wagon freighter who, like himself, had traveled from New York to the West seeking his fortune, while finding something more desirable. The old man was truly free—a great ideal in America—and Remington, continuing his reflection, stated that during a fireside conversation the old man provoked Remington to involve himself with the American West. Remington recalled, "I knew the railroad was coming—I saw men already swarming into the land. I knew the derby hat, the smoking chimneys, the cord binder, and the thirty-day note were upon us in a restless surge. I knew the wild riders and the vacant land were about to vanish forever, and the more I considered the subject the bigger the Forever loomed." If these really were the thoughts running through his nineteen-year-old brain, he was indeed a rare American, one who understood the future. It was not until twelve years later that Frederick Jackson Turner, a leading American historian, proclaimed the end of the frontier in his radical thesis delivered at the World's Columbian Exposition.

Since Remington neither kept a journal during his 1881 trip nor wrote any letters home describing his particular thoughts, it is impossible to confirm this recollection printed twenty-four years later. One record of the excursion, which also took him into Wyoming, does still exist: a drawing, made on a scrap of paper, which was sent to Charles Parsons, the art editor of *Harper's Weekly*, who ultimately published it. The image, depicting several cowboys being awakened in their camp by a scout bringing a word of warning, was redrawn by staff artist William Rogers prior to its publication on February 25, 1882, when it accompanied an article about cowboys operating almost as outlaws in the Southwest. It was common practice among the art editors of the day to make illustrations fit their articles, while at the same time striving for as much authenticity as possible. Seeing his name and his work in print confirmed Remington's inclination to pursue art as a career. He further reflected in 1905, "Without knowing exactly how to do it, I began to try to record some facts around me, and the more I looked the more the panorama unfolded. Youth is never appalled by the insistent demands of a great profession, because it is mostly unconscious of their existence."

Remington's twenty-first birthday on October 4, 1882, brought with it his inheritance of just over $10,000, which had been set aside upon his father's death on February 18, 1880. Seth Pierre Remington had been both a hero and a role model to his son. He and his wife, Clara Sackrider, had provided a comfortable home for their only child and saw to it that he had the education necessary for following in his father's footsteps in either the military or journalism, and in Republican party activities. The elder Remington had served the Union with distinction during the Civil War, first as a recruiter for the 11th New York Cavalry and later as a major in several battles. Upon his return to civilian life, Remington's father was familiarly known as "The Colonel." Following the war, men were often called by their title, which sometimes was upgraded, as was true of

Major Remington. He was especially noted for his heroism on August 4, 1864, at Doyal's Plantation, Louisiana, where his command, decimated by sickness, was surrounded by Confederate troops and asked to surrender, so as to avoid bloodshed. The major refused, whereupon his troops were bombarded and hastily made an escape, only to return later in the day with additional soldiers to recapture the plantation. "The Colonel" thus returned to his hometown a hero, although his overall war record was not extraordinary. Excessive admiration for any Civil War action was common throughout the country. Following a year with his family in Illinois, the elder Remington repurchased the *St. Lawrence Plaindealer* newspaper, which he had originally purchased in 1856 but had been forced to sell upon his departure for military duty. The *Plaindealer* was a staunch supporter of Republican politics, and as a result of his efforts, Seth was rewarded by President Ulysses S. Grant with the office of customs collector at the port of Ogdensburg, a larger town than Canton, located twelve miles away on the Saint Lawrence River.

Frederic Remington had been an infant when his father went off to participate in what became one of the bloodiest conflicts the world had ever known. Few American families avoided loss during those years. Well into the 1890s, monuments were still being erected in city after city to honor those killed during the conflict, and the survivors were revered. Because of this and the opportunities afforded by military service, Seth wanted his son to consider the military as a career. Accordingly, the Remingtons sent Frederic to the Vermont Episcopal Institute in Burlington and later to the Highland Military Academy in Worcester, Massachusetts, for his high school education. It was at Highland that Remington's desire to pursue art, at least as an avocation, began in earnest.

Upon the conclusion of his second year at Highland, it was clear that military regimentation was not to Remington's liking, nor would a career in this area be suitable for a young man who was just a corporal, the lowest rank in the hierarchy for a third-year student. He was well liked by his comrades and had an easygoing air among them. As he described himself, "I go a good many on muscle. My hair is short and stiff, and I am five feet eight inches and weigh one hundred and eighty pounds. There is nothing poetical about me." Drawing was an activity that occupied much of the cadets' time at the Academy. It should be pointed out that just seven years prior to Remington's arrival in Worcester, the state passed the Massachusetts Drawing Act. Diana Korzenik has beautifully outlined the perceived need for, and impact of, this act in her excellent book *Drawn to Art: A Nineteenth Century American Dream* (1985), which documents the art education of a Massachusetts family during those years. Section One of the law required drawing to be taught in all public schools, and Section Two provided that any city or town having more than 10,000 inhabitants should make available free instruction in industrial or mechanical drawing to all persons over fifteen years of age. Through a school friend Remington began a correspondence with Scott Turner, which included illustrating letters and the exchange of drawings. Several of Remington's sketchbooks from this time are extant in the Frederic Remington Art Museum and the R. W. Norton Art Gallery. There is no distinguishing char-

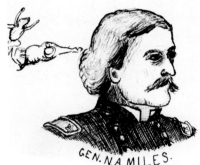

General Nelson A. Miles

1878. Pencil on paper, 3⅛ x 2¾″
Courtesy Frederic Remington Art Museum,
Ogdensburg, New York

Students at Highland Military Academy during the 1870s would have been well aware of the major military leaders of the Civil War and of the following years. Ten years after leaving the academy Remington met Miles and accompanied him on several expeditions.

acteristic of the young man's stiff, spare drawings, but their subjects do, in fact, hint at Remington's future. He concentrated on military subjects, as would be expected of a cadet, especially one who regarded his father as a Civil War hero. He was jealous of Turner, who drew shading better than he, and he complimented that ability while commanding, "Your favorite subject is soldiers. So is mine.... Don't send me any more women or any more dandies. Send me Indians, cowboys, villains, or toughs. These are what I want."

Two drawings contained in a bound sketchbook housed in the Remington Art Museum are of special interest to this study. The first is a small three-quarter profile bust of General Nelson A. Miles, then America's great military vindicator, who had been called upon by President Grant to retaliate for the slaughter of General George Custer and his immediate command at Little Big Horn. The success of Miles's efforts, just two years before this drawing, was no doubt applauded by the faculty of a military school such as Highland. Remington's awkward drawing records Miles as a square-jawed, purposeful military man. The foreshortening of the rear shoulder is out of scale and out of position, as is Miles's left eye. One can imagine Remington's delight a few years later when he met Miles on campaign in the Arizona Territory, where the general was assigned to pursue the escaped Apache chief Geronimo.

Almost prophetic is the cartoonlike self-portrait of Remington on the inside back cover of the same sketchbook. As he brought the book to a close, he pictured himself with brushes or pencils in his left hand, his drawing book tucked under his right arm, walking into a warm, friendly Western sunset. The ever-romantic artist's instinct led Remington to write "*Finis*" underneath the drawing.

It would be four years before young Remington would fulfill his dream of going west among the cavalry, Indians, miners, and cowboys. In the meantime, he was faced with making career decisions. During the spring of 1878 he decided to enroll in the journalism school at Cornell University, a move his newspaper-owning father no doubt viewed with pride. He wrote to his uncle Horace of his goal, and stated he would also study art. Remington must soon have discovered that Cornell had no art department because he began college the next fall at Yale.

For the next year and a half Remington and about thirty other students, most of whom were female, studied at Yale's School of Art. Students in the School of Art, a professional school, concentrated only on their art; they were not part of the undergraduate college, which had the requirements of a broad curriculum. So even though Yale had been chosen because both journalism and painting could be pursued, Remington had really decided that he would train as an artist. His chief professor was John Henry Neimeyer, a disciple of the French academic master Jean-Léon Gérôme, who taught beginning students the principles of art by having them copy from classical casts. These models were far from the images Remington had dreamed of making while a student in Worcester. Prior to taking up oil painting during the third year, each student had to demonstrate a mastery of drawing, perspective, form, and composition. Lectures were given on color, but there was little real practice.

When Remington returned home for the semester break later in 1879, he

found his father gravely ill with tuberculosis, and thus he could not return to Yale. Upon his father's death in February, his college education abruptly ended. Half of Seth's estate was willed to his son, but he had to wait until his twenty-first birthday to receive his inheritance. At the insistence of his mother, he struck out to find a government job through the efforts of Seth's brother, Lamartine, who lived in Albany and was part-owner of the local newspaper. At this same time Frederic was courting Eva Caten, a young lady two years his senior, whom he had met the previous year in Canton, where she was a student at St. Lawrence University. The Catens lived in Gloversville, New York, where her father was a railroad superintendent. Like Remington, Eva was home from school during 1879; she was attending her dying mother. Eva's presence in Gloversville, some forty miles from Albany, was perhaps the only reason Remington remained in Albany experimenting with different jobs, none of which held his heart. Whereas his father had granted Frederic's wish to pursue an art career, his mother was opposed to it. Eva Caten's viewpoint was that art was an avocation for her suitor and that at the appropriate time his business instincts would prevail and they would prosper. Following a year of courtship, Remington asked Eva's father for permission to marry her, a request immediately denied with the excuse that she was needed at home. The real reason was that Remington had not yet proved himself to be on a satisfactory career path. Sensing Frederic's restlessness, his uncle arranged for a more challenging position beginning in October 1881 with the State Department of Insurance. Perhaps as part of a bargain, the young man agreed to assume his duties following his dream trip to Montana and Wyoming, where he met the old freighter whose insight supposedly spurred Remington to pursue the West professionally.

Opportunity beckoned Remington at this time, represented by the full inheritance, which he would receive in October 1882. The insurance position he accepted upon his return could not hold his interest, so he resigned his job, remaining in Albany for a few months before returning to Canton for the summer. Since leaving Yale, he had maintained a correspondence with one of his classmates, Robert Camp, who, because of illness, had ventured west to Kansas, where he had begun a sheep-raising operation. Remington discussed with his uncle the prospect of buying land in Kansas with Camp's help and, like his friend, becoming a sheep rancher, a sound business at the time. For the past year the young man must have had such a move in mind because he had expressed hope that some situation would present itself in Montana or Wyoming. Now he had the luxury of being in control of his destiny and he decided to purchase a quarter-section sheep ranch near Peabody, Kansas. The business side of Remington's $3400 investment was fine, but from his arrival on a freezing day in February 1883 he realized success would mean extremely hard labor with little time to explore the West. His circumstances were just not the same as those of so many genteel persons whose family fortunes enabled them to hire plenty of help and build comfortable houses in which to become "gentleman ranchers." Such was the experience of Theodore Roosevelt, who invested in a quarter-section "hunting" ranch in the Dakotas that same year.

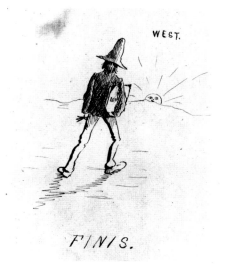

Sketchbook end note

1878. Pen and ink on inside back cover of sketchbook, 10½ x 8″
Courtesy Frederic Remington Art Museum, Ogdensburg, New York

Remington's sketchbook from military school contained images of riders and military activities as well as portraits of soldiers and scouts. The inside back cover shows the young Remington heading west with his portfolio and brushes.

Rather than risk his investment, Remington decided to sell his ranch and pursue a more urban path to Western wealth. During February 1884, he returned to Canton and initiated two partnerships. The first was with a friend, Charles Ashley, whom he convinced to join him in a Kansas City hardware venture; the second was to secure his engagement to Eva Caten. A wedding would be planned following his business success in the frontier city. Unfortunately, Remington's plan did not work out. The hardware business was a disaster, and Remington shifted what funds he had left into a silent partnership in a saloon in the city. The return on this investment netted enough to make a deposit on a small home. He could now return East to marry Eva, which he did on October 1, 1884, in Gloversville. The Remingtons returned to Kansas City, where Eva thought she would live a relatively stylish life in a burgeoning frontier city.

Her Frederic was not as mature as she thought him to be. His friends were those who frequented the saloon, and his silent partnership allowed him to spend all his time sketching. For appearances he had told the real-estate agent and friends in New York that he was an iron broker operating out of his house. There was no brokerage, which Eva soon discovered; there was only his art, which did not satisfy her. What was most devastating was the public disclosure that her husband owned a "bucket shop." With promises broken and hopes destroyed, Eva returned to New York before the end of the year. As if life were not bad enough, by July 1885 Remington's investment in the saloon was lost, and with it all the money his uncle had forwarded him from Seth Remington's legacy.

Remington had learned that his overactive personality was not suited for government work, ranching, or the retail business world. What he did enjoy was the male companionship of the saloon and spending as much time as possible developing his artistic abilities. Thus the only hope in the young man's life came from his art. W. W. Findlay, a Kansas City dealer, had been able to sell three of the burgeoning artist's paintings for the very good price of $50 each. A fourth was sold for $250, a sizable sum for 1885. In addition to his local success, Remington had sold a second drawing to *Harper's Weekly,* which was published on March 28, 1885. Titled *Ejecting an Oklahoma Boomer,* the picture shows cavalry officers ejecting a family who had improperly attempted to homestead in Oklahoma Territory. Remington also wrote the article to accompany the illustration. As was the case in 1882, Remington's effort was judged too awkward and was redrawn, this time by staff artist Thure de Thulstrup. His literary endeavor was judged similarly, and Montgomery Schuyler, one of *Harper's* editors, redrafted the essay. Remington was in no way discouraged by needing assistance. On the contrary, he was filled with enthusiasm, for he now knew his calling was that of an artist for the periodicals, and the West would be his specialty. Nothing would stand in the way of his aggressively pursuing this vocation, not even New York publishers. Frederic's other uncle, William Remington, agreed with this plan and allowed him access to the remainder of his inheritance. Disbursements were to be made to the more financially responsible Eva Remington, who had agreed, again through William Remington, to meet her artist husband in New York and set up housekeeping. With regard to Remington's relocation, Harold and Peggy Sam-

HARPER'S WEEKLY.

JOURNAL OF CIVILIZATION.

Vol. XXIX.—No. 1475.
Copyright, 1885, by Harper & Brothers.

NEW YORK, SATURDAY, MARCH 28, 1885.

TEN CENTS A COPY.
$4.00 PER YEAR, IN ADVANCE.

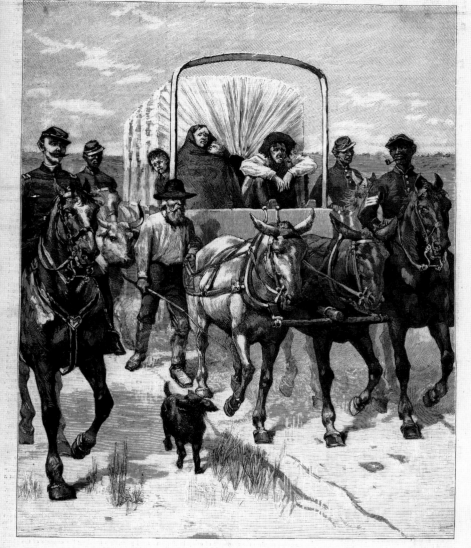

EJECTING AN "OKLAHOMA BOOMER."—Drawn by T. de Thulstrup from a Sketch by Frederic Remington.—[See Page 199.]

Ejecting an Oklahoma Boomer

Wood engraving (redrawn by Thure de Thulstrup) for *Harper's Weekly,* March 28, 1885

Redrawn by Harper's Weekly *artist Thure de Thulstrup, this was Remington's second published work. It was based on his experience traveling south into Indian Territory from his sheep ranch near Peabody, Kansas, in 1883.*

uels have written: "His next nine months need to be looked at in slow motion and enlarged. Otherwise, the transition beginning September 1885 is incredible. The angle of professional escalation is almost vertical. To lose focus for a moment is to blur the total change from the wastrel whose wife left him to the self-directed innovative illustrator recognized nationally as proto-typically American."

Within weeks of his arrival Remington found himself meeting not with the art editor of *Harper's Weekly,* Charles Parsons, who had purchased the two published drawings, but with Henry Harper himself. Harper had seen a selection of

the artist's rough Southwestern drawings; attracted by the images' immediacy and needing a draughtsman who had been to the Southwest, Harper asked Remington to his office. The publisher's 1912 book, *The House of Harper,* records his initial meeting with the struggling artist whose ambition allowed nothing—not even the truth—to stand in his way. Dressed in Western garb, the artist showed sketches to the publishing magnate that "were very crude but had all the ring of new and live material." Remington then informed his potential employer "that his ranch life had proved an utter failure and that he had recently found himself stranded in a small western town with but a quarter of a dollar in his pocket. He was anxious to get to New York, but was at a loss to conceive where the funds were to come from." Remington further told Harper that one evening he had come upon a sad scene: "Two professional gamblers were plucking a man who looked like an Eastern drummer . . . [he] then suggested to the commercial traveler that he had better stop. The savage looks of the two gamblers put Remington on his guard and he whipped out his gun . . . and covered his retreat." The upshot of the story was that, in order to reward Remington, the traveler brought the artist to New York. Remington's own gamble paid off—Harper bought two drawings purported to be those appearing months later over the titles *The Apache War—Indian Scouts on Geronimo's Trail* and *The Apaches Are Coming.* Harper's price for each work was the standard $75. Remington's career was launched.

The circulation of *Harper's Weekly* was then the largest in the world, in excess of 200,000. Its policy was "[to be] intelligible, interesting and useful to the average American" and to be generous in its use of illusrations. Beginning with the Civil War, when Winslow Homer was a staff artist, *Harper's* always attracted America's finest illustrators and writers, and it did so against fierce competition: the number of periodicals rose from 700 in 1865 to nearly 5000 at the turn of the century. During these years the school attendance rate rose to 70 percent of school-age children from 50 percent and the illiteracy rate dropped from 20 percent to 10. Given this environment, publishers had to look continually for fresh talent and also to pursue creative ideas. When Harper received Remington in his office, his magazine was being pushed hard by his main rival, *The Century Magazine.* The *Century's* approach was more refined, but in 1884 it began a Civil War flashback series entitled "Battles and Leaders." Seventy artists were commissioned to produce over 1700 drawings recording the famed battles and the great heroes of the war. The series was ultimately bound into a four-volume set, of which 75,000 were sold. The *Century's* editor, Richard Watson Gilder, called the series "a flank movement on all our rivals," and its success saw the *Century's* circulation double almost to that of *Harper's Weekly.* The editors at the House of Harper needed something that could offer the excitement and moral lift of Gettysburg, Grant, and Lee. At this time, efforts to capture Geronimo and to secure the Arizona Territory were the hottest stories going, and here in Harper's office sat an artist who had been to Arizona and whom he could send back.

Harper's had always been Remington's preferred publication, so it is fair to assume that he scrutinized its pages for clues as to what its editors wanted. Among the illustrators whose work he must have known, in addition to Rogers

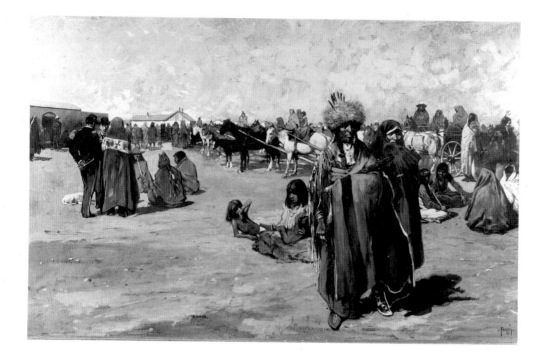

Henry Farny (1847–1916)
Issue Day at Standing Rock

c. 1882–83. Black and white tempera on paper,
16⅛ x 24⅞″
Archer M. Huntington Art Gallery,
The University of Texas at Austin,
Gift of C. R. Smith, 1972

As a staff artist for Harper's Weekly, *Farny had published his drawings since 1865. He made his first trip to Montana in 1881 and a second two years later. During these same years another* Harper's *artist, Rufus Zogbaum, was in the northern plains. This image was published in 1883.*

and de Thulstrup, would have been Henry Farny, Rufus Zogbaum, and Richard Caton Woodville, Jr. By this time, Rogers, Farny, and Zogbaum had all traveled in Montana, as had Remington.

Farny, an artist from Cincinnati, Ohio, had begun his illustrating career with the Harper brothers during the last year of the Civil War. He submitted work to them as well as to the *Century* and other magazines until the early 1890s, when he chose to concentrate solely on his paintings. His meticulous style had been developed chiefly in the academies of Munich and Düsseldorf, where he studied during the late 1860s and again during the mid-1870s. His approach can be examined in a work such as *Issue Day at Standing Rock*, which accompanied a *Harper's* article in July 1883. The image records the distribution of goods and supplies to a northern plains tribe that had been relegated to reservation life. He uses the line of Indians who are awaiting their goods on foot, on horseback, and in wagons to create his picture stage where smaller groups interact—playing games, sharing a pipe, or engaging in conversation. The conversational group of an Indian, a cavalryman, and a derby-hatted civilian is carefully constructed in order to underscore the activities that took place at the reservation. Dark figures, carefully delineated in silhouette against the brightly lighted ground, would have been easily read in a black-and-white publication and easily engraved by the printer. The tilt of the ground space and the distortion of the nearest figure as one's eye moves toward his exposed moccasin suggest that Farny may have used a photograph for his study of this subject, a method often employed by illustrators. Remington was in Kansas when Farny's work was published, and since his own first published effort had been the previous year in the same journal, it is highly likely that he saw this work or others by the refined Cincinnati artist.

A stronger influence was de Thulstrup's illustrations. By scanning the folio-sized *Harper's Weekly* for 1885, it is clear that de Thulstrup was its favored artist:

his byline is frequent and includes the major documentation of President Grant's funeral in Washington. Swedish-born, Thure de Thulstrup had been a member of the French Foreign Legion before studying topographical engineering in Paris. During the late 1870s he immigrated to New York, where he attended the Art Students League before becoming a staff artist for *Harper's*. The magazine's mere size—15¾ inches by 10½ inches—and the editor's commitment not only to full-page reproduction but also to double-page spreads make its lure to the illustrator obvious. A reader opening the magazine to such an image is dramatically brought into the action of the scene. Such was the case with de Thulstrup's *A New Cavalry Drill in the United States*, published as the center spread on April 4, the week following Remington's Oklahoma boomer picture. De Thulstrup's composition has the same cant as Farny's image, and interestingly, it carries the note, "drawn from a photograph." As had Farny, de Thulstrup employs mounted riders to establish the stage for the primary action of the drawing—and cavalrymen using horses trained to lay on their sides as protection, or breastworks, when attacked in the open landscape of the West. Careful attention is paid to detail, and a definite rhythm of light and dark is established. Compositionally, the picture is fragmented because there are no expressive or compositional devices to integrate the subject. This was common among illustrators since it allowed them to include several implied actions in one scene.

Another of the Harper brothers' favored illustrators was Rufus Zogbaum, a South Carolinian by birth and twelve years Remington's senior. He generally provided military and naval images to the magazine. Zogbaum's influence on Western American art is yet to be fully recognized, even though it has been hinted at by Robert Taft writing in the 1950s and more recently by Lonn Taylor, who believes several stereotyped cowboy images derive from Zogbaum's concepts. Zogbaum often wrote the articles to accompany his visual material, which was a good business approach, not only maximizing income but also providing a demand for his own illustrations. As Remington was being introduced to *Harper's*, Zogbaum was on assignment in Montana, traveling there yearly from 1884 to 1887. He had studied at the Art Students League in New York during 1878 and 1879 before spending two years in France studying under Léon Bonnat. His development can be viewed almost as a model for the young Remington. Zogbaum wrote late in his career, "During my two years in Paris I saw the work of DeNeuville and Detaille, and that decided me to paint military scenes...In 1883 I went West and brought back a number of magazine articles...I furnished both text and pictures." Zogbaum's *Indian Warfare—Discovery of the Village* was published on September 19, 1885, just when Remington arrived in New York, and it certainly would have been seen by the younger artist. It provides another compositional device Remington would make use of: the open range with a small ridge to create a foreground stage for the action, in this case a small scouting party seeking the location and, no doubt, fighting strength of a tribal village. The entire composition is built on a diagonal perspective line, which ties together the three elements of the picture.

Zogbaum's images and those of de Thulstrup were similar in one respect to

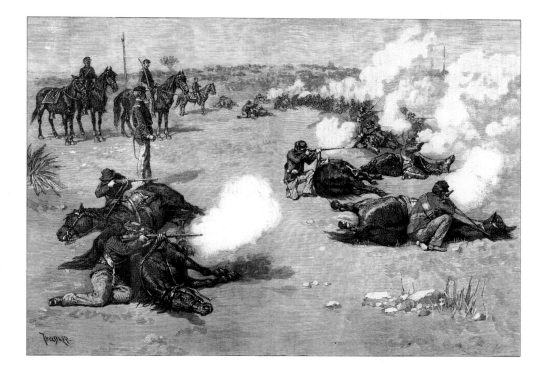

Remington's. The implied actions were calm and controlled, horses were cap-
tured in a trot, and troopers were depicted firing weapons. A third artist, the
Englishman Richard Caton Woodville, Jr., approached things much differently,
as can be examined in the series of illustrations he produced for Bret Harte's sto-
ry "Maruja," which was serialized in *Harper's Weekly* from June 13 through July 4,
1885. Woodville was said to be the greatest European delineator of the American
West, although he actually did not come to America until he was commissioned
by the *Illustrated London News* (*Harper's* English counterpart) to cover the 1890

Richard Caton Woodville, Jr.
Captain Carroll Finds the Saddle Blanket of Dr. West

Wood engraving for *Harper's Weekly*, June 27, 1885

An Englishman, Woodville was the finest illustrator of the American West in Europe. He worked for the Illustrated London News, which had been a model for the development of Harper's Weekly. His style was much more animated than other illustrators' during the 1880s, which helps to explain his popularity.

Sioux uprisings in Montana, which also attracted Remington. Woodville, the son of American genre painter Richard Caton Woodville, was somewhat of a child prodigy and studied at a very young age at various academies in Europe. He was a friend of Harte's, who during the mid-1880s lived in England. There he wrote "Maruja," the story of a young California girl on a land-grant California ranch who was pledged by her Spanish mother to marry a Spaniard, but who was courted by all the young men of the area. Woodville introduced in these images someone new, at least to Eastern readers—the vaquero. The cowboy, as he became known, evolved first from an image of a frontier ruffian with no respect for the law, to the morally sound, hardworking cattle driver we now remember. Presi-

dent Chester Alan Arthur referred to the cowboy in his first address to Congress in 1881 while describing a certain action in the West as "a disturbance of the public tranquility by a band of armed desperados known as cowboys . . . who had for months been committing acts of lawlessness and brutality in Arizona and Mexico." It should be understood that cowboying as a life evolved really from the Mexican vaquero, who migrated into Texas and California in the late eighteenth century with the first cattle herds. As the cattle industry boomed a century later, images of vaqueros and cowboys became popular.

What is critical to Woodville's efforts with "Maruja" is his attempt to capture horses in full flight as he did in his *Vaquero*, which was reproduced as a full-page cover of *Harper's* on June 20, or in *Captain Carroll Finds the Saddle Blanket of Dr. West*, which shows a cavalryman charging straight at the reader. The conventional hobbyhorse depiction of running animals was disappearing during these years due to the stop-action photographic experiments of Eadweard Muybridge in this country and Etienne Jules Marey in France. As a result of these pioneers, artists were able to depict animals and humans as they actually moved. Taken together, Woodville's two pictures are a complete study of the motion of a horse, and they appeared a full year prior to Remington's first similar studies. It is important to bear in mind here that, as Remington studied the works reproduced in *Harper's* during 1885, any lessons he learned would appear months later when his illustrations were actually assigned and then published. And, as circumstances would develop, his opportunity for study would shortly receive a great boost.

Amazingly, Remington's first work to appear solely as his own delineation, *The Apache War—Indian Scouts on Geronimo's Trail*, graced the cover of *Harper's Weekly*. Such prominence was due to its timely subject, not to the quality of the artist's draughtsmanship. It shows Remington's rudimentary efforts at horses and humans in motion, which were not very effective. The artist's understanding of a horse's anatomy was sound, but he lacked the ability to build the human figure from the bone structure to the muscular system, and finally to the individual's features. His awkwardness with the figure was really evident in his second image, which shows a vaquero on his horse coming to an abrupt halt to warn a ranch family of imminent danger. The rider's facial features look more like those of an ape than of a human. Crudeness was apparently considered part of the Western style as Harper stated when he first described Remington's sketches as having "all the ring of new and live material." It is only conjecture that these two drawings were purchased by Harper. Years later in an interview with the art critic Perriton Maxwell for *Pearson's Magazine*, the painter stated, "My first commission was from *Harper's Weekly*. I did a picture based on an incident of the Geronimo campaign." It is highly unlikely that Remington's 1885 trip to Arizona put him on the trail of Geronimo. What is more plausible is that due to public interest Harper commissioned a specific Geronimo topic for the cover after seeing the artist's sketches of the region. Nevertheless, Remington could not have been fully satisfied with himself at this point. Yes, it appeared that he had found a career, not *in* the West, but *of* the West. But he knew that if he wanted to excel at his chosen vocation, he had a lot to learn.

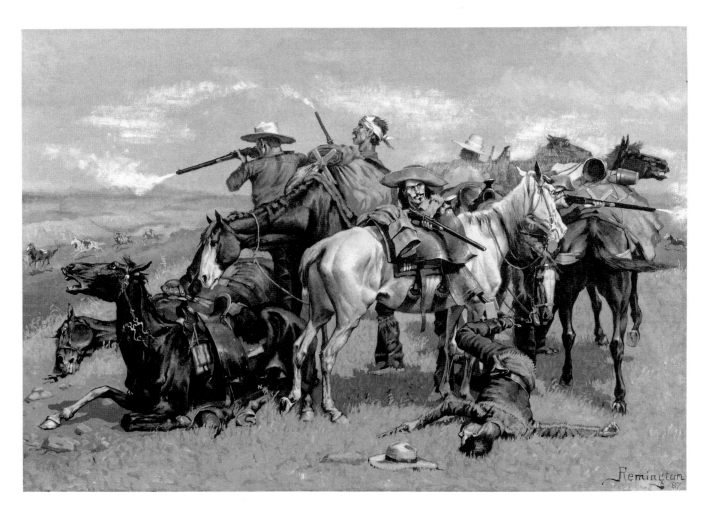

An Episode in the Opening Up of a Cattle Country

II. Achieving Renown: 1886–1889

ALTHOUGH CONFIDENT OF HIS OWN ABILITIES, Remington could plainly see that other published artists were more refined than he. This realization most likely caused him to enroll at the Art Students League in March 1886. The League was a loosely organized school where well-known painters taught as well as attended certain classes to hone their skills. Zogbaum and de Thulstrup had once studied there and might have suggested that the younger artist enroll. Remington, who had just received recognition for his work, would not have wanted to go to Europe as a fully dedicated student at this time, so the League offered him what he needed. Among the teachers that spring were Carroll Beckwith and William Merritt Chase, both with modern, Impressionist leanings, while on the more traditional side were Julian Alden Weir and Kenyon Cox. To understand the importance of the League, especially for illustrators, one need only mention several of the students enrolled with Remington: Daniel Beard, Charles Dana Gibson, Edward Kemble, Allen Redwood, and Ernest Thompson Seton, all of whom were or would shortly become widely recognized for their work. Kemble was shortly to become Remington's lifelong friend and neighbor. Remington chose to study with Weir at the League, perhaps (as Harold and Peggy Samuels have suggested) because Weir's brother had been head of the Yale College School of Art during Remington's student days. Weir, who taught at the Art Students League for twenty years from the mid-1870s, had not yet achieved his eventual renown as an Impressionist painter. His own academic lessons learned under Gérôme in Paris served as the basis for his approach, and they were tempered by his devotion to another French realist painter, Jules Bastien-Lepage. Weir's interior compositions and still lifes from these years demonstrate the solid armature achieved through drawing, and his vitality was expressed through bravura brushwork inspired by the seventeenth-century master Frans Hals.

It is difficult to reconstruct exactly what Remington learned or thought during his three-month experience at the League because he left no written descriptions nor any student work. Peter Hassrick has written that, in addition to Weir's painting class, Remington enrolled in life-drawing and a sketch class. Immediately upon conclusion of the session Remington boarded a westbound train on assignment from *Harper's* to visit Arizona and report on the Geronimo campaign. This action as well as other circumstances limited the artist to drawings for illustrations, and it was not until 1887 that Remington was able to apply some of his efforts to painting. Hassrick has properly noted two other skills that Reming-

An Episode in the Opening Up of a Cattle Country

1887. Oil on board, 17¼ x 24⅞"
Gene Autry Western Heritage Museum,
Los Angeles

Theodore Roosevelt published the serialized version of his Ranch Life and the Hunting Trail *in the* Century Magazine *throughout 1888. Remington was the illustrator, and he created dozens of paintings and drawings. This painting was one of five works exhibited the following year at the Paris Exposition.*

31

Powhatan Clarke

c. 1889. Oil on canvas, 10¼ x 13″
Courtesy Frederic Remington Art Museum,
Ogdensburg, New York

One of Remington's best friends, Clarke was a respected officer in the U.S. Cavalry, serving in Arizona and Montana; he drowned in the Little Big Horn River in 1893. Clarke provided photographs of Indians and soldiers to the painter as well as artifacts and military accessories. This painting is a fragment of an original full-length portrait, the lower portion of which was destroyed in a fire early in this century.

ton took away from his classes. One was how to describe color, and the other was how to utilize photography as a note-taking device.

Remington's diary of his trip to Arizona was inscribed on the cover, "Journal of a trip across the continent through Arizona and Sonora, Old Mexico." Upon his arrival in the Southwest he realized that it would be nearly impossible to accompany the newly appointed General Nelson Miles in his search for Geronimo due to the time it would take and the difficulty of the terrain. Remington wrote, "Let anyone who wonders why the troops do not catch Geronimo but travel through a part of Arizona and Sonora then he will consider that they even try." Remington wisely decided against the campaign and concentrated instead on the army of the frontier for his work, which resulted in a series of illustrated articles entitled "Soldiering in the Southwest." That Remington was inexperienced for such an assignment is reflected in the journal, which was poorly organized and chronologically inconsistent. It does reveal, however, how this twenty-four-year-old saw the land and its inhabitants. He used headings for his remarks such as "Frontier," "army," "indians," "Mexicans," and, of most interest for this study, "color notes." Under one such heading he described the Arizona scenery: "In the broken country of Western [read eastern] Arizona the earth is of a blue red color made cold in the shaddows [sic] and cold to [sic] in the sun though with marked difference. The misquit [mesquite]—of a [undecipherable] kind is a blue white green." Days later in the state of Sonora in northwestern Mexico he wrote, "It is impossible to get the white glare of the sun in this part [Hermosillo]. She cuts her lights square off and leaves no color in the highlight but diffuses it all in one glaring mass. Though the shaddow [sic] from reflection are never dark and always cold." And finally, "The brt [bright?] sky of the S.W. is a warm blue with a white tinge, not a good w. color mixture. Mountains near at hand are light red chromo cold in spots." These descriptions were written by a man whose assignment was to produce black-and-white images for the magazine. These notes would prove beneficial, however, once he was able to pursue painting in New York and submit entries to the American Watercolor Society and National Academy of Design annual exhibitions.

Remington's journal is also peppered with references to his use of the camera on this trip. Commonly used by artists during the late nineteenth century to capture reference material and for actual picture studies, cameras also provided many critics an opportunity to find fault in an artist for being overly dependent on photographs, even to the point of stifling creativity. This was certainly true of Remington, a fact about which he remained so self-conscious that he quite often downplayed the camera's influence and even created a myth that he had seen the horse's true locomotion before Muybridge. Remington later wrote, "It has been said that I first got my ideas of horses in action from the Muybridge instantaneous photographs. The fact is, I have never seen them. But I've taken lots of photographs of horses myself, and they never give you the feeling of motion. The camera paints what it sees and not what our eyes see. We want what we see." Most likely he learned of the camera's capability to assist an artist in both seeing and remembering during his months at the Art Students League. He was aware

that other illustrators made drawings for publication from photographs, as the half-tone process was still to come. But such journal statements as, "[I] photographed Col. Royal in various attitudes," or '[I] took camera went up to the detachment of 10th colored Cavalry—took a whole set of photographs," hint that he had a clear use for the photographs he was making. He recorded that he had thirty-eight plates developed in Tucson and even compiled a list of his photographic subjects. Hassrick noted that during Remington's months at the League he could not have avoided discussion about photography, as Thomas Eakins, the controversial head of the Pennsylvania Academy of the Fine Arts until a few weeks before Remington enrolled at the Art Students League, was lecturing at the League while thinking about opening a similar school in Philadelphia. Eakins was committed to the use of photographs by artists, especially to study the human anatomy in motion. He was a dedicated student of the experiments Muybridge had performed a few years earlier and had recently published. Someone of Eakins's reputation would doubtless have stirred a great deal of interest among the students, especially because, like Weir, he was a disciple of Gérôme, having studied with the French master ten years earlier.

Because Remington produced little besides illustrations from the trip west during 1886 and 1887, it is difficult to demonstrate the photographic and color influences directly. His experience at Yale and his three months in New York were the only formal art education he would receive. As a man in his mid-twenties, for the next few years he still had to absorb a great deal artistically. It is not until 1889 that a confident style emerged.

The Arizona adventure had another extremely important aspect to it—the friends and acquaintances he was to make. *Harper's* sent him to trail the well-known Indian suppressor Nelson Miles, whom he met at Fort Huachuca. Even though Remington chose not to accompany Miles, his reports drew attention to yet another success in "civilizing" the West. Miles was tremendously ambitious, even seeking the presidency, and he quickly realized Remington (and other illustrators) could manufacture valuable publicity. Many of Remington's future assignments would occur at the invitation of Miles.

The artist not only reported on a hero, but also attempted to create one. He befriended Lieutenant Powhatan Clarke, who was a slim, dignified man. Upon learning from comrades that Clarke was a daring and effective leader, Remington set about using one of Clarke's heroic acts to characterize for Eastern readers the soldiers serving in the Indian country. *The Rescue of Corporal Scott*—Scott was a black soldier rescued by the Anglo, Clarke—was drawn by Remington and reproduced as the frontispiece of the August 21, 1886 *Harper's Weekly*. Feeling strongly about Clarke's heroics, Remington had earlier sent a letter to *Harper's*, to be published unsigned, requesting a reward for the daring lieutenant who had risked his life in an open ambush to save Scott. The letter also served to promote Remington's forthcoming series of illustrated articles. These years were filled with prejudice, not only against recently freed blacks but also against various ethnic groups immigrating to America. Charles Darwin's earlier theories were current in genteel Victorian society, and they were being interpreted socially and

A Rearer

1889. Pen-and-ink gouache on paper, 12 x 8⅞"
Collection Mr. and Mrs. E. Coe Kerr, III

Remington provided a series of drawings for a Harper's *article, "Breaking a Horse to Stand Fire," which was published in February 1890. The drawings recorded the various actions a horse might take when the rider was forced to fire his pistol.*

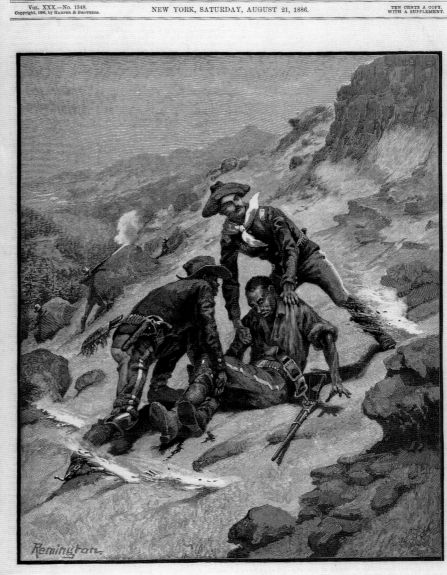

HARPER'S WEEKLY.

JOURNAL OF CIVILIZATION.

Vol. XXX.—No. 1548.
Copyright, 1886, by HARPER & BROTHERS.

NEW YORK, SATURDAY, AUGUST 21, 1886.

TEN CENTS A COPY.
WITH A SUPPLEMENT.

SOLDIERING IN THE SOUTHWEST—THE RESCUE OF CORPORAL SCOTT.—DRAWN BY FREDERIC REMINGTON.—[SEE PAGE 535.]

The Rescue of Corporal Scott

Wood engraving for *Harper's Weekly*,
August 21, 1886

Remington interviewed the wounded Corporal Scott in the hospital to learn firsthand of Powhatan Clarke's heroism during a skirmish with the Apaches in southeastern Arizona. The significance of an Anglo soldier risking his life to save one of the black Buffalo Soldiers did not go unnoticed. The artist's willingness to use the event as a subject for his own work reveals his own racial feelings during the 1880s and 1890s.

historically as the reason for what was seen as America's singular greatness. For Remington—who referred in his journal to the "nigger soldiers" of the 10th Cavalry (sometimes called Buffalo Soldiers)—to choose this subject was quite daring. He shared the "genteel" feelings of his time, often describing blacks, Mexicans, and European immigrants in extremely negative language. But this was never evident in his pictures of the Buffalo Soldiers, vaqueros, or Native Americans. So, to consider Remington a racist, as many have, may be valid, but his art rarely demeaned his subjects.

Clarke's friendship was beneficial to Remington during the ensuing years. Returning to Arizona two years later, he was again met by Clarke and accompanied the cavalryman on a scouting mission for several days. And when Clarke was assigned to Montana several years later, the two met again. Clarke visited the Remingtons' home in New York, and the two maintained a constant correspondence until Clarke's accidental drowning in 1893.

Remington's letters to Clarke, housed at the Missouri Historical Society in Saint Louis, reveal much about the artist's activities and desires. Most interesting is a series of notes regarding photographs the artist requested, having sent his own camera to Clarke, and his desire to have various items shipped to him for use in painting projects.

A third person Remington met on his 1886 trip was Leonard Wood, then an army surgeon stationed at Fort Huachuca, who was active in the Geronimo campaign. This action proved to be the beginning of a very important military career for Wood, which would climax in a run for the presidency in 1920. Remington recognized the value of knowing important persons, and his and Wood's career paths intersected several times, most notably in Cuba during the Spanish-American War, and when, in the artist's last year, he painted Wood's portrait.

The success of "Soldiering in the Southwest" and Southwestern illustrations sold to *Outing* magazine shortly thereafter provided financial stability to the Remingtons, enabling them to secure their own apartment with studio space for Frederic. Remington's income during this first year was approximately $1200, a sum greater than he could have realized had he remained in the government. Eva had accepted Frederic's career decision, so their marriage was stable. Art was indeed an acceptable occupation. Remington's workload during the next three years was unbelievable. Had he been told on New Year's Day, 1887, that almost 250 of his drawings would be published during the next two years, he would have thought it a dream. The high points of Remington's illustration assignments occurred during 1888 and 1889.

Late in 1887 Theodore Roosevelt contracted for a series of articles on the West for the *Century Magazine* to be serialized during 1888. These were later published as the bound book *Ranch Life and the Hunting Trail*. Roosevelt requested the editors of the magazine to obtain the young illustrator Frederic Remington. He felt the artist's somewhat crude, direct images embodied his own image of the strenuous life on the Western frontier. This was an important undertaking for Roosevelt, who had lost the New York City mayoral election of 1886 and soon after lost his Badlands ranch stock to the devastating blizzards of the plains. Remington produced eighty-three illustrations for the project, not only pen-and-ink sketches and ink-wash drawings, which was normal for him, but also several grisaille (black-and-white) oil paintings, the best of which was *An Episode in the Opening Up of a Cattle Country*. The text by Roosevelt that inspired this painting was a retelling by two acquaintances of how they and a handful of Anglos herding a thousand head of cattle on the open plains successfully defended themselves against a superior Sioux warrior force. As the Indians scattered the cattle, "the men themselves instantly ran together and formed a ring fighting from behind

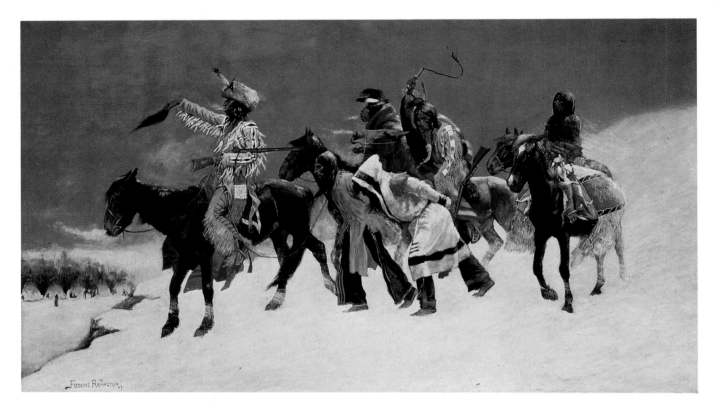

Return of the Blackfoot War Party

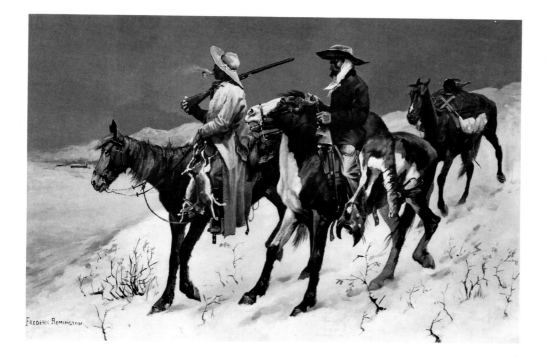

Thanksgiving Dinner for the Ranch

1888. Oil on canvas, 17 x 27"
Woolaroc Museum, Bartlesville, Oklahoma

Published in the holiday issue of Harper's Weekly *in 1888, Remington's image of cowboys returning from a hunt can be viewed as the "cowboy version" of* Return of the Blackfoot War Party.

the pack and saddle ponies. One of their number was killed, as were two or three of the animals composing their living breastwork; but being good riflemen, they drove off their foes." After repulsing the enemy, "Both the men . . . had been especially struck by the daring shown by the Indians in thus carrying off their dead and wounded the instant they fell."

The picture was published in the February issue of the *Century*, and Remington thought so well of it that he entered it the following year with four other works in the Paris Universal Exposition. This painting became Remington's model for an image that had been prevalent in America since Custer's own "last stand" eleven years earlier. How many artists painted Custer is impossible to guess. Brian Dippie in his superb study, *Custer's Last Stand: The Anatomy of an American Myth*, states that approximately 150 poems on Custer have been published as well as hundreds of visual images. When Remington was in Kansas City, the art talk had been about the local artist John Mulvany's 20-by-11-foot *Custer's Last Rally* (1881), which the artist exhibited all over America. Both Henry Farny and Rufus Zogbaum created images of Custer's fate, but there is no reason to think Remington saw either. By this time the events of the Little Big Horn had become part of America's mythology, especially among the cavalrymen and infantrymen whom Remington knew. Custer stood for all the heroics Remington never experienced, and he came to symbolize the winning of the West. Interestingly, beginning with *An Episode in the Opening Up of a Cattle Country*, the "last stand" was a subject Remington would often return to, but he never painted a work specifically depicting Custer's last battle.

The integration of Remington's illustrations with Roosevelt's text, especially in the hard-bound volume, is masterful. Picking up the volume a century later, one is struck by the quality of the imagery and the directness of communication. Lacking photographs, the author and the artist, who had not met, teamed to de-

Return of the Blackfoot War Party

1887. Oil on canvas, 28 x 50"
Courtesy the Anschutz Collection

Remington's first trip west had been to Montana in 1881 at the age of twenty, and he again traveled the northern plains during 1887. Many of his early works were based on northern plains subjects, including this work, which won the Hallgarten Prize for young artists and the Clark Award at the 1888 National Academy of Design exhibition. The original composition included seven figures but was simplified prior to its sale in the early 1890s.

Ben Clark, Interpreter

c. 1888. Ink wash on paper, 10½ x 8½"
Private collection

On his return from a trip to the Southwest in 1888, Remington stopped at Fort Reno in Indian Territory (present-day Oklahoma) to observe the Cheyenne. Ben Clark was assigned to assist the artist, and he often engaged the Indians in conversation while Remington sketched. Here, Remington captured his "interpreter."

liver a thoroughly authentic experience. This publication was largely responsible for furthering Remington's career. During 1888 the artist had 139 illustrations published, including reproductions in almost every issue of *Harper's Weekly*. His income doubled, and as Dippie has recorded, from 1887 until 1899 only eleven months were to pass without at least one Remington image in the *Century, Collier's, Cosmopolitan, Harper's Monthly*, or *Harper's Weekly*. In recognition of Remington's quickly acquired stature in American illustration, he was commissioned in late 1889 to provide over 500 works for a deluxe edition of *The Song of Hiawatha*. Written by Longfellow in 1855, the epic poem had become the romantic symbol of the Native American in America's Western territories. Remington's boyhood goal of fame was being won, but it was not enough. He was achieving greatness in a field viewed as secondary to the one he desired—fine art.

A fine artist's reputation was established by acceptance in major annual exhibitions, by recognition from the critics reviewing these exhibitions, by inclusion in the holdings of leading collectors, or by one of America's few art museums purchasing new work. Illustrations in large-circulation publications might be financially rewarding, but they also worked against efforts to be accepted as a serious artist. Then, as now, widespread popularity made an artist questionable among the critics, who felt they and not the public should make careers.

Realizing the rules, Remington early on began exhibiting watercolors and paintings in the annual exhibitions of the American Watercolor Society and the National Academy of Design. His first entries came in 1887, the year following his trip to Arizona in search of Geronimo. Both *The Courier's Nap on the Trail*, shown at the National Academy of Design, and *The Flag of Truce in the Indian Wars*, shown at the American Watercolor Society, are today lost, as is his entry to the Watercolor Society's exhibition the following year. Extant is his *Return of the Blackfoot War Party*, a color oil painting inspired by his 1887 experience in Montana, Wyoming, and western Canada, which was shown at the Academy the following year. The picture received mixed reviews: some critics believed its strength demonstrated a great future for the painter, while others were critical of the anatomical deficiencies of the Indians, especially the faces, which approached "caricature." The picture won the coveted Hallgarten Award, given to the most promising artist under the age of thirty-five, providing, one would think, great satisfaction to Remington.

The history of this picture, best documented in the Samuels's 1982 biography, demonstrates the artist's concern that it did not achieve the highest quality. The painting seen today, depicting four Blackfoot warriors returning through windblown snow with two captives, is not the same painting viewed by the thousands of visitors who attended the National Academy of Design exhibition beginning March 31, 1888. What they viewed, based on contemporary reproductions, was a jumbled scene of seven Blackfoot warriors escorting the captives. At some point following the exhibition, Remington repainted the work, making radical alterations. Why? One clue might be found in his *Thanksgiving Dinner for the Ranch*, made for the *Harper's* holiday issue of 1888. Painted in grisaille and depicting the effects of a calm wind so as to provide clear contrast to the horse's legs

against the ground cover, this work can be seen as a smaller, simplified, cowboy version of the Blackfoot painting. The returning cowboys are shown on a ridge overlooking the ranch in the distance, a composition identical to the war party overlooking their camp. The lead horse is very similar in pose and carries two dead rabbits, as does one of the Indians' pack horses, which, in turn, is practically the same pack animal the cowboys use. Comparing the grisaille painting with the production of the original National Academy picture, it is obvious what Remington had learned: by simplifying the composition its meaning is more easily read. The elements in the larger picture, with all the horses' legs and the seven riders, are almost impossible to sort out. By removing a rider immediately to the right and behind the lead Blackfoot and replacing three trailing riders with one isolated, blanketed figure, the silhouettes of the riders are more easily articulated and the captives are brought more into focus. When Remington made these changes remains a mystery.

Exhibited pictures put greater pressure on the painter to deal with the subtle aspects of painting, such as expression, the unification of figures for communication, color harmonies, and the paint quality itself. Drawings and grisaille paintings made on deadline to be reproduced as black-and-white images accompanied by explanatory text were deemed much easier to create than a work intended to stand alone. Remington's desire to create "fine" art can perhaps be better understood by comparing the elements of an illustration to those of a genre painting, as defined by Herman Williams, Jr., in his 1973 book, *Mirror to the American Past.*

Lt. Carter P. Johnson—10th Cavalry

c. 1888. Watercolor on paper, 13½ x 8½"
Private collection

From his trip to Arizona and Sonora in 1888 Remington derived tremendous inspiration and made several longtime friends, among them Lieutenant Carter Johnson. Remington accompanied Johnson on a two-week scout among the Apaches near San Carlos in eastern Arizona and later wrote an article on the subject. The confidence the artist saw in the army officers helped him to create the heroic images of his mature years.

A genre painting is an artist's commentary on a commonplace everyday activity of everyday people, painted in a realist manner. The artist must be contemporary with the scene depicted. The subject should not be of extraordinary nature or of infrequent occurrence, but one which arises often and naturally from the nature of the circumstances. A genre painting portrays the labors, pleasures and foibles of anonymous people in the course of daily work and leisure. There should be no incongruity, and every incident should be typical: that is, characteristic of the time, the place, the social class, the age of the participants and their vocations, down to the last details of clothing, expressions, accessories and background. The participants, although appearing as individuals, will be composite types but not lifeless stereotypes. A genre scene may have a cast of dozens or of only one. People, caught in some homely moment of life, dominate genre scenes. The true theme of genre painting is not the incident, but the human condition. The genre painting's source of strength is the rapport between seer and seen, calling for the establishment of a bond of sympathy—based on a familiar response to the human situation presented. Thus a genre painting may be frivolous or profound, a pictorial pun good for a quick laugh, or a moving statement of some eternal truth, refined from the mundane circumstances of daily experience.

Practically every aspect of a genre painting articulated by Williams is applicable to the pictures Remington was creating. Only one sentence might be held aside and that is, "The true theme of genre painting is not the incident, but the human con-

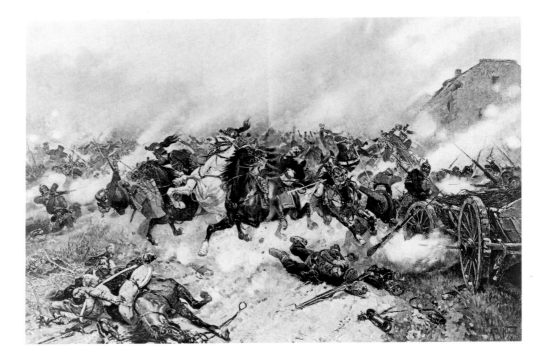

Alphonse-Marie de Neuville
(1836–1885)
Charge de dragons à Gravelotte

(From Jules Richard, *En Champagne, Tableaux et
dessins de Alphonse de Neuville*, Paris, 1893)
Color lithograph

*Throughout his early years Remington
was quite aware of the French military
painter de Neuville and his colleague
Jean-Baptiste-Édouard Detaille. They
were famous painters in their native
country, thus the American's emulation.
This work was reproduced in a book
owned by Remington, and it compares
closely to his masterpiece,* A Dash for the
Timber.

dition." The illustrator's first responsibility is to capture the incident described by
the author, but at his best the illustrator, too, communicates through the incident
the larger human picture.

Remington, and artists like him, chose the West as their subject and fought a
battle for critical acceptance. The battle is still being fought, and again Williams's
book can serve as example. Less than 5 percent of the more than 200 pictures
Williams selected are Western. Rural scenes dominate, as would be expected, but
wilderness subjects are absent; absent, too, is the Native American; and only one
cowboy scene can be found. Clearly, the definition of genre he posits, and the
willingness to accept such subjects by late-nineteenth-century critics, character-
izes the limitations only of the writer, who simply does not understand the West
of the late nineteenth century. During these years the Native American was be-
ing either eradicated or placed on reservations out of the way of "civilization."
That they were human beings who had a culture of their own in which everyday
activities occurred was not accepted. Rather, they were seen as exotic, romantic
reflections of a past civilization. The cowboy can be seen much in the same light
because his job was one performed, not in the East, familiar to the critics and buy-
ers of pictures, but in the West, where most art aficionados had never traveled.
Therefore, the cowboy's activities were equated to those seen in the traveling
Wild West shows or described in the pulp novels and magazines, a romantic im-
age, and one not appropriate to "genre" painting. This line of thinking can also
be applied to Remington's third and most frequent subject—cavalrymen. That
these men who populated the West for two generations had a life in the sense
projected by Easterners was not accepted. But Remington depicted them not
only in action, but also eating breakfast, bringing home dinner, socializing,
readying their animals, and exploring—all normal, daily activities.

Truthful realism as practiced by Remington in his paintings and illustra-

Vasilii Vasilievich Vereshchagin
(1842–1904)
Mortally Wounded

1873. Oil on canvas, 28⅞ x 22¼″
The State Tretyakov Gallery, Moscow

*Vereshchagin's 1888 exhibition at the
American Art Galleries in New York was
a great success and impressed the young
Remington, who attended with his wife.
Internationally famous, the Russian re-
corded several wars. His action pictures
used generalized backgrounds, intense
light, and strong shadows to echo the
figures—techniques Remington used to
enhance his own pictures.*

tions was not popular among all the critics during the 1880s and 1890s. Ameri-
can painting, beginning in the eighteenth century and continuing through the
Hudson River School painters of the mid-nineteenth century, celebrated detail
and specificity. Following the Civil War, styles favored the ideal and the univer-
sal. The aesthetic "art-for-art's-sake" approach of James McNeill Whistler set the
most modern pace, while many painters settled into a classical, academic ap-
proach. In landscape, Tonalist painters such as George Inness chose intimate
scenes, whose compositions were unified by tonally equating all colors, which was
thought to evoke spirituality. Finally, the most popular movement was that of
Impressionism, which was rapidly finding support in America. The French deal-
er Paul Durand-Ruel organized a New York exhibition of 300 French paintings
in 1886, the year Remington enrolled in the Art Students League. Two years lat-

er he opened the Durand-Ruel Galleries in New York. The Impressionist approach of heightened color with short, choppy brushwork was chiefly a landscape style with attention paid to the intimate "snapshot" of nature, not the grand omnipresent nature that existed in earlier American painting. All these newer styles made Remington and others who painted like him seem merely anecdotal realists with too much emphasis on truth and fact.

By concentrating on his illustration career Remington ignored the modern styles exhibited in New York. He and Eva would attend exhibitions at the Metropolitan Museum of Art, but they had little direct influence on his work, and naturally he viewed the exhibitions in which he participated. There was, however, one group of artists who did exert an influence on Remington—an influence that would lead to the creation of his mature style. These were military artists active in France and other European countries. Military painters have always been viewed separately from the mainstream, so even though they were famous a century ago, their names are footnotes in art history books today—with one exception, Ernest Meissonier.

Meissonier, a Frenchman, was of an earlier artistic generation and served as the inspiration for younger artists who mourned the French defeat by Germany in the Franco-Prussian War of 1870–1871. Meissonier exhibited annually at the Paris salons of the 1840s, 1850s, and 1860s. His work celebrated the efforts of Napoleon III's Italian campaign in great detail, but when the French lost in 1870, Meissonier left the subject to younger artists, shifting his interest to celebrating Napoleon I. The position of such artists as Meissonier was best summed up by the great French painter of the period Edgar Degas, who termed Meissonier "a giant among dwarfs." Late in his career Meissonier was initially reluctant to change his method of recording horses in action despite Muybridge's research, and even though they had met. He did eventually change, however, as did two younger Frenchmen, Jean-Baptiste-Édouard Detaille and Alphonse de Neuville.

Both Detaille and de Neuville made their names recording events of the Franco-Prussian War. They dealt with the dignity and glamour of the French soldier, not the events of the war, which they regretted. In addition, both artists traveled widely, documenting the armies of the world. Just as Remington, Zogbaum, and de Thulstrup constantly had their pictures reproduced in American magazines, so did their counterparts in French publications. Remington was certainly aware of their work; in his 1886 journal he describes a vagabond he saw in El Paso as having "De Neuville's Henry the 6th eyes." Several years earlier, when he wrote to his Aunt Marcia from Highland Military Academy, Remington had requested "De Neuville's last autotype" for a Christmas present. No doubt, images by these artists would have been used for teaching purposes at military schools. Remington's personal library, much of which remains at the Remington Art Museum, contains numerous folio-size volumes dedicated to European military artists and military subjects. Most of the books were acquired during the mid-1890s, and among them is a deluxe volume dedicated to the work of Detaille and de Neuville. De Neuville died in 1885 at the age of fifty, and *Harper's Weekly* carried a long, glowing obituary of the painter and reproduced his last work, *The*

Flag of Truce (1884), as a full-page plate. Remington would have seen this article, and he produced two similar subjects during the next two years: *The Flag of Truce in the Indian Wars*, his first entry to the National Academy of Design, and *Signalling the Main Command*, published in *Harper's* on July 17, 1886.

Remington, both during his lifetime and more recently by Peter Hassrick, has been compared to a third, often-reproduced military artist of the late nineteenth century, Vasilii Vereshchagin. Trained at the Royal Academy in Saint Petersburg, Russia, Vereshchagin enrolled in the Paris studio of Gérôme, as did many Russians. Rejecting Gérôme's overly academic approach, the Russian set out to learn from nature. His pacifist-inspired pictures of the Turkestan Wars during the late 1860s first brought him fame, and he also painted scenes of the Russo-Turkish War of 1877–1878 and the Russo-Japanese War of 1904, during which he died as the result of an explosion aboard ship.

Vereshchagin's fame was equaled by no other Russian artist of his day. During 1888 an exhibition of his work was presented first in Philadelphia and then in New York at the American Art Galleries on 23rd Street at Madison Square. The *Harper's* issue of November 17 dedicated two pages to the show, an inordinate amount of space for any art exhibition. Clarence Cook, the well-respected critic, was full of compliments. His article opened, "A richer, more inspiring artistic feast has not been offered us in this generation than the Russian painter Vasili Verestchagin [*sic*] has set before us in the Galleries of the American Art Association." Vereshchagin's method of installation may have contributed to the writer's enthusiasm. His grand paintings were presented together with Russian objects, Indian objects, and many high-quality Middle Eastern carpets. His style was academically based, and as the artist stated in the accompanying catalogue, "My intention was to examine war in its different aspects, and transmit these faithfully. Facts laid upon canvas without embellishment must speak eloquently for themselves." Of course, his approach was not popular among most critics of the time, and the exhibition generally went unnoticed by the dailies.

The Russian's technique was to generalize the background and concentrate in detail on his subjects. He was well aware of building contrasts, and he captured the hot light of India and Africa very boldly. In action paintings such as *Mortally Wounded* he presented a dramatic scene with a stop-action effect, strongly lighted as seen in the soldier's shadow. Cook went on to describe Vereshchagin's works in terms that should be kept in mind when considering criticism of Remington. "Indeed we remember to have heard it intimated that he was not a painter at all, and that it was only the literacy or historic interest in his works that made it worth while to consider them. This opinion is now perceived, in the presence of the pictures themselves, to be wholly mistaken." When Remington and his wife viewed the exhibition some days later, he must have recalled Cook's concluding lines: "Artists at least will recognize the talent, nay, the genius that speaks so eloquently from the walls of these galleries, and calls them to emulate not only the technical excellence of their fellow-craftsman, but his enthusiastic devotion to the poetry and the religion of his art."

The opulence of the exhibition installation, the vastness of the works them-

A Dash for the Timber

1889. Oil on canvas, 48¼ x 84⅛″
Amon Carter Museum,
Fort Worth, Texas

Created as a commission for businessman
E. C. Converse, A Dash for the Timber
was one of Remington's greatest works.
Converse wanted a major picture repre-
senting the struggle for life on the frontier.
Beating their escape from a band of
Apaches, these cowboys are masterfully
caught in this instant of terror. When
shown in the 1889 National Academy ex-
hibition, the canvas garnered high marks
for its action and attention to detail.

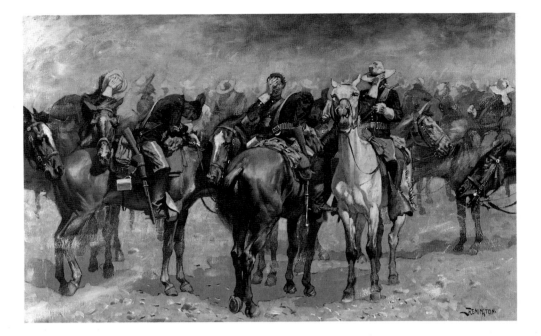

Cavalry in an Arizona Sandstorm

c. 1889. Oil on canvas, 22½ x 38⅜″
Amon Carter Museum,
Fort Worth, Texas

*The hard life of the frontier was very pop-
ular with Eastern readers during the lat-
ter years of the nineteenth century. In this
work produced for David Kerr's article,
"Cavalry in a Sandstorm," the artist drew
on his firsthand experience to describe the
reactions of both the soldier and his horse
at the instant when a cloud of blowing
dust engulfs them.*

selves, and the praise printed in *Harper's* must have communicated to Remington
that Vereshchagin's career could serve as a paradigm. Throughout his life Rem-
ington did not comment extensively on other artists' works, but in a letter written
to Powhatan Clarke two days after Christmas, he tells his Arizona friend, "You
ought to see Vertschagin's [*sic*] collections [*sic*] of paintings now here—priest
blessing a field full of dead and plundered soldiers—white marble forms of
dead—dry grass—spots of blood—thousands of 'em—awful—good." This de-
scription is especially noteworthy as it follows immediately his description of his
own painting *The Last Lull in the Fight*, which he intended for either the spring Na-
tional Academy exhibition or the annual Paris International Exposition. The
work, now lost, was sent to Paris with four other pictures, where it won a silver
medal. As described by Remington it depicted "sand hill—hot as devil—big
plain—mesquite Indians around in far distance. 4 old time Tex. cow punchers—
one dead—two wounded—damdibly interested—tough looking chaps—ten
dead horses—saddles canteens old guns buckskin etc.—one man bandaging a
damaged leg—critics will give it hell—brutal—etc." The picture, later repro-
duced in *Harper's*, was a major stride forward from the last-stand format of *An
Episode in the Opening Up of a Cattle Country*. The entire scene was unified through
the use of the traditional compositional pyramid. Seeing Vereshchagin's exhibi-
tion certainly encouraged Remington to proceed with a tough picture and led
him to realize that large-scale pictures carry great impact in exhibitions.

In addition, Vereshchagin's harshly lighted pictures of India may have lin-
gered in the American's mind when he ventured to Mexico to gather informa-
tion for Thomas Janvier's series, "The Aztec Treasure House." Remington
absorbed the glamour of Mexico, and unlike his first, three-day excursion to
Hermosillo, he really experienced the Mexican people. He was as comfortable
painting a dandy *Gentleman Rider on the Paseo de la Reforma* as he was documenting

A Regimental Scout. Both of these works show the painter at his best. A crisp ground shadow, similar to his Russian contemporary's, is utilized here in the white light of Mexico. Remington's buildup of impasto, especially in the horse of the dandy, beautifully accentuated the detail of the horse, which is, in turn, built up through careful layering of color. The breeze blowing through the mane and tail of the horse in *A Regimental Scout* is accomplished with a masterful blending of paint, and the composition is delicately held in balance by the artist's use of red, ranging from the subtle ground tones to the brash Mexican red of the scout's scarf, the horse's bridle, and the blanket streaming in the breeze.

Remington's Paris success encouraged him to pursue other large subjects for the annual exhibitions. Later that same year he created what is unquestionably one of his greatest paintings, *A Dash for the Timber,* which was hung in a place of authority in the National Academy. E. C. Converse commissioned from Remington a work that would symbolize the life-and-death struggle that takes place on the frontier, and Remington chose to draw from his Arizona experiences. He depicted eight cowboys beating an escape to the cover of the woods from a charging band of hostile Apaches. This picture, the most reproduced and discussed of the artist's paintings, can be seen not only as a summation of Remington's career to that time but also as a source for the many "charge" subjects he developed in future paintings, as well as the source of the 1902 sculptural group, *Coming Through the Rye.*

In creating this canvas, Remington drew upon his Arizona journal notes that discussed the color of the land and the coldness of the shadows. He wrote to Clarke, asking the lieutenant to purchase and ship specific styles of old chaparajos so that his cowboys would not look alike. These and the other props he amassed in his studio would provide the specific detail necessary to make the picture believable to the public. By this time, Muybridge's motion studies were fairly common knowledge, and the artist had no problem presenting the horses in full flight with all four hooves off the ground.

Finally, aspects of the work of other artists, such as Woodville, Detaille, de Neuville, and especially Vereshchagin, were brought to bear in *A Dash for the Timber.* Remington even asked others to come to his studio and critique his large canvas, which led to the removal of some foreground elements and the articulation of the ground cover. He put everything he had into this great picture and his effort did not go unnoticed. The critics gave the work encouraging reviews. The reviewer for the *New York Herald* pointed out, "The drawing is true and strong, the figures of men and of horses are in fine action, tearing along at full gallop, the sunshine effect is realist and the color is good." Remington was thus able to write his friend Clarke, "My picture, Dash for the Timber in the Academy has got a *grand* puff in the papers.—They all had a good word to say." In a very short time Remington had been able to amalgamate a great deal of learning and experience. His career had come to a peak. No illustrator in America was more respected, and now his easel work was gaining the recognition he so desired. His achievement allowed him to brag to Clarke in the same letter, "I have signed a contract for the purchase of an estate—estate is the proper term—three acres—

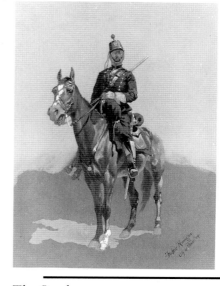

The Gendarme

1889. Watercolor on paper, 17 x 13"
The Hogg Brothers Collection, Gift of Miss Ima
Hogg, The Museum of Fine Arts, Houston

In the spring of 1889 Harper's requested their Western picture man to travel to Mexico to gather images for Thomas Janvier's serialized article, "The Aztec Treasure House." Remington, always eager to travel west, also intended to observe the Mexican military forces for an article he planned to write. He received permission from the Minister of War to have one soldier from each regiment as a model.

A Regimental Scout

Gentleman Rider on the Paseo de la Reforma (Dandy on the Paseo de la Reforma, Mexico City)

1890. Oil on canvas, 32½ x 23"
Collection Mr. and Mrs. Larry Sheerin

The subject of leisurely rides along the main boulevard of a city was popular among painters of the late nineteenth century. Paris, London, Boston, and New York were frequently depicted, but not Mexico City. Dated the year following Remington's trip to Mexico, this oil retains the life and immediacy of something personally observed. The gait of the horse is expertly captured as is the white color, which is achieved through a buildup of several hues.

A Regimental Scout

1889. Oil on board, 28 x 18"
The John F. Eulich Collection, Dallas

Remington often referred to himself as a "character man," and his visual efforts cannot be better represented than by this scout, proudly astride his prancing horse. The fluidity of this oil painting, unlike his more documentary watercolors, evokes the actual feeling of moving through the landscape and depicts the sharp light and clear air of the Mexican desert.

brick house—large stable—trees—granite gates—everything all [undecipherable]—lawn tennis in the front yard—garden—hen house—am going to try and pay $13000 cold bones for it—located on the 'quality hill' of New Rochelle—30 minutes from 42nd with two horses . . . good society—sailing and the finest country 'bout you ever saw—what more does one want." Remington's glee is reminiscent of his Christmas letter to his aunt written but ten years earlier.

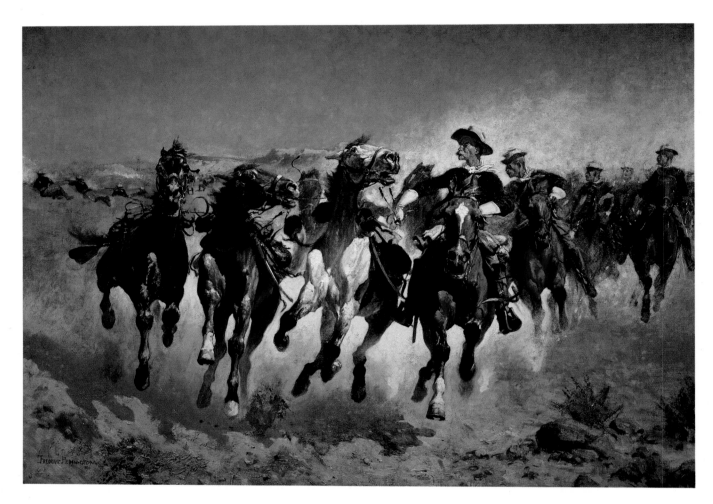

Dismounted: The Fourth Troopers Moving the Led Horses

III. An Era Dies: 1890–1895

THE REMINGTONS' LIFE AT ENDION, as their New Rochelle estate was christened, delivered all the couple wanted. Remington selected the name from the Ojibwa language; it means "the place where I live." Eva had never been particularly interested in being the wife of an artist, but now, given the financial rewards, she was able to pursue her own concerns and also to build their home. They were welcomed into local society and Frederic's fame continued to expand.

Harper's was generating a publicity campaign around their prized illustrator. Julian Ralph, a writer friend of Remington's with whom he enjoyed north country adventures, was the principal promoter. In January 1891 he wrote, "The building up of the West formed an era that is past; but the scenes have left him [Remington] upon the stage, with an enthusiastic memory filled like a storehouse with accurate notes. Remington has had adventures in such numbers as to have made his career almost romantic...." This description was timely, as it followed on the heels of the death of Sitting Bull and the final Indian submission achieved by Nelson Miles in Montana at the Battle of Wounded Knee. The Indian Wars were now over, and new heroes would have to be sought. It was true that Remington had a great storehouse of concepts. Throughout his career, he often digested aspects of his experience before making a painting months or years later; his illustrations, however, were more direct.

Immediately following the success of such pictures as *The Last Lull in the Fight* and *A Dash for the Timber*, Remington's easel held one superb picture after another. His educational experiences assimilated, the painter was able to attack the subjects he had been carrying in his mind and execute such scenes as charges, last stands, and cavalry movements. His entry in the National Academy of Design exhibition in the spring of 1890, *Dismounted: The Fourth Troopers Moving the Led Horses*, was a continuation of the charge scene from the previous year. It must have drawn great attention because Remington was nominated for and elected to associate membership the following year. His entry that year in the Academy's sixty-sixth annual exhibition was *Arrival of a Courier*, a carefully crafted scene based on his experiences in Arizona. Against the background of the adobe buildings of the army fort, the commanding officer anxiously reads an important communiqué. Remington expresses the tension of the moment not in the figures, which include his dashing friend Clarke, but through the horse's appearance of exhaustion. Throughout his career, Remington was more comfortable delineating an equine figure than he was the human anatomy. Nowhere is this

Dismounted: The Fourth Troopers Moving the Led Horses

1890. Oil on canvas, 34⅛ x 48⅞"
Sterling and Francine Clark Art Institute,
Williamstown, Massachusetts

Hoping to lure their adversaries into a trap, the cavalry often made a retreat, leaving behind a few dismounted soldiers; if the ruse were successful, those in pursuit would be ambushed by the hidden soldiers. This stratagem, seen in the work of the French artist Detaille, was one that, according to Powhatan Clarke, was not used in the U.S. Cavalry. During 1890, the year in which this work was exhibited at the National Academy, Remington used the onrushing phalanx of troops in several paintings. Created as an exhibition piece, it was not published until January 1892, when it accompanied E. S. Godfrey's article, "Custer's Last Battle," in the Century Magazine.

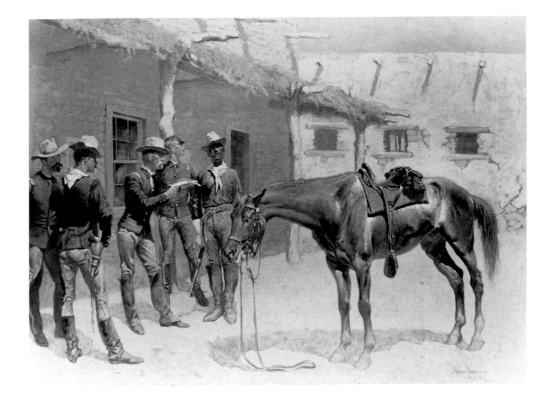

This painting was exhibited in the National Academy of Design show of 1891, and many writers believe it was the catalyst for Remington's acceptance as an associate member of the Academy. It was painted to illustrate an article about General George Crook's activity in the Southwest during the Indian Wars. Powhatan Clarke is included, second from left.

better demonstrated than in the artist's sole finished self-portrait completed in 1890 or 1891. Drawing on his single-figure format, the artist places himself as a confident rider on a hillside that slopes toward the viewer, creating the picture space. The barren landscape of the Southwest needed conventions such as this because it is predominantly devoid of architecture, trees, and other normal framing devices. The horizon line is cut through the abdomen of the figure so that his head and upper body are silhouetted against a deep blue high Western sky. Blues are used to harmonize the picture both in the rocks strewn across the foreground and in the cold shadows under the breast of the horse, which actually dominates the picture. The artist, garbed as a cowboy, is almost completely hidden behind the head of the horse, with his own head visible between the animal's upright, alert ears.

This self-portrait is an anomaly in Remington's later work. In earlier years he often included himself on the trail with cavalrymen in order to accentuate his actually being at the scene of his story. Perhaps because of his tremendous girth, he lost interest in depicting himself. One other possibility is that, because he had been elected as an associate in the National Academy, he expected full membership in the very near future, and the Academy required a full member to submit either a portrait of himself by another artist or a self-portrait. According to correspondence at the Academy, there was concern on Remington's part as to whether the painter Benoni Irwin had submitted the required portrait that Remington had commissioned. Concurrently, Irwin was corresponding with the Academy regarding frame size of the portrait, which was submitted and still remains in the

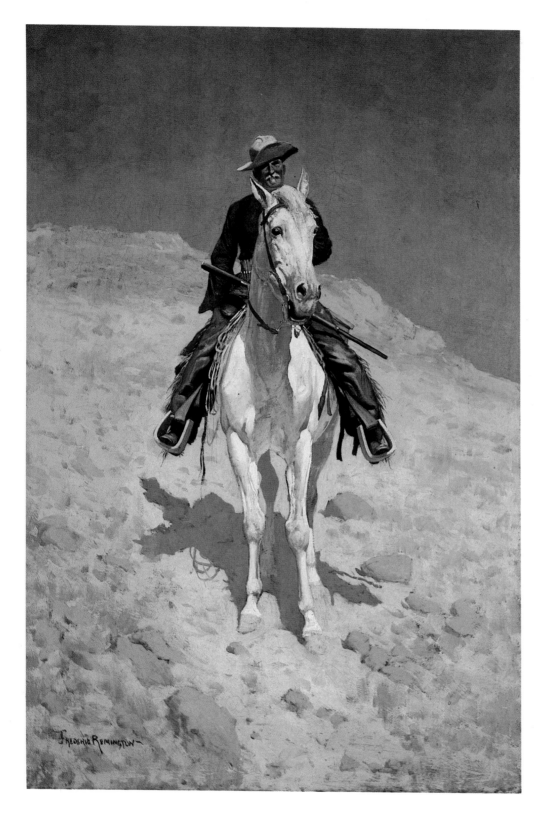

Benoni Irwin (1840–1896)
Portrait of Frederic Remington

1891. Oil on canvas, 21 x 17″
National Academy of Design, New York City

Benoni Irwin painted this portrait of Remington during 1891, when Remington was elected to the National Academy of Design as an associate member. It was required by the Academy that a new member submit either a portrait of himself or a self-portrait. Remington traded one of his own works to Irwin for this portrait. Irwin was a member of the National Academy of Design where he exhibited annually from 1880 until his death.

Self-Portrait on a Horse

c. 1890. Oil on canvas, 29¼ x 19⅜″
Courtesy Sid Richardson Collection
of Western Art,
Fort Worth, Texas

Remington's interest in the horse has often been cited, and here it is confirmed, as the artist is really secondary to his mount. The selection of a white horse enabled the painter to harmonize the entire painting around the strong blue sky and the cool blue shadows of the Southwest to which he often referred.

Academy's collection. If Remington intended his self-portrait as the required portrait, he certainly would have been challenging the Academy's self-portrait tradition, but he often offered such challenges. His complacency toward the Academy became a real problem when during the next several years he did not

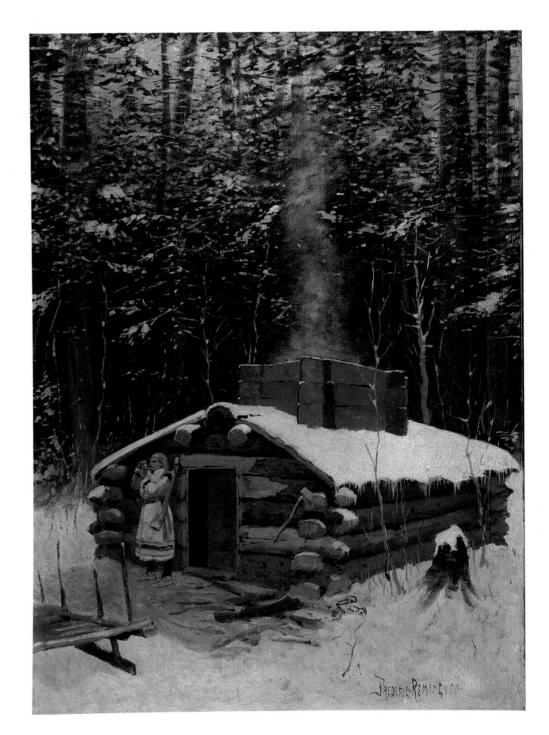

Cabin in the Woods

c. 1890. Oil on canvas, 28½ x 20"
Courtesy Frederic Remington Art Museum,
Ogdensburg, New York

Remington and his writer friend Julian Ralph often accompanied each other on hunting trips into Canada. During the winter of 1889–1890, the two went north to hunt moose, an expedition that resulted in Ralph's article "Antoine's Moose Yard." Antoine's cabin was the base of operation and the subject for several oil sketches and paintings.

submit a major picture. The Academy, feeling rebuffed, never voted him into full membership even when he made a concentrated effort with his large 1899 canvas, *Missing*. It would be his last attempt at membership. The picture, though large, was by no means Remington at his best. It was a static image, overly symbolic and awkwardly toned throughout the ground cover with an unsettling pink color.

The greatest of the artist's soldiering scenes was *The Cavalryman's Breakfast on the Plains,* a marvelously composed multiple-image painting, a technique he

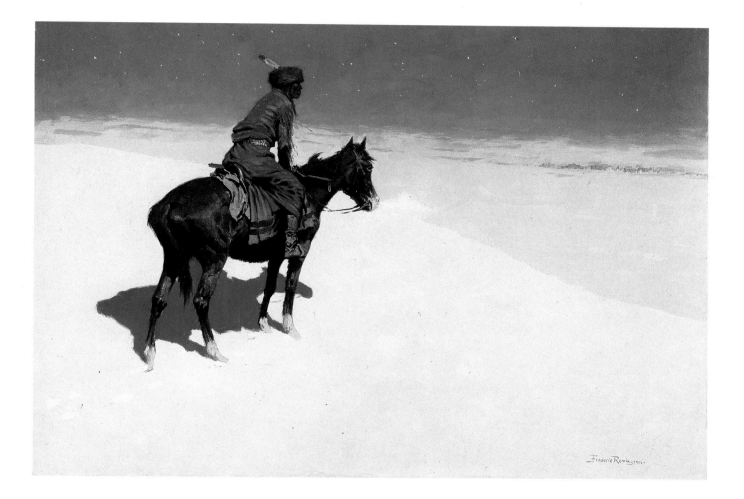

The Scout: Friends or Enemies?

c. 1890. Oil on canvas, 27 x 40"
Sterling and Francine Clark Art Institute,
Williamstown, Massachusetts

As dusk settles over the snow-covered plains landscape, there is an immense quiet and a sharp quality to the cold air. The painter heightens our sensation of this effect by adding the camp in the distance and leaving unanswered the question of who is there.

learned from de Thulstrup, which was reinforced by Detaille. The critical reason for this picture's success over others of the same type is its compositional technique. The diagonal established by the log in the lower left is consistent with the line of horses receding in space to the upper left. The artist chooses to create, however, a dense massing of the horses with the farthest gathering of soldiers, thus establishing compositional space. The calmness of the moment is communicated by the atmospheric conditions, the gestures of the men, their actions, the established horizon, and finally, the neutral colors. As the eye drifts from one group to the other and to each person around the campfire, the multiple actions of the morning unfold.

Exactly the opposite feeling is generated by Remington's next and perhaps greatest last-stand concept. It is simply titled *The Last Stand* and was painted the year following the success of *The Last Lull in the Fight*; in it the frenzy of the moment is expressed by the tight massing of the soldiers pinned down at a small rise by unseen attackers, who are undoubtedly Indians. The terrain provides a natural triangle with which to build the composition, even though the group's leader is not placed at the apex. Rather, he is distinct because his costume is the only uniform that is not blue. Remington depicts dead, dying, and soon-to-be-slain cavalrymen who had gallantly defended themselves from all directions. The staccato vertical slashes of the sabers stuck in the ground heighten the tension of the event. Painted in the year of the Battle at Wounded Knee and following a trip by the artist to the Big Horn Mountains with General Miles, this work takes on even greater significance. It has often been taken to represent Custer, but there is no real evidence to support such an idea.

The Last Stand was published two weeks prior to the routing of the Sioux by Miles's command, ending the Ghost Dance uprisings. Just as the campaign to capture Geronimo several years earlier had gained national attention, so did the gruesome events of the Battle at Wounded Knee, in the southwest of the Dakotas. A catalyst for the event was the killing of one of the last great chiefs, Sitting Bull, two weeks prior to the battle. Remington was in the region at the time, having been invited by Miles to document the conclusion of the Indian Wars. Miles was directed by advisers in Washington to negotiate a settlement, which he was successfully doing when one overzealous captain allowed events to get out of his control. What ensued at Wounded Knee on December 29 was the slaughter of Chief Big Foot and his people, an action Miles deplored. Remington was not at Wounded Knee but hastened from Lieutenant Edward W. Casey's unit near Hermosa to join Miles. Interestingly, Remington did not go to the scene; rather he chose to interview participants. The scene he would have found would not have been pleasant. The slaughtered Indians, left on the field, had frozen, so the bodies were loaded like logs into communal graves. Remington's brief published version, "Sioux Outbreak in South Dakota," presents the cavalrymen as heroes of the moment who performed well in battle. He stated, "The military process of killing men sometimes rasps a citizen's nerves. To the captain everything else was a side note of little consequence so long as his guns had been worked to his entire satisfaction." No question was raised as to necessity or responsibility. For many,

The Last Stand

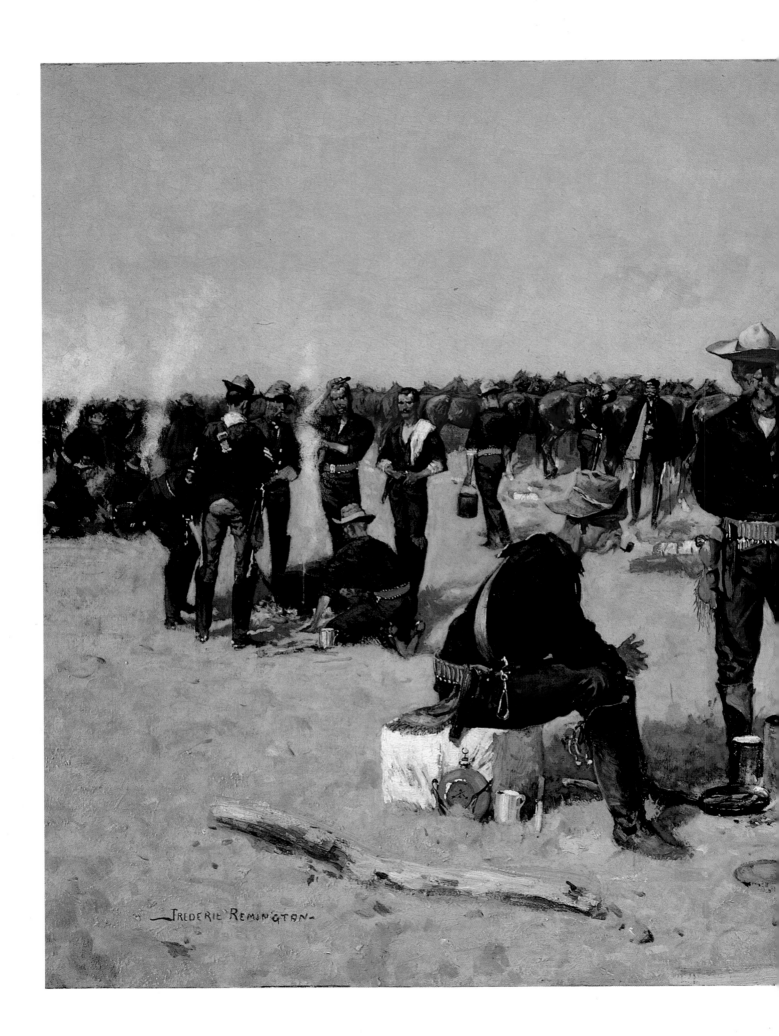

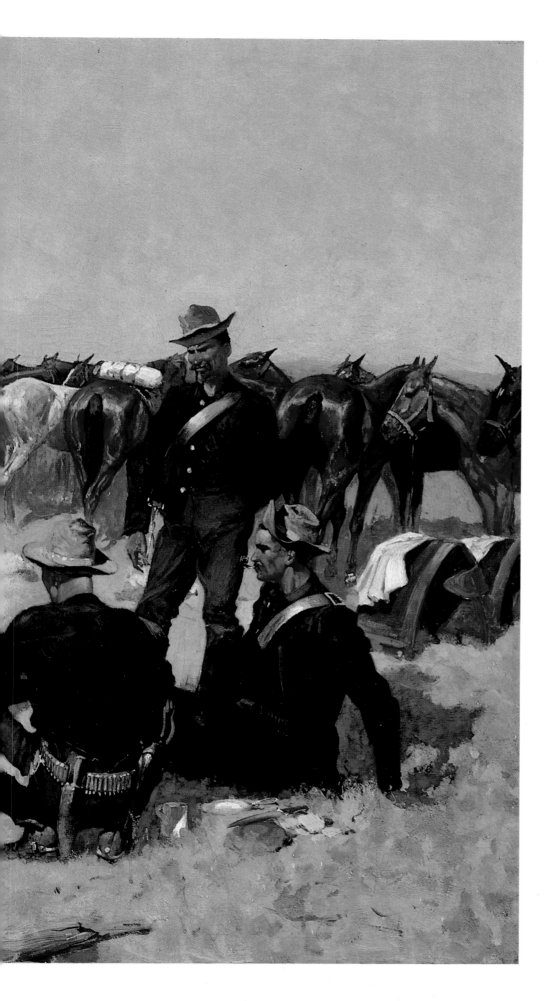

The Cavalryman's Breakfast on the Plains

c. 1890. Oil on canvas, 22 x 32⅛"
Amon Carter Museum,
Fort Worth, Texas

Remington often used a series of vignettes in one scene to create an entire narrative. Quite often these scenes are disjointed and unsuccessful: this painting, however, beautifully harmonizes four interactions taking place on a stage created by the "wall" of the pony herd. In addition, each vignette contributes to creating the recession of space in the picture.

Merry Christmas in a Silby Tent

the death of Custer had been vindicated. Remington's best visual work from this event so heralded in our history appeared a year later as the Christmas picture in *Harper's Weekly. Merry Christmas in a Sibley Tent* recalls the artist's frivolity with Lieutenant Casey and his men, when he spent Christmas Eve with them in their tipi-like plains home.

Remington's prolific burst of artistic energy during 1889, 1890, and 1891 seemed to cease during the next year. However, he was as busy as ever with illustrative work, his popularity pressuring the *Harper's* editors to use him in new ways. On January 7, 1892, the aging American historian Francis Parkman wrote to Remington regarding the publication of a deluxe edition of his classic *The Oregon Trail.* His compliments must have gratified Remington, who had just been given the illustration commission for the book. "I am very glad that you are to illustrate the 'Oregon Trail,'" Parkman wrote, "for I have long admired your rendering of Western life, as superior to that of any other artist. You have seen so much and observed so closely that you have no rival in this department." The historian was responding to a letter Remington penned two days earlier asking for photographs and descriptions of the West in 1846, the year of Parkman's Western exploration and three years before the book's original publication. This assignment was similar to Remington's commission to illustrate *The Song of Hiawatha,* which, by coincidence, was being released at approximately the same time. *Hiawatha* was Longfellow's romantic vision of the West during earlier times, and in his pen-and-ink sketches for the book Remington intended to concentrate on symbolizing the Indian, since he himself had not been present during the era. His more ambitious oil paintings for the book related to the story itself. In Remington's letter to Parkman he asked what kinds of rifles were carried, what hats were worn, and whether regulation uniforms were normally worn. Even though detail was critical, he expressed his goal, which was similar to

Merry Christmas in a Sibley Tent

1891. Oil on canvas, 22½ x 32½"
Collection The '21' Club, New York City

A trooper's home in the field was a large canvas tent with a conical top, called a Sibley tent. This tent was heated by a stove placed in its center around which, during long winter evenings, the men would recount events of the day. Remington's eagerness to know the soldiers and his penchant for drink enabled him to experience a scene such as this firsthand.

The Famine (also known as
The Death of Minnehaha)

1889. Oil on canvas, 17 x 25″
Courtesy The R. W. Norton Art Gallery,
Shreveport, Louisiana

*In December 1889, Remington wrote to
Powhatan Clarke that for the next half
year he would be involved in a big job: the
illustration of* The Song of Hiawatha *for
Houghton Mifflin. He produced hun-
dreds of pen-and-ink drawings of Indian
accessories and twenty-two oils represent-
ing crucial moments in Longfellow's epic
poem. The oils are not among the artist's
best works, but this important commission
brought great attention to the illustrator.*

that of the *Hiawatha* project: "You paint men very vividly with your pen and I
fancy I can almost see your people. I shall never be able to fill your mind's eye but
if I manage to symbolize the period successfully I shall be content." By the end of
February he had completed much of the work and sent it to the historian for
comment. Parkman suggested a couple of minor changes as well as an image for
consideration, "the subject of one of the full page pictures, the Indians coming
down the mountain gorge—the most striking sight I ever saw anywhere." Their
correspondence ended with Remington telling Parkman he would be spending
the next year in Europe.

During the spring of 1892 the artist undertook a project that would color his
opinion of Europe for the rest of his life. He agreed to accompany Poultney Bige-
low to Germany and Russia with the goal of producing illustrations of the armies
of each country and of making a canoe trip down the Volga River, all of which
Bigelow would describe with his pen. Remington first knew Bigelow as a fellow
art student at Yale, and later as editor of *Outing* during the mid-1880s, when he
published scores of the artist's early drawings. Son of the ambassador to Ger-
many, Bigelow was not entirely truthful with the artist as to why the trip was
being organized. Aside from their magazine adventure, Bigelow was to
communicate specific information to people in Russia. Remington knew nothing
of this. It was not until Bigelow vanished for a short period and Russian police be-
gan harassing the artist that he decided he had better get out of Russia. Reming-
ton had been reluctant to go to Europe in the first place, and having such an
escapade destroyed his confidence as a European traveler, which for any artist
should have been an important experience. Part of the reason he had accepted

*Illustration for the Oregon Trail
(Indian Riding Down a Hill)*

1892. Pen-and-ink wash, 17¼ x 10⅜″
Museum of Western Art, Denver

*When Remington was riding the crest of
his popularity as an illustrator, he was
contracted to provide images for a new,
deluxe edition of Francis Parkman's clas-
sic,* The Oregon Trail. *The artist in-
formed the elderly writer that he would not
simulate the West of 1846 as written, but
would provide his own symbolic interpre-
tation. This image was created at Park-
man's request.*

Frontier Guard and Custom House

the invitation was that Powhatan Clarke was then stationed in Germany to study their cavalry, and the two old friends planned to meet. Unfortunately, prior to Remington's arrival the lieutenant was reassigned to Fort Custer in Montana. Remington beat his retreat through Paris and London, where he saw Buffalo Bill's Wild West and wrote his own article for *Harper's*. Upon his return, Remington wrote to Clarke about his "fairish" trip: "I hate Europe and nothing but due necessity will ever drive me there again.... The German army is the only thing in Europe that we can't beat—except for the things which were built before 1492." Toward the end of the three-page letter, Remington remarks, "I have discovered that America is the only place on the Earth which is worth the efforts of men in the Grace of God." Amazingly, Remington agreed to a second trip with Bigelow the following year—this time to Algeria, where he drew French soldiers. This would be the last time this American artist would leave North America.

Other illustrative commitments at this time were not accompanied by quite so much personal adventure. Remington created illustrations for several of Julian Ralph's articles, the least he could do since Ralph was doing much promotional writing about the artist in *Harper's*. Ralph and Remington enjoyed the outdoors and often camped, hunted, and fished together, mostly in the north country. One of Ralph's articles was a historical look at the fur trade, entitled "A Skin for a Skin," while another, "Talking Musquash," was a description of the muskrat trade. Remington produced *In a Stiff Current* for the latter article, and it remains one of the artist's finest illustrations. Three hunters going upstream have decided to fight the water instead of portaging their canoe. The soft trees in the background encircle a calm eddy in the river where the three can join a second group of hunters. To reach it, they must struggle through white-water rapids by pulling the canoe. The strength and concentration of the canoeists is captured beautifully by Remington.

Remington's return to the north with Ralph and others also provided him a time to experiment with his paintings by sketching outdoors. These summer jaunts, which eventually became trips to a summer home, were important for the artist as retreats from the demands of the illustration world. On several occasions during this period Remington went on sketching trips with the little-known Canton artist Charles Ehricke. According to Paul Schweizer, Ehricke even posed for one of Remington's cavalry subjects. The quality of Remington's best north country work is equal to the pictures he executed of the West, but their impact was nowhere near the same. As he is today, during his lifetime Remington was known as a Western American artist, a great compliment to an Easterner. William Coffin, an important art writer during Remington's day, summed it up in an article titled "American Illustration of Today," written for *Scribner's Magazine* in January 1892: "It is a fact that admits of no question that Eastern people have formed their conceptions of what the Far-Western life is like, more from what they have seen from Mr. Remington's pictures than from any other source, and if they went to the West or to Mexico they would expect to see men and places looking exactly as Mr. Remington has drawn them. Those who *have* been there are authority for saying that they would not be disappointed."

Frontier Guard and Custom House

1892. Ink wash on paper, 21½ x 29"
Courtesy Frederic Remington Art Museum,
Ogdensburg, New York

In 1892, Remington accompanied the writer Poultney Bigelow, his longtime friend, to Europe to illustrate Bigelow's articles on the German and Russian military. They were asked to leave Russia. The experience was a bitter one for the painter and he never returned to Europe.

**Rival Traders Racing to the
Indian Camp**

1892. Ink wash on paper, 17⅞ x 24¼″
William Weiss Estate

*Julian Ralph's article "A Skin for a
Skin," published in* Harper's Monthly,
*was a historical look at the fur trade of the
West. Remington provided twelve illus-
trations for the article, the first of which
represented two traders racing to a village
in order to get first trading rights.*

In a Stiff Current

1892. Oil on canvas, 24 x 36″
Courtesy Sid Richardson Collection
of Western Art,
Fort Worth, Texas

*During Remington's lifetime the canoe
was a major means of transportation in
the north woods as well as a form of recre-
ation. Going upstream was often a battle,
as shown in this masterful grisaille paint-
ing, which illustrated one of Julian
Ralph's article on the Canadian north.*

Even though Remington knew a great deal about the business aspects of il-
lustration, from aggressively getting assignments to the reproduction process
and to self-promotion, he seemed unable to approach the business side of the
fine-art world. Even his early success in Paris and his second National Academy
showing resulted in a complacent attitude toward the Academy. His desire to sell
his work resulted in personally organized auction exhibitions in 1890, 1893, and
1895. None of these endeavors can be considered a marked success, even though
the model for his undertakings was the very successful Vereshchagin sale of
1888.

Another important opportunity came his way, and again he may have taken
the situation for granted. On May 1, 1893, the World's Columbian Exposition
opened in Chicago. The "White City," as it was termed, wanted to prove that the
United States could rival Europe culturally, and so the Exposition adopted the
dominant Beaux-Arts architectural style and its complementary mural decora-
tions. The environment symbolized the apogee of the genteel tradition in Amer-
ica. The art exhibitions were extensive, with hundreds of painters included in
various buildings aside from the Fine Arts Building. Remington had written to
Clarke on July 19, 1892, reviewing his dreadful trip to Europe, and included the
following comment, "have spent all my money and got to get ready a picture for
World Fair so can't make Fort Custer—I can't do anything anymore that I want
to and am thinking seriously of getting off the Earth." Despondency was rare for
the artist who had been riding the crest of a wave for several years, but in fact he
produced little work during the next months, with the result that he was not rep-
resented in the painting galleries at the Exposition. His publishers did forward
fifteen drawings to the Exposition, but they were predominantly pieces that had
been published years before. That Remington failed to recognize the impor-
tance of this event is further demonstrated by his own visit to Chicago the next

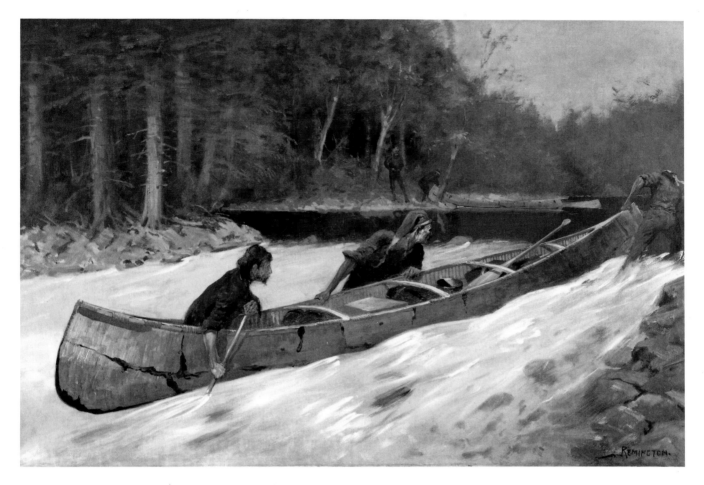

In a Stiff Current

The Infantryman

1890. Watercolor on paper, 18 x 10"
New Britain Museum of American Art,
Connecticut, Harriet Russell Stanley Fund

Throughout his career Remington not only documented the appearance of American military uniforms but also made suggestions as to more efficient uniforms and equipment. Of his scores of such drawings, this work, published in the Century Magazine, *March 1891, is among the finest. Its publication title was "Infantryman in Field Costume," and it is inscribed "with compliments to J. S. Hartley." It is not clear if Hartley was the subject or an acquaintance of Remington's.*

summer, following a trip to Yellowstone National Park. He commented in a rambling letter to Bigelow, "Have seen the World's Fair. Its the biggest thing that was ever put up on this rolling sphere." No mention is made of his work being included, which was out of character for him. Perhaps he was not aware of his own inclusion. He did not lose the opportunity, however, to write a brief article for *Harper's Weekly*, "A Gallop through the Midway," which mainly spoke of the midway barkers and the Bedouins who were part of the fair's entertainment programs.

The Exposition was an important effort by America during this critical time in its history. It was the American response to the Paris fair of 1889, symbolized by the engineering feat of the Eiffel Tower. America responded by building the first Ferris wheel, a 250-foot-high marvel placed on the midway. Elizabeth Broun, in her dissertation about the art at the Exposition, wrote, "As the verdicts came in on the Chicago World's Fair, the consensus was that at last America had achieved full membership among the culturally advanced nations. The Chicago Fair, it was thought, marked such an epoch in the affairs of men that it would itself be commemorated by grateful Americans a hundred years hence." This prediction has come true, partly because just about every writer visited the fair as well as over 27 million people from all over the world. Practically every important painter and sculptor exhibited. To thumb through the art catalogue of the Exposition is to see a "who's who" of American art. The works by Remington and other illustrators forwarded by *Harper's* and its counterparts were put together in a section titled "Pen and Ink, Charcoal, Black and White, and Other Drawings"—in other words, the minor arts.

For an artist of Remington's stature not to submit an oil painting was a mistake, and not to pay attention to what was there compounded his poor judgment. Among those who critically responded to the art exhibited at Chicago was the writer Hamlin Garland. For him, the exhibitions signaled the triumph of Impressionism, and he became the first real American defender of the style by dedicating an entire chapter of his book *The Crumbling Idols* to the concept. Garland most likely would not have championed Remington's own painting, but had Remington participated, he might have perceived a way to move from the traditionalism he found increasingly frustrating toward a more modern concept, a move he would indeed make ten years later.

During this period of despondency, Remington's artistic output experienced a serious decline while his writing increased. More and more articles appeared in periodicals, culminating in his first book, *Pony Tracks*, published in 1895. What was actually occurring was frustration sensed by the artist that the West, *his* domain, was being perceived differently. This would have been clear to him at the Chicago fair if he just could have seen it. Broun concluded in her study that "The artistic displays in the World's Columbian Exposition represented a concentrated effort on the part of many nineteenth century Americans to solidify America's position as heir to the grand European tradition." This was also true of the dominant architectural style. The popular or naturally American characteristics, to borrow an idea from Henry Adams, were literally kept outside the

gates. One of the most popular attractions in Chicago during 1893 was Buffalo Bill's Wild West, which was excluded from the exposition grounds and had to lease space just outside the main entrance. The West, in fact, was first declared dead at the Chicago fair.

Frederick Jackson Turner prepared his famous essay, "The Significance of the American Frontier in American History," for the fair's convocation of American historians, and he announced the thesis on July 12 in the lobby of what is today the Chicago Art Institute. The changed social environment of the period was clear everywhere in America as the nation moved toward the major depression of 1896. Americans, according to Turner, were "compelled to adapt themselves to the changes of an expanding people," but now, "the existence of an area of free land, its continuous recession, and the advance of American settlement westward" were constrained, thus ending the first era of America's history. As Ray Billington, Turner's biographer, has pointed out, the historian identified three new traits that had been born on the frontier, all traits admired and utilized by Remington: first, the mixed races of the frontier formed a composite nationality; second, democracy was strong in selfishness and individualism; and third, coarseness and strength were combined with acuteness and inquisitiveness to create a grasp of things material without an appreciation of things artistic. Perhaps the painter's tentativeness at this moment proves that he had already intuited what Turner was proclaiming. If not, it came to him quickly. A strong shift in his attitude began in 1895, and by the turn of the century, as Turner's thesis was being accepted by historians, sociologists, and geographers, Remington's work mirrored the passing of the West.

The first indication of the artist's changed perception was evident a few days prior to his visit to the fair, when he met a young writer, Owen Wister, at North's Inn in Yellowstone National Park. Remington had been assigned to illustrate the young man's first Western story, "Balaam and Pedro," for *Harper's*, but the two had never met. The story introduced a character who would shortly become a real star in American literature and the stereotypic cowboy, "The Virginian." The Ivy League-educated Philadelphia lawyer and Remington were to become fast friends and remain constant correspondents for years to come. Their friendship endured several rocky moments, usually because of Remington wanting favors from Wister while not returning them. Remington had just lost his close friend Powhatan Clarke in the spring, and here was to be, in many ways, his replacement.

Following this initial collaboration, Remington, agreeing with *Harper's* as to Wister's future, began encouraging Wister, as he had Clarke, to write essays that he would illustrate. Remington had a specific idea in mind, the development and the demise of the cowboy. Several years earlier Remington had been close to the fall of both Geronimo and Sitting Bull, marking the end of the Native American's dominance in the wilderness. And now he could see a parallel in the cowboy's fate. His great picture, *Conjuring Back the Buffalo,* painted two years after Wounded Knee, poetically depicted the frustration of the northern plains Indian and his longing for his people's cultural mainstay to reappear. A solitary figure is seen

The French Trapper

1891. Pen-and-ink wash on paper, 17¾ x 14⅛"
Courtesy Buffalo Bill Historical Center,
Cody, Wyoming

Wherever Remington traveled, he attempted to characterize visually and verbally the "types" of the region. The French trapper had long disappeared by the time he arrived, so this masterful drawing is a creation of the artist's mind, not from direct observation.

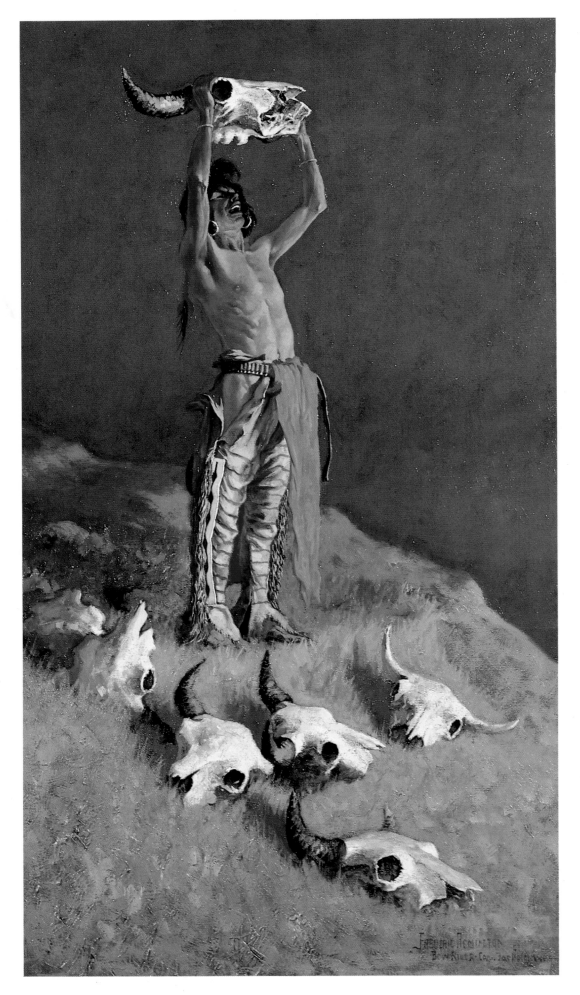

Conjuring Back the Buffalo

against a cold steel-blue sky in the long rays of the setting sun, pleading to his gods for the return of the almighty buffalo.

Wister felt comfortable writing stories about cowboys, having traveled west to observe the work performed on ranches, but he did not feel adequate to undertake the task of an historian. After a year of cajoling, he agreed to write the article, provided Remington would help. Remington's letters to Wister at this time were full of trivial facts as well as philosophical observations about the cowboy. "Say Wister—go ahead please—make me an article on the evolution of the puncher—the passing as it were," Remington wrote in the fall of 1894. He even suggested, "Title 'The Mountain Cowboy—a New Type,'" and went on to describe equipment, its cost, and its uses. Later, the artist even sent lists of words to be included. Wister accepted the help graciously, but he did not work fast enough for Remington, who continually prodded the writer to complete his article. Finally, following two years of discussion, *Harper's Monthly* published the essay in its September 1895 issue, accompanied by five Remington illustrations.

"The Evolution of the Cow-Puncher" was faithful to Remington's letters, but with one exception—Wister equated the cowboy to the Saxon noblemen who came to this country from England. He stated: "No doubt Sir Launcelot bore himself with a grace and breeding of which our unpolished fellow of the cattle trail has only the latent possibility; but in personal daring and in skill as to the horse, the knight and the cowboy are nothing but the same Saxon of different environments." This line of thought was typical of the genteel spirit, and to say that Remington had a problem with it is an understatement. His illustration, *The Last Cavalier,* which attempted to describe Wister's concept, is one of the most overly romanticized, sentimental pictures Remington ever made. Two of the other four pictures were the painter's standard compositions: the charge in *A Sage Brush Pioneer,* and the last stand in *What an Unbranded Cow Has Cost.* Neither picture is particularly notable.

Later in the essay, Wister turned his attention more to fact with such insights as, "Let it be remembered that the Mexican was the original cowboy, and that the American improved on him. Those were the days in which he was long in advance of settlers, and when he literally fought his right of way." Here, Remington's information was being put to its best use. Wister went on to quote directly from the artist when describing the accessories used by the cowboy. Wister even concluded "Evolution" with Remington's original inspiration, "Except where [the cowboy] lingers in the mountains of New Mexico he has been dispersed.... Three things kept him away—the exhausting of the virgin pastures, the coming of the wire fence, and Mr. Armour of Chicago."

Here the thinking of Remington and Wister joins that of Turner and is reflected in one of Remington's greatest canvases, *The Fall of the Cowboy.* Inspired by a visit to a New Mexico ranch, Remington tells the whole story of the end of his West. The puncher, fatigued from a day's work on a damp winter day, is forced to dismount in order to open the gate in a barbed-wire fence, the symbol of the demise of the open range. The heads of the horses even bow to the moment. Integrity and action are absent. Nowhere in Remington's work did he capture the

Conjuring Back the Buffalo

1892. Oil on canvas, 35 x 20"
Private collection

Frederick Jackson Turner, the famed American historian, proclaimed the frontier dead in his thesis presented in 1893. Remington knew firsthand that the life of the plains was gone, especially for the Indian, as he so poignantly depicts here. There was no magic strong enough to bring back the slaughtered buffalo herds, which had provided food, clothing, and shelter to the Indians for generations.

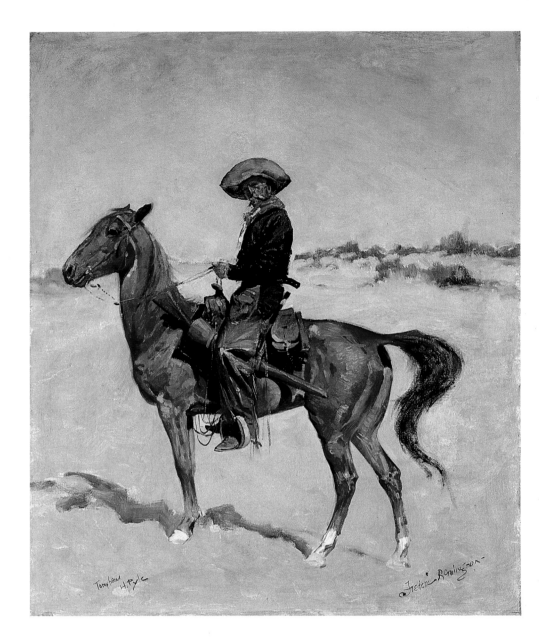

The Puncher

1895. Oil on canvas, 24 x 20⅛″
Courtesy Sid Richardson Collection
of Western Art,
Fort Worth, Texas

Howard Pyle was widely regarded as the greatest illustrator of the late nineteenth century, not only for his work, but also for his activities as a teacher. Remington shared this respect as is evidenced by The Puncher, *which he inscribed to Pyle when the two artists agreed to exchange works.*

The Fall of the Cowboy

1895. Oil on canvas, 25 x 35⅛″
Amon Carter Museum,
Fort Worth, Texas

Owen Wister, along with Remington and William Cody, are largely responsible for our concept of the American cowboy. During 1895 Remington urged Wister to write a history of the cowboy, since he had several paintings in mind that he wanted to use as illustrations. The open range was gone by then and with it had gone the glamorized nomadic life of the cowboy.

moment as sensitively as he had here. As is true of all great pictures, a universal chord had been struck. A comparison of this work to another by Remington of the same year will further prove the point: *The Puncher,* painted as an exchange gift for the great American illustrator Howard Pyle, can be seen as the antithesis of *The Fall of the Cowboy.* The puncher, head erect, looks directly at the viewer. All of the compositional lines are activated—the ever-alert range horse with his swishing tail, and the bright light. The image is that of a snapshot, capturing the cowboy in a wide-open space. These two works taken together practically parallel Turner's thesis that the closing of the frontier ended an era in American history. Remington was there; he witnessed and reported it. The passing left him a frustrated interpreter of the American West, and yet there was still a strong demand for his work, which by this time needed a new direction if the artist were to maintain his own enthusiasm.

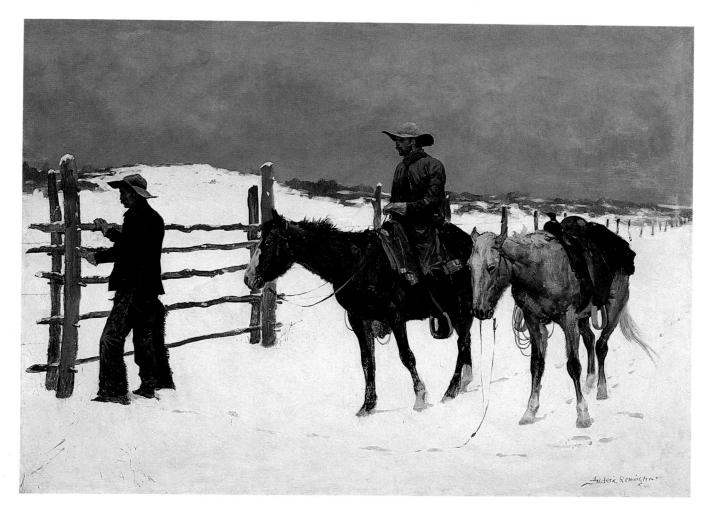

The Fall of the Cowboy

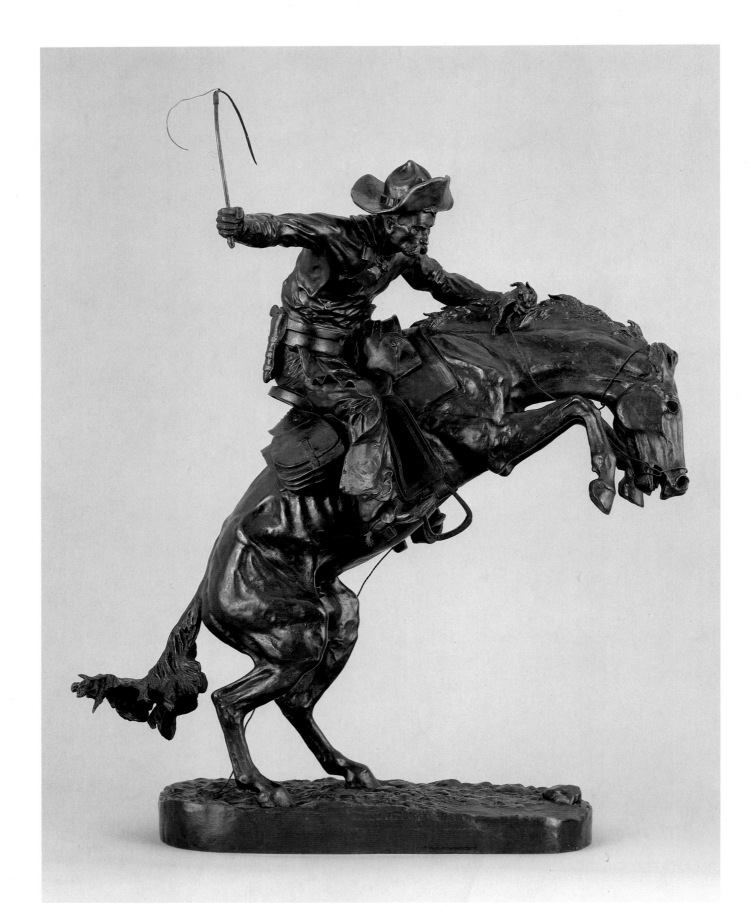

Bronco Buster

IV. Success and Dissatisfaction: 1895–1902

IT IS DIFFICULT FOR AN ARTIST to confront the conflict between popularity and financial success on the one hand and aesthetic quality and critical acceptance on the other. The story most often told throughout the past century is that of the struggling, bohemian artist who refuses to lower his artistic ideals even slightly when faced with the seduction of the commercial world. Remington's tale is different and certainly less romantic. It may even have been more difficult for him. Having gained financial stability through the commercial side of the creative process, how does one throw off the albatross of commerce and gain acceptance among the aesthetic power brokers? This question always disturbed Remington. When the tastes of society changed and Remington's popularity waned, he wanted more. He could not shift abruptly and start painting idealized mural subjects or popularized images of Breton peasants, subjects he did not comprehend. Meanwhile, it was impossible to foretell events that would affect the cavalry, the cowboy, and the Indian, *his* subjects, so just what could a man thirty-three years old and at the height of his career do?

Part of his frustration was relieved when on October 1, 1895, he copyrighted his first bronze, *Bronco Buster,* or as he spelled it, "*Broncho.*" He had no formal training in sculpture, having only drawn from antique casts at Yale. Among the painter's many friends was Augustus Saint-Gaudens, America's leading sculptor, but he did not encourage Remington to take up the medium. Lacking experience, Remington worked on *Bronco Buster* for months, beginning almost a full year prior to its copyright. Its design is said to have come from two individuals— his neighbor Augustus Thomas, a very active playwright, and Frederick Ruckstull, a conservative academic sculptor who was Thomas's lifelong friend.

Ruckstull had received a commission for a heroic bronze of Major General John P. Hartranft, which was to be installed on the grounds of the State Capitol in Harrisburg, Pennsylvania. The sculpture, ultimately cast in Paris, followed in the long tradition of equestrian statuary, showing the subject confidently astride his horse. The era was an active one for lifesize equestrian sculpture in America, with such statues of our heroes being installed here and abroad. Paul Bartlett's *Lafayette* was installed in Paris, as was Daniel Chester French's *Washington.* These two works followed the same formula as did Ruckstull's. As if to communicate the great importance and confidence of the sitter, the horse's weight is equally distributed throughout a frozen composition. Only with the completion of Saint-

Bronco Buster

1895. Bronze, Henry-Bonnard Foundry,
cast no. 6,
height 24⅜", base 20¼ x 7½"
Choate Rosemary Hall Foundation, Inc.,
Wallingford, Connecticut

Remington took up the art of sculpture through the encouragement of his playwright friend Augustus Thomas, and Thomas's friend, the sculptor Frederick Ruckstull. His first effort, Bronco Buster, *proved immensely popular, signaling the sculptor's ability to capture action as no other artist had. A cast was given to Theodore Roosevelt as a gift by his Rough Riders, helping to make this bronze an American icon.*

Gaudens's *General William Tecumseh Sherman* did any real motion appear in a heroic equestrian group; realized here through the accompanying striding angel, the general's cape blowing in the wind, and finally, by placing the horse's weight on its front leg.

Thomas had invited Ruckstull to complete the interim four-foot model for his project at the writer's house in New Rochelle, where he would have ample space and privacy in which to work. According to Thomas's autobiography, Remington came over every day after finishing his own studio work to observe the progress of the model. Thomas recalled: "It was interesting to hear the dispute of these two [horse] experts as Ruckstull's horse progressed in modelling, Remington always arguing for the wire-drawn Western specimen and Ruckstull standing for the more monumental, picturesque horse of the Eastern breeders."

According to Thomas, it was he himself who, during a studio visit with Remington, suggested that Remington make a sculpture. As Remington deftly shifted the position of a figure in his charcoal underdrawing for a painting, Thomas said, "You are not a draftsman; you are a sculptor. You saw all around that fellow, and could have put him anywhere you wanted him. They call that the sculptor's degree of vision." Shortly thereafter, according to Thomas, Ruckstull sent the painter some modeler's wax and the appropriate tools at Thomas's request.

Writing thirty years later, in 1925, Ruckstull recalled the events somewhat differently in an essay entitled, "Autobiographical Notice." He wrote, "During this time Frederic Remington, the painter, who lived close by, came over frequently to watch me at work. One day, he invited me over to his studio and, while I was there, asked: 'Ruck! Do you think I could model?' I replied: 'I don't *think* so, I *know* you can, and your first subject should be that drawing of The Bronco Buster.' " Ruckstull probably did not select the subject for Remington, as there was no specific preliminary drawing for *Bronco Buster*, although he had used the action many times in his drawings and paintings and owned numerous photographs of the subject as well.

No matter how the seed was planted, the obsessive artist was quickly into the "mud," as he called it, up to his elbows and liking it. He wrote a wonderful letter to Wister in which he mentions how bronze would be his "receipt" for fame. This letter bears reproducing in full as it expresses the painter's frustrations and unknowingly predicts the future. It was written in January 1895, when Remington wanted Wister to finish "The Evolution of the Cow-Puncher," and it is emblazoned with a skull and crossbones and no salutation.

Either leave the country—Manuscript or Die—I feel that I may—I have grip—and there is a riot in Brooklyn and I am tired out—and two servants are sick and the old lady has to work and is out of temper and I am going to Florida for a month the very minute I can get the Doc. to say I can—come—go 'long—alligators—tarpon.—I have got a receipt for being great—everyone might not be able to use this receipt but I can. D____ your 'glide along' songs—they die in the ear—your Virginian will be eaten up by time—all paper is pulp now. My oils will all get old wasting—that is, they will look like sale molasses in time—my water colors will fade—

but I am to endure in bronze—even rust does not touch.—I am modeling—I find I do well—I am doing a cowboy on a bucking bronco and I am going to rattle down through all the ages, unless some anarchist invades the old mansion and knocks it off the shelf. How does that strike your fancy Charles—I have simply been fooling my time away—I can't tell a red blanket from a grey overcoat for color but when you get right down to facts—and that's what you have got to sure establish when you monkey with the plastic clay, I am there—there in double leaded type—Well—come on, lets go to Florida—you don't have to think there. We will fish.

Yours Frederic R.

Included in the note are a sketch of the statue and a cartoon of the large painter and the slight writer fishing in Florida. Little did Remington know that nine months later "Evolution" would be published, setting the stage for the cowboy stereotype of future generations. Nor did he know his sculpture would become one of the best remembered in America. The painter also described his problems with color, a subject that he would shortly address head-on, as was his fashion.

The completed bronze was approximately twenty-four inches high and depicted a wildly lunging Texas bronco gallantly ridden by a cowboy. Nothing like it had ever been produced. The cowboy, quirt in hand, remains astride the bronco by clutching the rein and part of the horse's mane with his left hand, and by pressing his knees against the sides of the animal. The rider's left foot barely has contact with the stirrup, while his right foot is free. The artist's intention was to leave the fate of the rider in doubt; the strong determination of the ranch hand seems to give him the advantage, however.

Some critics hailed Remington's work as a success, while others disparaged his efforts to create an illustration in bronze. Since its unveiling, this sculpture has been such an icon of the American West that it is difficult to imagine its impact when first constructed, which itself had not been an easy process. Earlier bronzes rarely showed the horse in motion, much less in violent action. This required creative support techniques in the composition to disguise how the weight of the bronze was balanced. Such was the case in Randolph Rogers's *The Last Arrow*, which classically depicts two Indians defending themselves—one with his last arrow drawn back in his bow while his horse rears, the other reclining on the ground with his arm uplifted. It is this arm, which touches the belly of the horse, that balances the composition and distributes the weight of the bronze. Remington's inexperience actually was an asset because he built his horse just as he envisioned it, not how a foundryman would tell him to build it. This effort forced the craftsmen at the Henry-Bonnard Foundry, who sand-casted the bronze, to develop new engineering techniques, something that would be required of many of Remington's bronzes over the next fourteen years. Remington's putting into bronze his *Bronco Buster* fulfilled Julian Ralph's glamorizing statement about the artist's career for *Harper's* in July 1895. Ralph stated that vigorous men from around the world respected Remington's horses, equated his humor with that of Thackeray, and even used the Bible to serve as a metaphor for the artist's ap-

proach to his work. Ralph's puffery proved to be of some historical importance because it included a phrase that has been applied to Remington ever since. He wrote, "I hardly need to say that he loves the horse, but what not everyone knows is that he has said he would be proud to have carved on his tombstone the simple sentence, 'He knew the horse.' "

Many authors have described the circumstances surrounding the creation of Remington's first three-dimensional work of art, a story that has great appeal, as one can see from the above synopsis. Only Michael Shapiro, however, has been able to place succinctly Remington's sculptural work in the broader context of American and European sculpture. The opening lines of Shapiro's essay for the 1988 Remington exhibition catalogue hit hard at his importance as a sculptor and dispelled the promotional story that his sculpture "just happened." Shapiro wrote, "Remington's bronze sculptures fused complex sources, built upon the achievements of many of the most talented American and European sculptors of the time, and moved beyond the work of the artist's American contemporaries by realizing a *fin de siècle* vision of the American West so compelling that it enfolded suggestions of aspiration and struggle, victory and defeat within its forms . . . Like Augustus Saint-Gaudens, he experimented with unusual patinas and subtle surface textures, and like Paul Bartlett, an American sculptor in Paris, Remington adopted lost-wax casting as his preferred method of sculptural reproduction and became the finest practitioner of the method in America." Shapiro's discussion establishes that Remington quickly became aware of the leaders of the older generation, such as Saint-Gaudens and Daniel Chester French, as well as a younger Beaux-Arts-influenced group of Americans led by Paul Bartlett, Frederick Mac-Monnies, Gutzon Borglum, and Cyrus Dallin. Due to the training offered most sculptors in European academies, sculpture was classically inspired compositionally, and greatly idealized expressionistically—Rodin being the sole exception. Unlike his colleagues, Remington forced his commitment to truth into his sculptural work just as he had in his works on paper and canvas. As an illustrator, Remington created much of his work with an eye to how the engravers would cut their plates and ultimately print the image. Likewise, his interaction with the foundries during the coming years would demonstrate his consistent desire to understand processing. He was so fascinated with the process of bronze casting that he continually changed the detailing of the molds as new casts were made for sale. Most of his contemporaries simply created their model and then turned it over to the foundry for completion.

In summary, Remington's rough alliance to the European-schooled sculptors was similar to his rough fit with the painters of his time. A case can be made to include him stylistically with many of his contemporaries, yet his dedication to the truth and faithful attention to detail burden him with the term "illustrator" even in his three-dimensional work. Contemporary critics, collectors, and historians still downplay the very real impact he had on the art world during his career.

Bolstered by the success of *Bronco Buster* and by the great satisfaction he derived from the modeling process, Remington immediately undertook a second

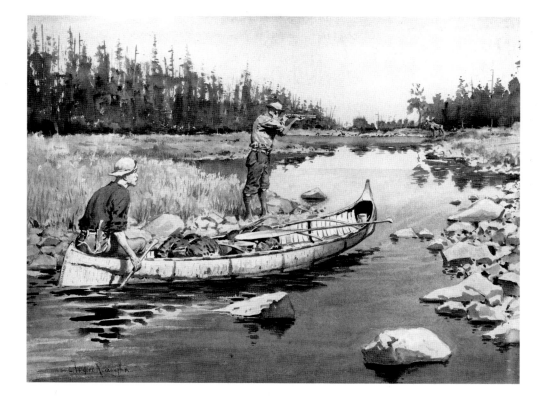

Unexpected Shot

c. 1896. Pen-and-ink wash on paper, 22¼ x 30"
Shelburne Museum, Vermont

*The process of reproduction in 1896
could not translate the subtleties of a great
wash drawing such as this one. The quiet
of the moment before the animal discovers
the hunter is masterfully represented by the
reflections on the water and the haze sur-
rounding the trees.*

bronze, *The Wounded Bunkie,* which he completed the following year. Just as *Bron-co Buster* had been drawn from the painter's inventory of subjects, so was his next project. The bronze depicts two troopers in flight, both on horseback. One, just shot, is reeling from the wound, while the other, alert to the enemy, steadies his comrade as they flee the scene. The action and detail of the moment of charge or retreat were ones Remington depicted often. The challenge of this group was again one of engineering. Of the horses' eight hooves, only one from each horse touches the ground so that, when seen from the side, as was intended, it is difficult to understand how the bronze stays erect while giving the effect of flight. The composition is flawed only by the overly pronounced buffalo skull on the base of the bronze; it was included for necessary visual balance but is in fact a somewhat trite piece of Western American symbolism. *The Wounded Bunkie* was a more sophisticated undertaking than *Bronco Buster* and, many say, aesthetically more successful. Certainly, it was more in keeping with the artist's major painting themes.

Remington's success as a sculptor occurred at a time when he was seeking an alternative to his illustration career. It did not, however, have any impact on what he thought of as his not totally successful two-dimensional work. Stylistically, it could not have alleviated his chief fears because, as he had pointed out in his letter to Wister, his real shortcoming was his use of color, which is absent in sculpture except for tonal patinas. Rather, in his major paintings he carries on his acquired style but takes on more historic subjects, such as *The Meir Expedition— Drawing of a Black Bean* and *Through the Smoke Sprang the Daring Young Soldier.* The

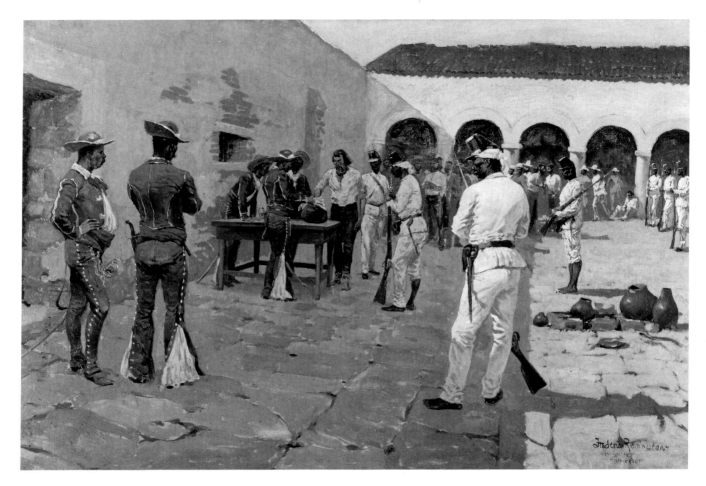

The Mier Expedition—Drawing of a Black Bean

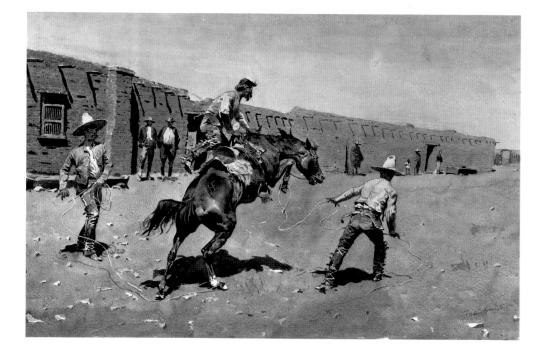

first subject recalled an event that took place in 1842 and was recounted in a *Harper's* article on the history of the Texas Rangers; and the second image involved a story told by the artist's friend, Carter Johnson, who participated in the bloody destruction of a northern Cheyenne tribe during the winter of 1879. Compositionally, both works maintain formats developed earlier: in the one case, drawing from the intense-light compositions similar to Vereshchagin, and in the other, a pyramidal last-stand approach, with the hero located at the apex of the composition. Stylistically, both works utilize a rhythmic alternation of dark and light needed for successful black-and-white reproduction.

Still dissatisfied with his stature as a painter, Remington continued his interest in writing and publishing during the last years of the decade and shortly thereafter. In 1897 Remington collaborated with R. H. Russell and Company to produce a folio-size book of his work, entitled simply *Drawings*. Sixty-two works were reproduced, many of which had illustrated earlier magazine articles. Even here the artist's excitement with his sculptures is shown by *The Wounded Bunkie* being used as the frontispiece. It set the pace for the book, which consisted, in great part, of cavalry subjects. This publishing venture did not meet with financial success, so Remington experimented next with a portfolio of eight color lithographs, *A Bunch of Buckskins*, published in 1901. The lithographs were photomechanical reproductions of pastels made in earlier years as well as more recent work. By reproducing the works in color, Remington and the publisher, again R. H. Russell, mistakenly thought they would be more popular. His publishing efforts finally met with success the following year with the publication of *Done in the Open*, a folio of black-and-white images reproducing over sixty works. This book, which went through five annual printings, owed part of its appeal to Owen Wister's introduction. It varied from his two prior statements in that it was

more hyperbolic in praising the artist, Wister having been given the liberty to pen poetic descriptions of many of the works, whose titles he even altered. This formula resulted in a true "art book" from the public's point of view.

While Remington conducted these publicity ventures, he continued his activities as a recorder and also turned to fictional interpretations of the American West. Two anthologies of his magazine reports, similar to *Pony Tracks*, were released, *Crooked Trails* in May 1898, and *Men with the Bark On* in 1900. Only the last was a financial success. More important, Remington ventured into fiction for a five-year period beginning in 1897. Taken together, his three books—*Sundown Leflare* (1897), *Way of the Indian* (1900, published 1905), and *John Ermine of the Yellowstone* (1902)—pose interesting questions, given the artist's dissatisfaction with his painting. All three deal with the interaction of races on the frontier, but from the Indian's point of view, a position he hardly ever took on canvas. *Sundown Leflare*, a series of five stories brought together in book form, documents the exploits of an Anglo-Indian, Leflare. The writer's intention was to balance the efforts of Wister, whose work he thought overly romanticized and not reflective of the truth about the West. Remington wrote his novel, *John Ermine of the Yellowstone*, in direct response to Wister, who released the instant best-seller *The Virginian* in May 1902. Wister's main character, a Virgininan who moved west, became the revered cowboy of twentieth-century film and fiction: a man of great integrity, hardworking, quiet except when provoked, and of course, the good guy who always won the heart of his girl. John Ermine, on the other hand, was intended by Remington to be a more realistic character. His book describes the life of an Anglo-Indian who, brought up by Indians, tries, with disastrous consequences, to live among the Anglos. Remington wrote the novel in the summer of 1902, making it available for sale in November. The book quickly went through two editions, netting the author $4000. But when it was adapted the following year as a Broadway play, it failed.

That Remington made even a minor literary mark is a tribute to his capacity as an artist. The five years he spent on his fictional work are roughly those he spent learning the new, complicated medium of sculpture. Meanwhile, he kept up a steady flow of illustrative work for several magazines in addition to *Harper's*. What did suffer during these years was his ability to travel as extensively in the West as he had earlier. But given the changes the West had undergone, it seems unlikely he would have ventured there anyway.

The significant artists who now worked in the West were a group of painters, trained in the art academies of Europe, who did not want to continue the tradition of painting Breton peasant scenes. Seeking new subjects, they gravitated to Taos, New Mexico, at the suggestion of Joseph Henry Sharp, who had been there on assignment for *Harper's* during the early 1880s. When he traveled to Paris for study, he stressed that the Pueblo tribes of the Southwest had the color, dignity, and exotic characteristics that the Breton peasants had originally offered so many painters in Europe. So, upon their return to America, Sharp's friends Bert Phillips and Ernest Blumenschein ventured west to look for subjects; their 1898 trip resulted in the formation of the Taos Society of Artists several years lat-

Through the Smoke Sprang the Daring Young Soldier

1897. Oil on canvas, 27⅛ x 40"
Amon Carter Museum,
Fort Worth, Texas

The artist's desire to experience a war had until this time not been realized. Rather, for material he had to rely on others' recollections of feats during the Indian Wars. Nine years prior to this painting, Carter Johnson had told Remington of his exploits among the Cheyenne in Montana. Remington related the story in his article "A Sergeant of the Orphan Troop," which included this painting, the artist's first to be reproduced in color.

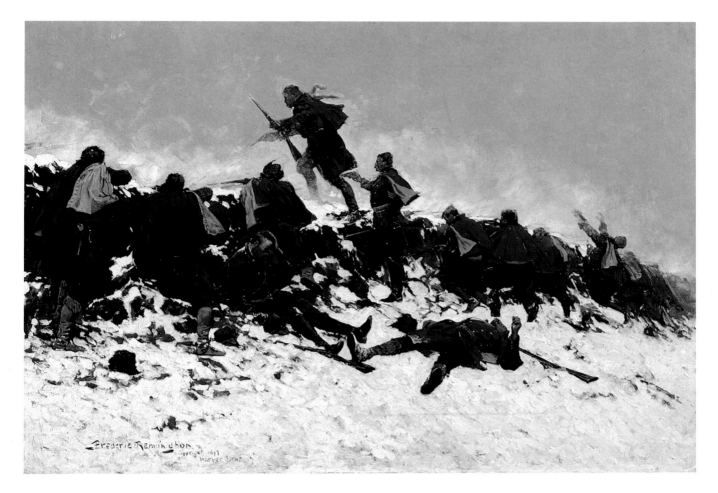

Through the Smoke Sprang the Daring Young Soldier

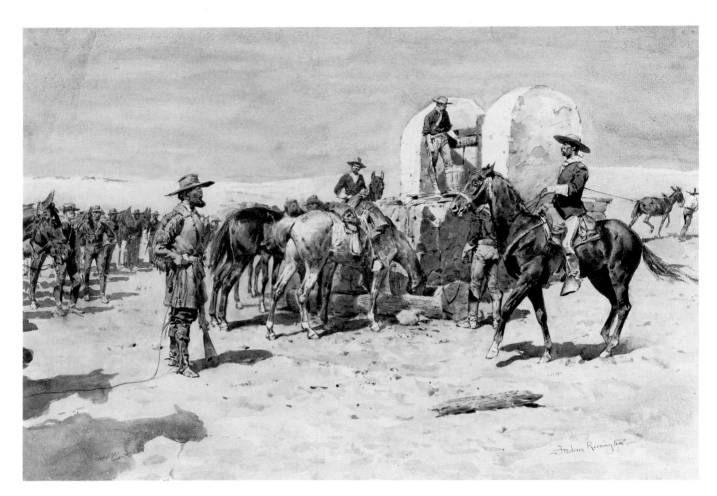

Well in the Desert

er. The open landscape, bright light, adobe pueblos, and colorfully clad Indians excited these painters who were discovering the West for the first time. That these characteristics provided little excitement for Remington goes without saying. On one of his infrequent trips west during these years, Remington went through New Mexico and met with Phillips, whose pictures he found uninspiring. The flame was not there, as he wrote his wife from Santa Fe on November 6, 1900: "I am either going to do Pueblos or not and I don't yet know. I think I won't. They don't appeal to me—too decorative—and too easily in reach of every tenderfoot. Shall never come West again—It is all brick buildings—derby hats and blue overalls—it spoils my early illusions—and they are my capital."

While Phillips and Blumenschein had been planning their wagon trip from Denver to Taos, Remington was realizing a dream he had always held dear—war. As the son of a "war hero," he wanted to experience the ultimate heroic activity. The Indian Wars were partly viewed as an activity to keep many of the Civil War troops in uniform and prepared in case a real war came along. The bombing of an American ship, *The Maine*, in the harbor at Havana quickly escalated the frictions between America and Spain into a declared war in April 1898. Remington accompanied his colleague, Zogbaum, to Florida early in April under contract to William Randolph Hearst's *New York Journal;* he was also still working for *Harper's.* Remington moved from Florida to Cuba with the invasion troops on June 22 and found the going rough. Sleeping outdoors, eating rations, and struggling as "one of the correspondents" was not the life Remington was used to at Endion and on his most recent travels. During the invasion, Remington became ill and was home shortly following the famed Battle of San Juan Hill, which catapulted its hero, Theodore Roosevelt, into the national spotlight as leader of the conquering Rough Riders. Remington's experience in Cuba was similar to that at Wounded Knee: at the height of the fighting he was absent, thus experiencing only the aftermath. Even being behind the lines proved too much for Remington: The gore of modern warfare spoiled his dreams of soldiering, leaving him extremely distressed.

The Cuban illustrations made by the artist were uninspiring attempts at using the formulas he had developed on the frontier. He attempted to depict soldier types and the general movements of the troops, but his lack of enthusiasm and isolation did not allow him the spirit to enliven his pen-and-ink drawings. It should be also be pointed out that he had always depended on his extraordinary ability in depicting horses to unify his compositions and aid his expression. Unfortunately, there were few horses in Cuba; it was an infantry war, not a cavalry conflict. Most successful were two large paintings he made upon his return, *The Scream of Shrapnel at San Juan Hill* and *The Charge of the Rough Riders at San Juan Hill.* The charge subject was a characteristic Remington effort, and this painting gained renown due to the promotion of Theodore Roosevelt and his Rough Riders during the Spanish-American War. Indeed, the painting was commissioned at the suggestion of Roosevelt. Its success, however, did not equal that of the event itself. Much has been made of the influence of photography on Remington's action pictures, especially Eadweard Muybridge's motion studies, and had

Well in the Desert

c. 1897. Gouache on paper, 26⅛ x 38⅛"
Stark Museum of Art, Orange, Texas

Remington's wanderings throughout the Southwest gave him ample opportunity to understand the value of water in that environment. This drawing, depicting the action around a well, is built up through the artist's characteristic use of pyramidal composition. It was included in his first portfolio book, simply titled Drawings.

*The Scream of Shrapnel at
San Juan Hill, Cuba*

1898. Oil on canvas, 35¼ x 60¾"
Yale University Art Gallery
New Haven, Connecticut.
Given by the artist, 1900

*The horror of modern war left the artist
quite disillusioned regarding the heroism
of its participants. He used the same tech-
nique in his paintings as he had in his In-
dian Wars pictures—that is, he did not
show the adversaries. Here, even the sol-
diers are unable to locate their opponents.
The action of this picture, compared to*
Charge of the Rough Riders, *is much
more fluid and harmonious.*

The Charge of the Rough Riders at San Juan Hill

1898. Oil on canvas, 35 x 60"
Courtesy Frederic Remington Art Museum,
Ogdensburg, New York

Remington's dream of experiencing war was realized when he was sent to Cuba to cover the action of the war with Spain in December 1898. Working for William Randolph Hearst's New York Journal, *Remington was to provide illustrations for articles by Richard Harding Davis. Following the war, Theodore Roosevelt asked Remington to create illustrations for his own article, "The Cavalry at Santiago." There has long been debate as to whether Roosevelt had really been on horseback during his famed charge.*

The Cow Puncher

he paid closer attention to the photographer's figure studies, the chaotic running motion of this painting would have been more successful. Most of the forward troopers look like ice skaters rather than charging soldiers.

The Cuban experience also posed a painterly problem for Remington. He was used to recording harsh Western light upon the open range or desert, but the denser foliage of the Caribbean island created color demands he had not faced except in smaller studies made during his summers in the north country. The light was more muted, and this effect was augmented by the haze of artillery fire. One need only compare *The Charge of the Rough Riders at San Juan Hill* to *A Dash for the Timber* or *Through the Smoke Sprang the Daring Young Soldier* to understand the deficiencies of the Cuban picture.

Remington's war experience had an even deeper impact on his work than one would expect. At the beginning of his assignment he thought he would be treated like "number one," a stature to which he was accustomed on the plains. But, in fact, when he requested such treatment he was ostracized by his colleagues as well as the troopers. Illness did not help his reaction to events, which he found to be inhuman and demoralizing. Upon his return to Endion, Remington slipped even further into despair. During the next few months, his weight ballooned to 295 pounds. His modeling activity was all that kept his spirits up.

Within the next year, Remington's painting would receive two more damaging blows. The prestige and power of *Harper's Weekly* had been gradually slipping as the political winds of the nation shifted, and in 1899 the economic erosion of the magazine forced its editors to release some of their highly paid writers and illustrators in favor of younger, less-experienced men. Remington's close fifteen-year association with the publication ended with little fanfare. He had always depended on *Harper's* for his living. Now, even though the illustrator label had stifled the artist's goals, he was concerned for his future. He was also making a final effort to gain full membership in the National Academy of Design by entering his large painting *Missing* in the spring 1899 exhibition. Again he was overlooked. This would be his last effort with the jury.

Not all was dark for Remington, however. Soon after his release by the Harper brothers, Robert Collier signed the forty-year-old painter to a contract to produce paintings for *Collier's: The National Weekly*. His new contract was an improvement on his arrangements with *Harper's* because it called for the artist to create paintings for reproduction, not simply as illustrations to accompany articles. The timing could not have been better. *Harper's* circulation was slipping, but *Collier's* rose from 88,000 to 178,000 during 1899, and by January 1901, circulation stood at a quarter of a million weekly copies.

Harold and Peggy Samuels wrote in their biography of Remington that "It was the Santiago experience that helped to mature him. Just as Roosevelt became a national politician because of the Santiago campaign, Remington developed as an easel painter by coming to terms with himself after Santiago. He had learned that he would never be a hero, the humility gave him insight, and three years of dedicated drills in applying color gave him the start toward mastery."

Remington had complained to Wister in his note about the success of *Bronco*

The Cow Puncher

1901. Oil on canvas, 28⅞ x 19″
Courtesy Sid Richardson Collection of
Western Art, Fort Worth, Texas

Although reproduced on the cover of Collier's *on September 14, 1901,* The Cow Puncher *was not intended as an illustration. As a new twist for the painter, Owen Wister was asked to write a verse about the picture, instead of the picture being intended as an illustration for a text.*

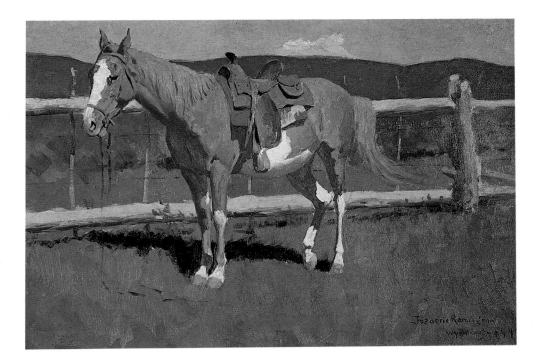

Horse Study, Wyoming

1899. Oil on board, 11¾ x 17½"
Courtesy Frederic Remington Art Museum,
Ogdensburg, New York

Many artist-illustrators of the time had to gain a better understanding of color because the new printing technology at the turn of the century allowed for prolific color reproduction. A lifelong student of the horse, Remington turned his attention to a subject with which he was comfortable in order to experiment with his own color approach.

The Intruders

1900. Oil on canvas, 27 x 47"
Gerald Peters Gallery, Santa Fe

Throughout his career, Remington often returned to the subject of the last stand to represent the strength of character found on the frontier. Invariably, the composition was based on a pyramid or, in this case, a triangular recession in space that builds to a point of action or confrontation.

Buster that "I have simply been fooling my time away—I can't tell a red blanket from a grey overcoat for color…" This comment, made in 1895, was neither the first nor the last expression regarding the need to master color. Almost one year later, Remington confided his shortcomings in even greater detail to Wister: "The *thing* to which I am going to devote two months is *color*…I have studied form so much that I never had a chance to '*let go*' and find if I can see with the *wide open eyes of a child* what I know has been pounded into me I *had* to know it—now I am going to see—I am sufficiently idyllic to have a *color sense;* and I am going to go loco for 2 months." Over four years later he was still haunted by color as can be seen in his letter to fellow illustrator and painter Howard Pyle: "Just back from a trip in Colorado and New Mexico. Trying to improve my color. Think I have made headway. Color is great—it isn't so great as drawing and neither are in it with imagination. Without that a fellow is out of luck." Even five years later, despite his success in this area, he complained to a young illustrator, Charles Chapman, that "for ten years I've been trying to get color in my things and I still don't get it. Why, why, why can't I get it. The only reason I can find is that I've worked too long in black and white. I know fine color when I see it but I just don't get it and it's maddening. I'm going to if I only live long enough."

It is clear that Remington did not view lightly his inadequacy at handling color. Following his Cuban experience, his rejection by the Academy, and the new contract to make paintings for *Collier's,* the time had arrived to do something about his artistic shortcomings. Remington was a dedicated student, having proved this in learning sculptural techniques and illustrational approaches. As in all areas of his education, the study of color came on his terms. His only preliminary color work would have come during his three months at the Art Students League in the spring of 1886. Evidence in his journals immediately following his

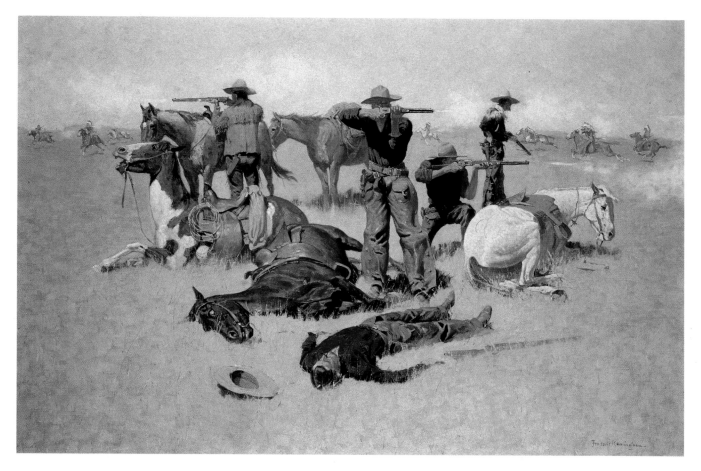

The Intruders

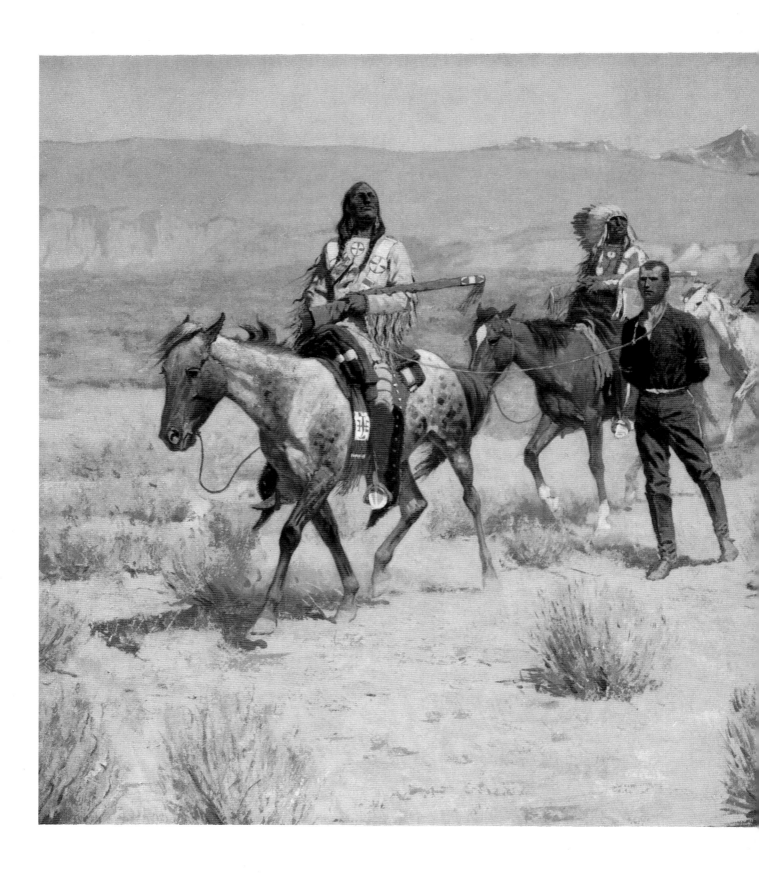

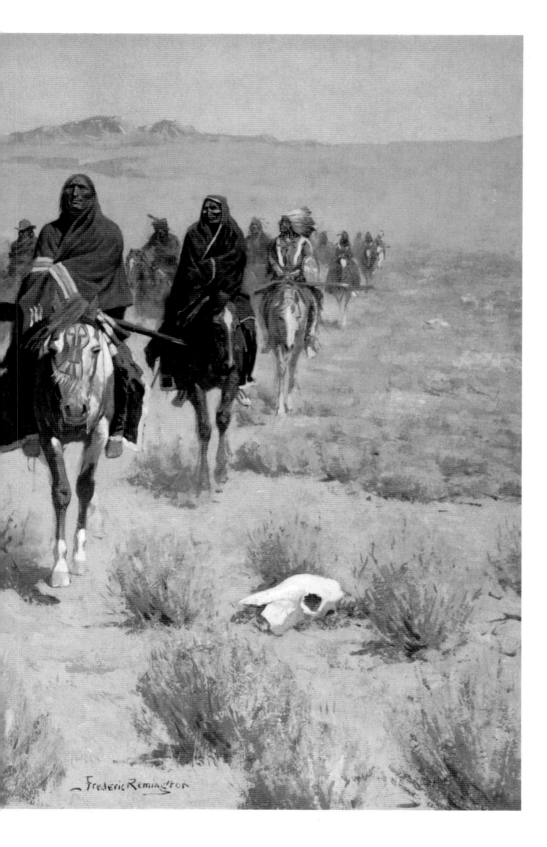

Missing

1899. Oil on canvas, 29½ x 50"
The Thomas Gilcrease Institute of American
History and Art, Tulsa, Oklahoma

*Following the Spanish-American War,
Remington returned to subjects he knew
intimately. Still wanting full membership
in the National Academy of Design, he en-
tered* Missing *in the 1899 exhibition but
was again denied. This was to be his final
membership effort.*

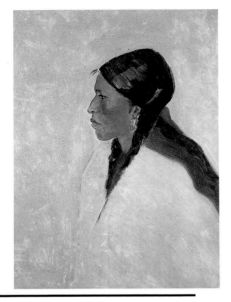

study there shows that he learned to recognize colors by description and to record them in notation form for later use in completed paintings.

Recent publications point to a rather interesting volume on color that Remington owned and heavily annotated. The book, *Watercolor Painting: Description of Materials with Directions for their Use in Elementary Practice,* written by H. W. Herrick in 1882, was in common use during the mid-1880s, and it has been assumed that Remington used it at the Art Students League. But the annotated aspects of the volume (David Karpelis Manuscript Library, Santa Barbara) lead to the discovery that the book represents a compilation of many sources used by Remington at about the turn of the century. Using Herrick's book on the descriptions and uses of color as an outline, the artist personally copied the interpretations of six other authors on color into the Herrick book or inserted carefully numbered pages into the text. Most of the notes are copies from George Field's *Chromatography, A Treatise on Colours and Pigments and of their Powers in Painting,* first published in 1835, and Daniel Parkhurst's *The Painter in Oil,* a text on the principles necessary to paint pictures in oil, published in 1898. Parkhurst's book shows that Remington's study of color could not have been at the Art Students League, which was twelve years prior to its publication. Two other volumes that Remington studied—*Watercolor Painting* (1898) by Grace Allen, and *Landscape Painting in Oil* (1893)—were also published several years after the artist's Art Students League experience. The other two sources consulted by Remington were Michel Eugène Chevreul's standard text, *The Principles of Harmony and Contrast of Colours* (1854), and *Amateur Art* (1884) by Henrietta Cosgrove. Once compiled, Remington's notes became his sourcebook when he wanted to select palette colors. Unfortunately, the annotations are all merely transcriptions, not statements by the painter of his own methods. There is also no way to match specific ideas to individual paintings. What is evident is that during these years Remington was finally able to dedicate himself to color study because of the freedom provided by his *Collier's* contract. When he exhibited at the Clausen Gallery in New York during December 1901, he felt that the exhibition was his first as a real painter, according to Harold and Peggy Samuels. It included twenty-five works in oils and pastels, not all of which were new works.

Remington's intense attention to color did not result in an immediate, radical shift in the appearance of his work. It was his method to digest material over a long period before making major changes. Subtle differences can be noted, especially in his pastels. In a simple, single figure such as the *Infantry Soldier* there is no area of the picture solely in one color. Rather, the artist builds the shadows on the pants legs by constructing a web of many colors to give the desired brown effect. And even the infantryman's blue shirt utilizes at least three different blues. In the watercolor of *A Packer,* made at about the same time, Remington employs the same process even though the medium is much more fluid. Maintaining detail in all the accessories, he plays them off the packer's beautifully modeled mount. Ten years earlier, Remington would have painted a brown horse with only highlights and a hint of cold shadow on the underside of the animal. Finally, in an exquisite oil, *The Parley (Questionable Companionship),* the lessons he learned are

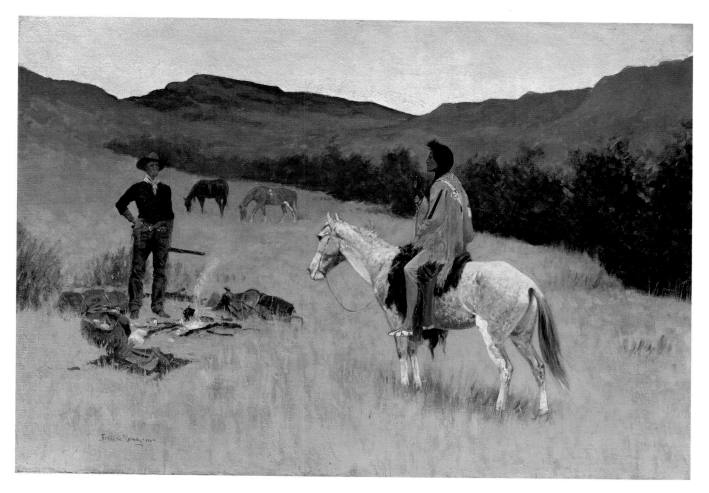

The Questionable Companionship (The Parley)

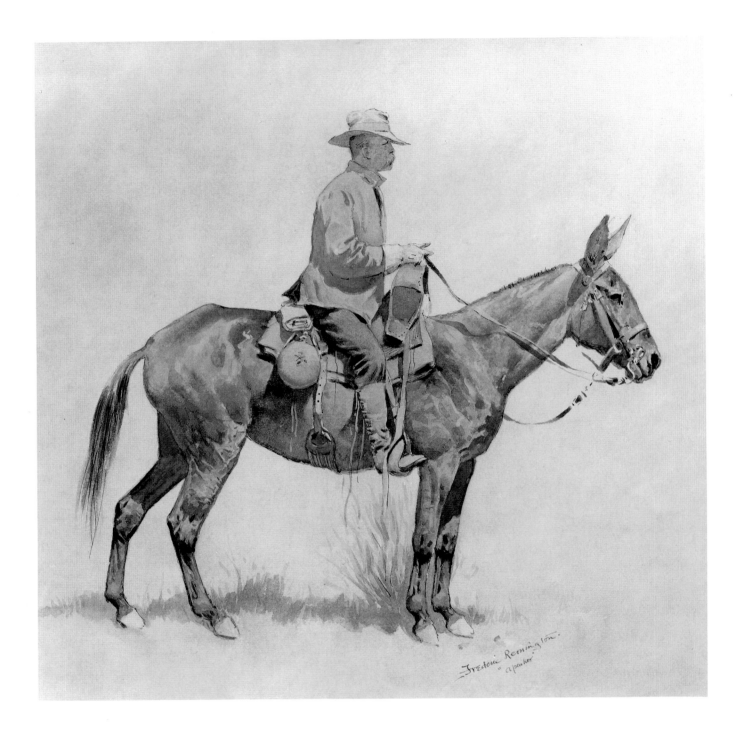

A Packer

c. 1901. Watercolor on paper, 16½ x 16½"
The Gerald Peters Gallery, Santa Fe

Remington most likely experimented with color in watercolor at the time he was producing his eight pastels for the portfolio A Bunch of Buckskins. *The approach of a profiled figure with no background is the same and lacks innovation. What is important is the modulation of color in the horse.*

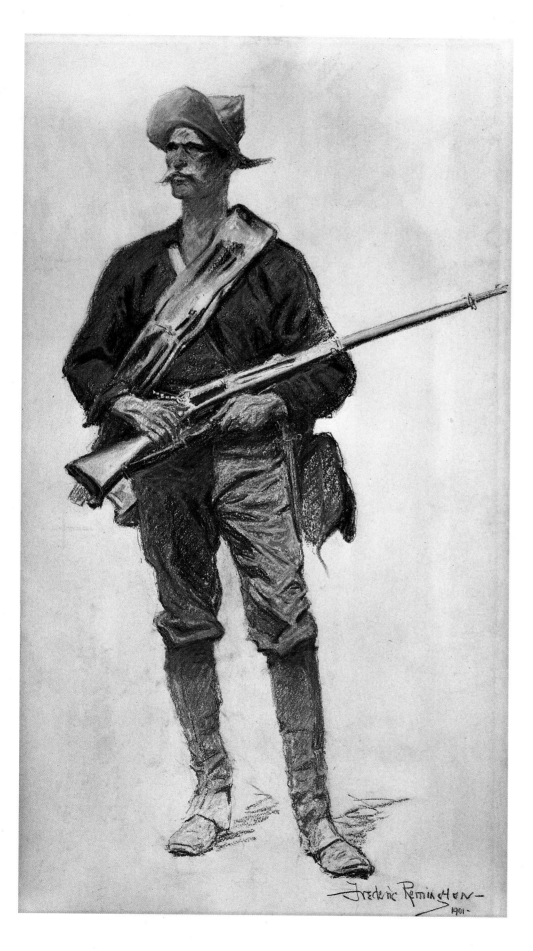

Infantry Soldier

1901. Pastel on paper, 29 x 15⅞"
Amon Carter Museum,
Fort Worth, Texas

*Experimenting with pastel at the turn of
the century was part of Remington's at-
tempt to better utilize color. The success of
this work led to its use on the cover of the
artist's 1902 book,* Done in the Open.

clear. The interrupted cavalryman is not merely drawn, he is painted with a buildup of color. The careful placement of green and red together on the rider's leggings demonstrates a method of intensifying each complementary color, and that, combined with the careful blending of paint and color shifts from greens in the foreground to purples in the middle ground and background, represents a new sensitivity to painterly qualities. His days of harshly applying jarring colors were past.

Reading about color theory and painting techniques encouraged Remington not only to experiment but also to look more carefully at other artists' works. Many painters his age were comfortably proficient in their mature style, offering much to the learning artist both through personal relationships and in exhibitions of their work. This activity would really create an impact several years later, but one exhibition Remington viewed during 1899 helped him push forward in his studies. The Union League Club hosted an exhibition of the California Tonalist painter Charles Rollo Peters, whose specialty was nocturnal subjects, something Remington had worked at throughout his own career. The Californian's ability to capture the silvery sheen of the moonlight reflecting from the adobe ranch buildings seduced the New Yorker. The muted tones of nocturnal pictures presented a narrower range of colors for a painter experimenting with color himself, as can be seen in both *Old Stage Coach of the Plains* and *A Reconnaissance*, which are tonally unified with deep night colors, in the first case, brownish green tones, and in the other, bluish hues.

Melissa Webster has properly pointed out in her work on the artist's nocturnal paintings that Remington was unable at this time to free himself from detail. The pictures, though pleasing, result in observations that would be impossible for the eye to make. Remington, too, realized this, and during the ensuing years

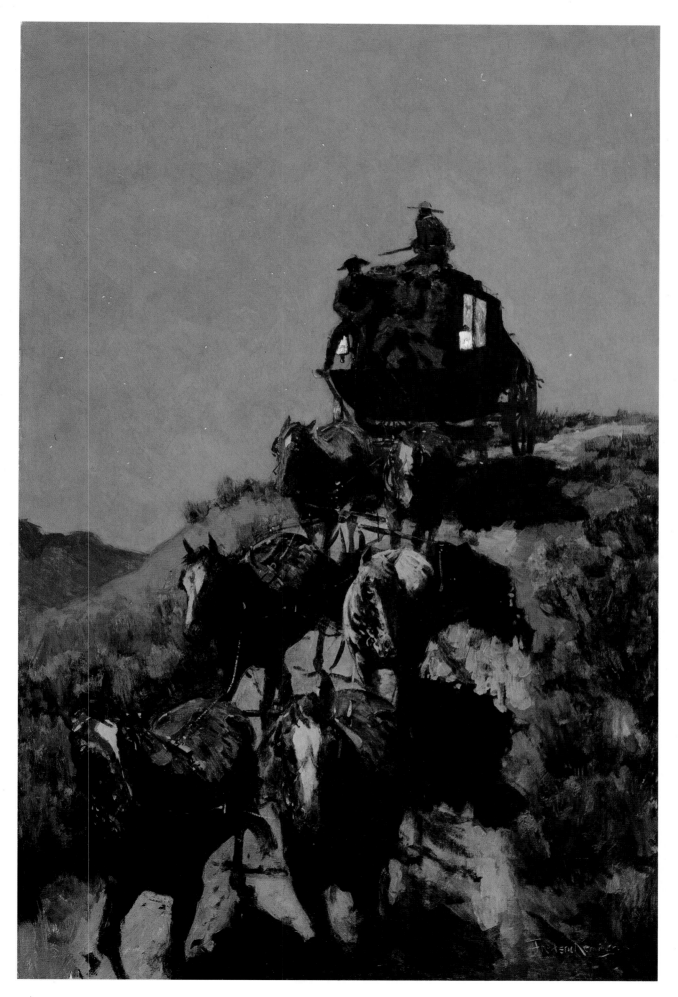

Old Stage Coach of the Plains

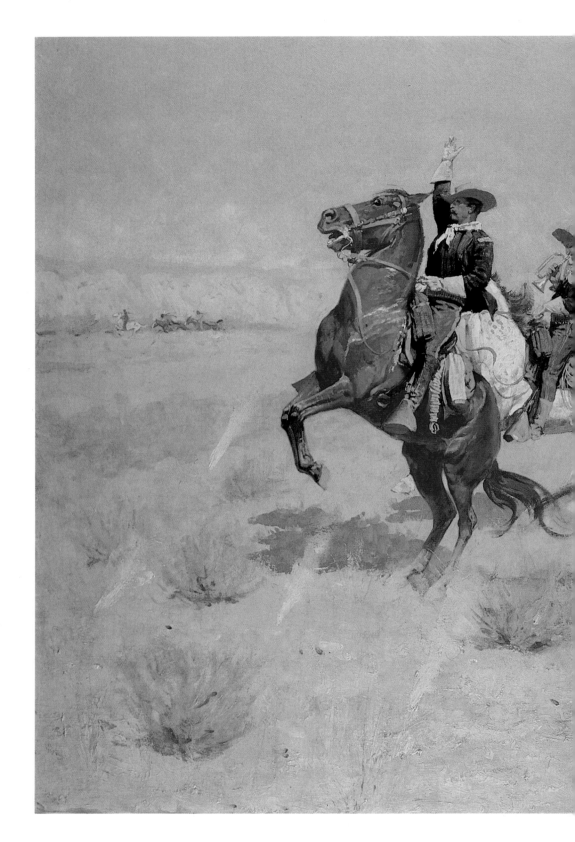

Halt—Dismount!

1901. Oil on canvas, 30¼ x 51¼"
Stark Museum of Art, Orange, Texas

Attacked on the open plains, a column of troops would use their horses as protection. The response to their leader's command provides the artist with a frozen moment in which to capture the varying attitudes of horses as they quickly stop.

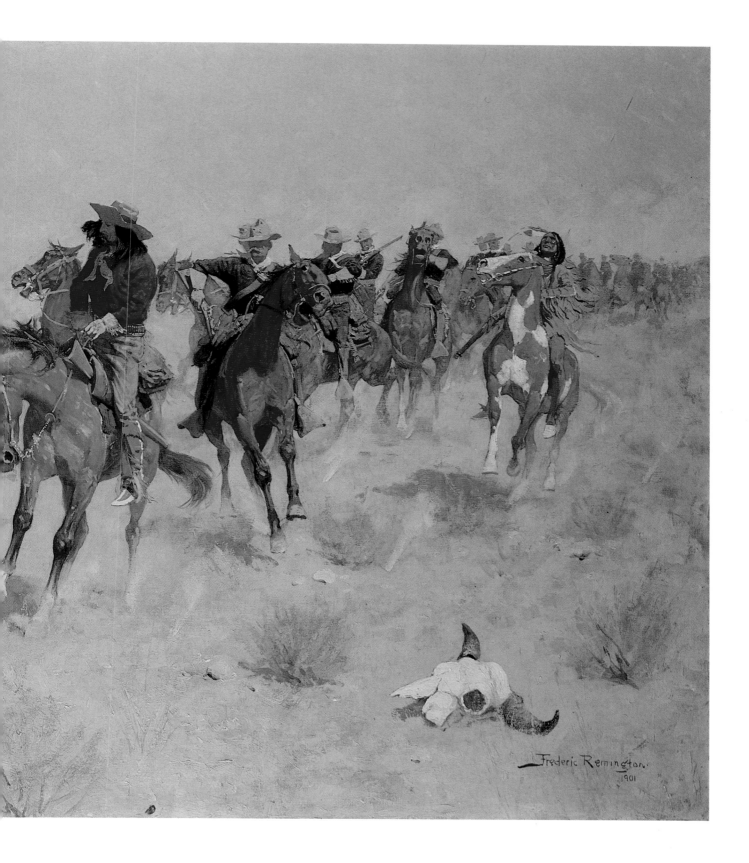

Frederic Remington
1901

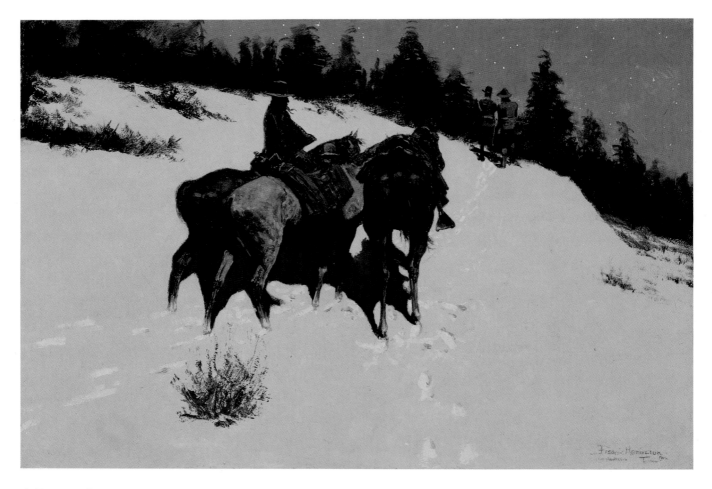

A Reconnaissance

he gradually minimized his emphasis on detail, thus enabling him to communicate mood and atmosphere—the goal of all tonal painters such as Peters. It took careful study to understand exactly how the flickering moonlight danced across the landscape.

The artist's concentration on color did not lead him away from sculpture during these years, although Remington was forced to change foundries from Henry-Bonnard, which had experienced a destructive fire, to the newly organized Roman Bronze Works. The change, made in 1900, allowed Remington to avail himself of the lost-wax casting process, then new to New York. Michael Shapiro has eloquently described the making of a sculpture in his Remington catalogue, so only a brief description will be offered here. Sand casting was done directly from the artist's plaster model by cutting it into pieces and pressing them into fine, wet sand to create the mold. The lost-wax method used the same model, but it was used to make a negative mold from which a thin wax casting was created that was then used to make the bronze edition. The wax, serving as a positive mold, easily accepted very fine detail work made with a brush or cutting tool. This allowed the artist such great flexibility that serious changes, such as arm positioning, could be altered from cast to cast.

Remington was thrilled, and his first effort, *The Norther*, representing a rider caught in a blizzard, was eminently successful. The detailing of the horse's hide would not have been possible with a sand-cast process, and being able to model the horse with detailed, directional strokes and to contrast them against the smoothness of the rider's outer garment, the sculptor could work almost like a painter.

Remington's paintings at this time were becoming much more sensitive, and he was able to convert this characteristic into bronze, combining careful patina work with the capabilities of lost-wax casting. During the next year, Remington challenged the new foundry to stretch its abilities just as he had the craftsmen at Henry-Bonnard. Luckily, Remington and Roman Bronze Works' owner, Riccardo Bertelli, had become fast friends, thus new methods of casting were easy to encourage. *The Cheyenne* utilized the same surface sophistication as *The Norther*, but in his desire to capture the attacking Indian at full speed on his pony, the artist discovered a way to build the sculpture with all of the horse's hooves off the ground.

The next bronze Remington created for public sale was his most ambitious to date, *Coming Through the Rye*, copyrighted late in 1902. It was an extremely ambitious four-rider composition, made possible structurally by lessons learned during the casting of *The Cheyenne*. This bronze joined *Bronco Buster* in becoming an icon of the American West. Whereas *Bronco Buster* represents the cowboy hard at work taming a bronco, *Coming Through the Rye* personifies the good-natured, wild spirit of the cowboy making fun. The subject for this work was drawn from earlier works, most closely his *Cowboys Coming to Town for Christmas*, a grisaille painting created for the 1889 Christmas issue of *Harper's Weekly*. Perhaps because of the work's $2000 price tag, the bronze was not an instant success, and only fifteen were cast under authorization. Never before had such action been

A Reconnaissance

1902. Oil on canvas, 27¼ x 40⅛"
Amon Carter Museum,
Fort Worth, Texas

A full moon and fresh snow provide a wonderful light source and mood. Sound created by these scouts would be muffled by the snow while they attempt to locate the Indians' campfire. The soft light reduces one's ability to see detail, thus emphasizing the picture's mood.

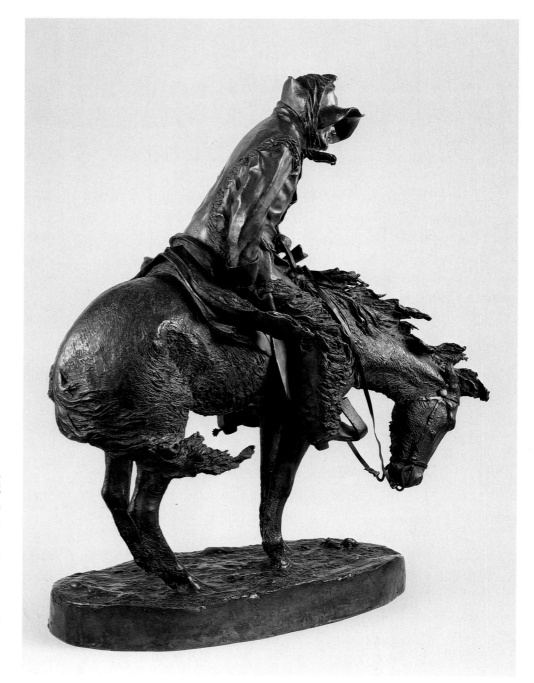

The Norther

1900. Bronze, Roman Bronze Works,
cast not numbered
height 22″, base 15¾ x 8″
Private collection

In Remington's earlier bronzes he had paid the same close attention to detail as he had in his paintings. At the same time when he was working on color in two-dimensional works, he turned his attention to texture and patina in the bronze The Norther. *Modeled during 1900, it was his first sculpture in the lost-wax process and his first with Roman Bronze Works.*

captured in a sculptural group, but scrutiny reveals less successful articulation of the reveling riders, and compositionally, the piece remained frontal. The lack of successful multiple viewpoints had long been a criticism of Remington's sculptures, and not attempting to solve this flaw in such a complex composition as *Coming Through the Rye* was a disappointment. Remington worked on the bronze for months, but beginning in April, his correspondence with Bertelli showed an anxiety about getting the models to the foundry. Remington's stated reason was that he wanted the sculpture finished before leaving the city for summer in the north country. The Remingtons had purchased a small island, Ingleneuk (today

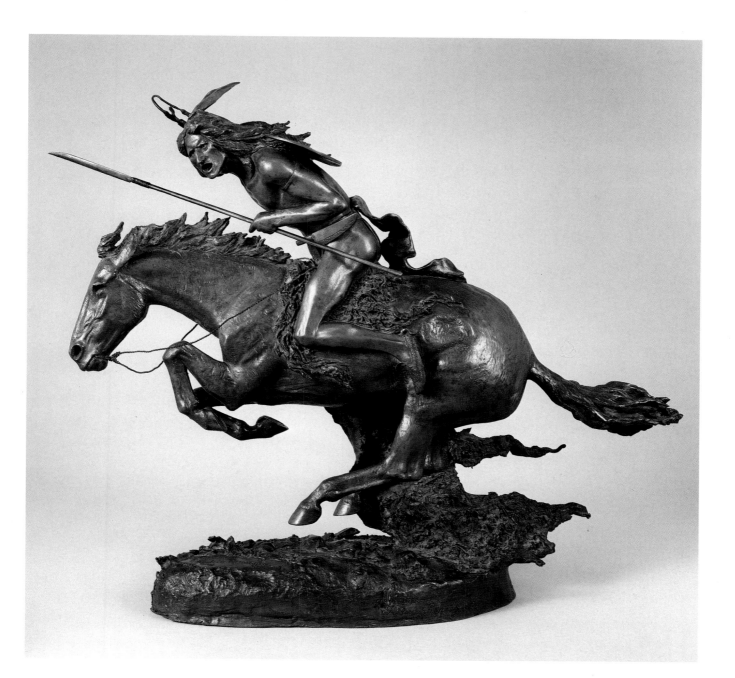

The Cheyenne

1901. Bronze, Roman Bronze Works, cast no. 3,
height 20½″
Denver Art Museum, purchased with gift from
the Mr. and Mrs. William D. Hewit Trust
(1981.14)

The Cheyenne's *horse is freed from the ground in rapid action by the robe being placed behind the center of the composition in order to maximize action.*

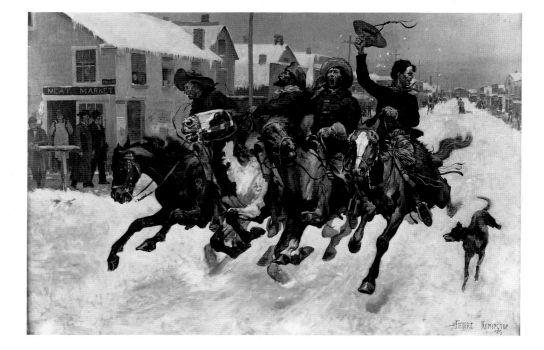

Cowboys Coming to Town for Christmas

1889. Oil on canvas, 26 x 40″
Private collection

The reputation of the cowboy underwent a change during the late 1880s from a frontier rogue to the hardworking, fun-loving denizen of the West. Remington's painting, reproduced in the 1889 Christmas issue of Harper's Weekly, *is closely related to a work by another* Harper's *artist, Rufus Zogbaum, reproduced in the same journal three years earlier.*

Coming Through the Rye

1902. Bronze, Roman Bronze Works, cast no. 2,
height 28⅛″, base 28⅜ x 19⅞″
The Art Museum, Princeton University,
Promised gift of Laurance S. Rockefeller

Cowboys shooting up the town in a fun-loving spirit has been synonymous with the West for the past century. Remington made a drawing and painting of the subject over ten years before he translated it into this bronze. When it was acquired by the Corcoran Gallery of Art in 1904, it was the artist's first work purchased by a museum.

called Temegami), in the Saint Lawrence River not far from Odgensburg, where Frederic could work leisurely and sketch out-of-doors, Eva could work in the garden, and they could spend time with old friends.

There may have been another reason for his anxiety, however. His friend Wister had been working for several months on combining seven of his short stories into a novel that Remington had promised to illustrate. When Wister delivered his manuscript for *The Virginian* to the publisher, he was told that his friend had reneged on his commitment, claiming he was too busy with the large bronze group. Remington was at the same time conceptualizing his own novel, *John Ermine of the Yellowstone,* which he intended to finish during his summer at Ingleneuk. He also wanted Wister to write an introduction and descriptive comments for his next folio, *Done in the Open,* which was in the final planning stages. It was this project that prompted the painter to ask Wister to New Rochelle on May 13. Wister agreed to meet Remington's publishing request when time was available; meanwhile, he waited to see the success of his own novel. *The Virginian* was almost impossible to keep on the bookstore shelves, and by June the book was clearly a best-seller. Remington's refusal was most likely due not to lack of time or to his writing a competing story. It was probably an overt signal that he was no longer an illustrator. He had come full circle in a relatively short time. Seven years earlier Remington had pleaded with Wister to finish his "Evolution" because he had great picture ideas for the saga. By 1902, he still had great picture ideas, but he wanted his canvases to stand alone. By the end of the year, he had written his last story, published his last art book, and made his last illustration. What the future held, Remington did not know. What he did know was that he would continue solely as a painter and a sculptor.

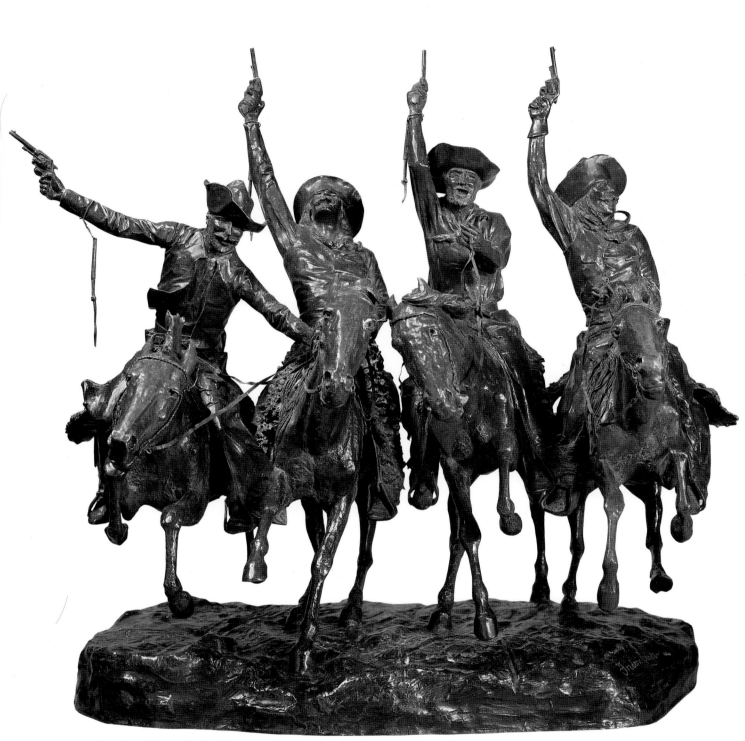

Coming Through the Rye

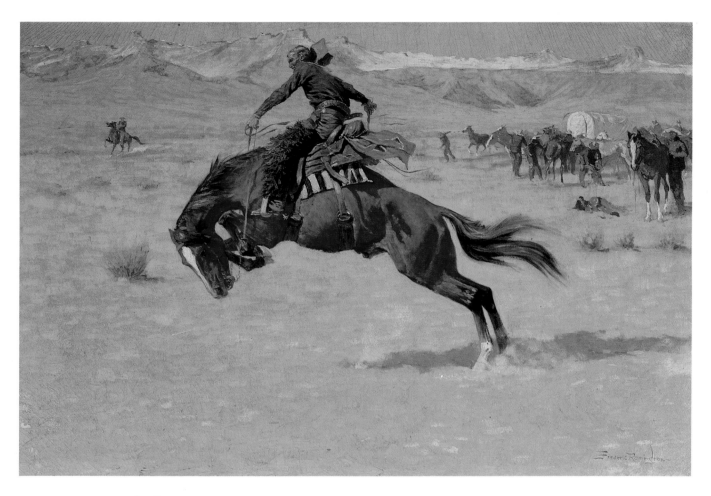

Cold Morning on the Range

V. Becoming a Painter: 1903–1909

REMINGTON'S DECISION TO END his reputation as an illustrator was not as simple as turning down one prestigious assignment. The Remingtons had grown accustomed to a comfortable life-style at Endion, and more recently at their summer retreat, Ingleneuk. Remuneration from *Harper's* and *Collier's* provided what could be viewed as a salary, since the scheduling of articles provided a regular income. Because Remington had never demonstrated a penchant for budgeting, the couple sensed they could be headed for rocky times while Frederic tried his hand as a painter. *Collier's* very much wanted Remington's name and work to keep up their circulation, so both parties began searching for a method to keep Remington's work before the public while not compromising his newly declared idealism. During April 1903 a solution was found and a four-year contractual arrangement began. The magazine's offer was not only lucrative—$1000 for the reproduction rights to each painting—but it also gave the artist total freedom to select his own subjects, a minimum of twelve per year. The pictures would be reproduced in full color and independent of any articles, thus removing the stigma of "illustration."

Ironically, the inaugural piece reproduced in the September 23, 1903 issue was *His First Lesson*. The selection, a conservative one, was Remington at his best—as an illustrator. Rather than allowing for a free interpretation of the subject, the painter virtually guides the viewer into the picture, beginning with the led horse seen in the stable doorway. The inclusion of the mounted rider between the emerging horse and the central figure of the hobbled pony suggests how the central characters arrived in the picture. Practically dead center in the composition is the first contact between rider and pony, represented by the outstretched touch of the cowboy. And, characteristic of Remington, the picture's expression is found in the horse, not the man, which leads us to question, whose first lesson is it? Though well painted, and certainly demonstrating the painter's heightened abilities not only in the application of paint but also in maintaining superb color harmonies, the overly simple work does not ask much of the viewer.

A fine selection by the editors was *Fight for the Waterhole*, their second, chosen as one of their "Christmas art features." Made two years earlier, this painting brought to the public Remington's adventurous West in full color. *Fight for the Waterhole* was a simplified version of his last-stand compositions, improved by his recently acquired understanding of color. No other situation better represented the courage of the cowboy or cavalryman on the frontier, thus stirring the emo-

Remington in New Rochelle Studio (front of fireplace)

1905 photograph
Courtesy Frederic Remington Art Museum,
Ogdensburg, New York

Remington's New Rochelle house and studio, Endion, was a symbol of the artist's great success. At age forty-four, he was at the peak of his career and confident of his future. By this time his excessive weight made it difficult for him to travel west comfortably.

Cold Morning on the Range

c. 1904. Oil on canvas, 27 x 40″
Photo courtesy Gerald Peters Gallery, Santa Fe

During the mid-1890s, a favorite subject of Remington's was the bucking horse. It was a test of man's strength, and a symbol of man's control of the frontier, something the artist mourned. Remington often returned to a subject as if to see how it succeeded in a new painting style. This painting is close in subject to Turn Him Loose Bill *(1892) and* Blandy *(1890s).*

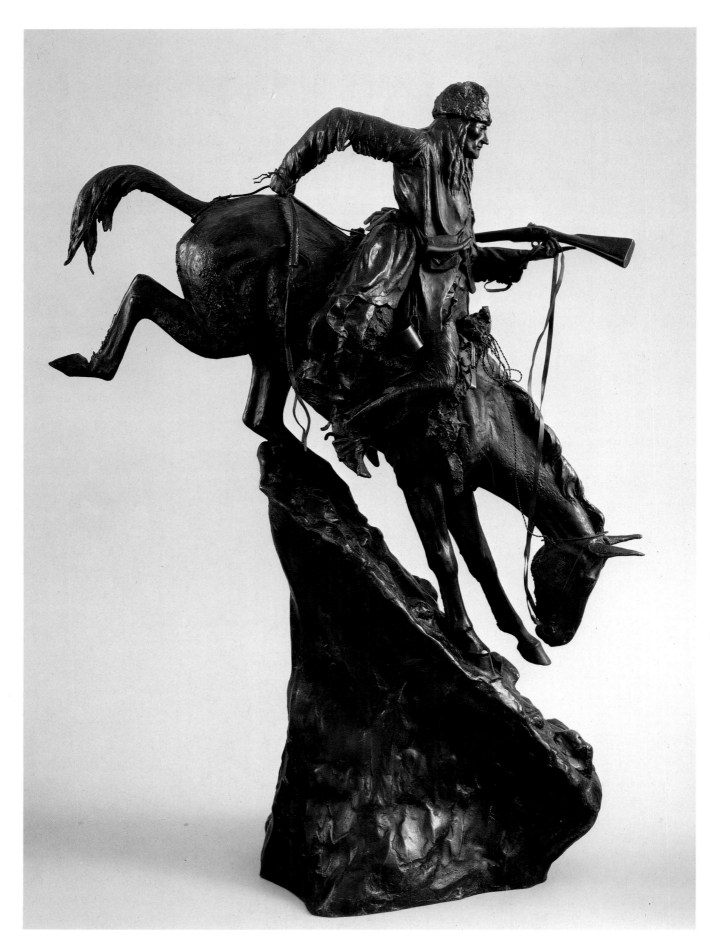

Mountain Man

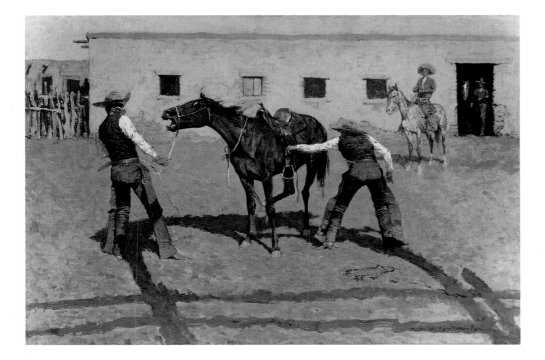

His First Lesson

1903. Oil on canvas, 27¼ x 40"
Amon Carter Museum,
Fort Worth, Texas

Saddling a horse for its first ride was an event demanding wariness on the part of the cowboy and some nervousness on the part of the horse. Remington employs his technique of implied motion by the position of the other horses, while leading the viewer's eye to focus on the central action. Harmony in the composition is achieved through the tonality of the paint; this picture was the first of Remington's to be reproduced in color by Collier's, *in 1903.*

tions of the viewer. Six cowboys are dispersed on the circumference of a water hole in order to protect it against attacking Indians. They are faced with death— on the one hand from their attackers, and on the other from dehydration. The two concentric circles provide a strong organizational shape to the composition, but rather than allowing those circles to dominate the picture, Remington masterfully crops part of the outer circle of the embankment at the left side of the canvas, taking with it one of the defenders. This approach encourages the interaction of the viewer, unlike *His First Lesson.*

Fight for the Waterhole exemplifies several of the qualities Remington had been striving for during the previous three years. Comparing it to another "last stand," *The Intruders,* painted in 1900, one finds the artist minimizing detail to strengthen the emotional impact of the picture. Greater attention is given the subtle color transitions of the scene as one's eye moves from the browns and grays around the small crater through the golden yellow of the arid plain to the soft blues of the distant mountain range. To avoid having only three horizontal bands of color, the artist interrupts them sharply with the reflection of the sky in the small pool that the cowboys are protecting.

Two elements prevent *Fight for the Waterhole* from being a masterpiece. One, most likely intentional, is the reflection of the distant mountain range and the horses' heads along the upper edge of the pool. In terms of color harmonies, the intense blue is necessary, but the reflected image would be physically impossible given the point of view provided by the painter. This is borne out when studying the small Kodak snapshot of a Sierra Bonitas watering hole taken by Remington in the Southwest years earlier, which served as the landscape study for this paint-

Mountain Man

1903. Bronze, Roman Bronze Works, cast no. 5,
height 28", base 11 x 10½"
North American Life and Casualty Company,
Minneapolis, Minnesota, 55403

Although completed in 1903, this sculpture was not cast until three years later. The base of the work is masterfully integrated as part of the overall subject to assist in creating the violent downward action of the animal and rider, a composition that may have been loosely based on Prussian cavalry photographs in the artist's own collection.

Fight for the Waterhole

1901. Oil on canvas, 27 x 40″
The Hogg Brothers Collection, Gift of Miss Ima
Hogg, The Museum of Fine Arts, Houston

The superior marksmanship of the infantryman or cowboy over the Indians gave the white intruders a great advantage in a fight, especially when they had protection such as this nearly dry waterhole. Because Remington's concerns were shifting to more painterly challenges, the event no longer dominates the scene. Rather, it occurs in a sensitively painted landscape built around the pool.

ing. Given their distance, the low mountains should not appear, especially since they are interrupted by the small ridge of the water hole.

The other inadequacy of this painting is one that often marred Remington's work. To express the real space of the West is no easy task, and to use successfully the vast plain as the picture stage is almost impossible. The spatial transition in *Fight for the Waterhole* from the sharply depicted foreground figure, to his comrade on the far side of the sink, and then to the circling antagonists simply does not work. The scale of the figures is wrong, a fault that results in an imbalance throughout the whole picture. This same flaw is apparent in *The Intruders, Aiding a Comrade, Cold Morning on the Range,* and others. *A Dash for the Timber,* painted twelve years earlier, is more resolved than later pictures because the action is confined to two groups who cut off the background, the fleeing cowboys and the attacking Indians. The most appropriately composed works are those such as *Missing* or *The Scout: Friends or Enemies,* which focus attention on a lone figure or a single group of figures. Once the action spreads out, Remington loses slightly his ability to keep figures in proper scale.

It should be pointed out that very few painters were ever successful in bringing the vast spaces of the West to a pleasing conclusion on canvas. Thomas Moran and Albert Bierstadt are two landscape painters who could, whereas many of their Hudson River School colleagues could not make the transition from the short vistas of the Adirondacks or the White Mountains to the vast spaces of the Rockies. The real space of *Fight for the Waterhole* could be up to one hundred miles of landscape. Throughout his career Remington solved this issue intuitively. Most Arizona subjects were inspired by the rugged canyons and mountains of

Waterhole, Sierra Bonitas

Before 1890. Photograph, 1¼ x 2¾"
Courtesy Frederic Remington Art Museum,
Ogdensburg, New York

*It is not known whether Remington actu-
ally took this snapshot in southeastern Ari-
zona; it ultimately served as a study for*
Fight for the Waterhole. *He did take nu-
merous photographs during his early
travels in Arizona, and he received others
from friends, some of which he pasted into
scrapbooke of operation and the subject
for several oil sketches and paintings.*

the eastern part of the state, allowing the slant of the landscape to provide a more immediate stagelike setting. Conversely, *The Cavalryman's Breakfast on the Plains* employs a string of horses to provide the parameter for the morning events. A fence naturally bounds the landscape in *The Fall of the Cowboy,* and the ranch buildings provide backdrop in such pictures as *His First Lesson.* Finally, the nocturnal subjects with which Remington was experimenting during these years were by their nature limited in space.

While Remington was negotiating the fine points of his *Collier's* contract, another new phase of his career was evolving. He was presenting his first one-man exhibition through a dealer in New York City. The gallery, Noé, located on Fifth Avenue, was new; it nevertheless provided the painter an opportunity for his work to be acquired and, equally important, reviewed. Remington made a tactical mistake in his spring 1903 and 1904 showings with Noé by including some older work. He presented an overview dating from the 1889 painting *The Last Lull in the Fight.* For a museum retrospective this would, of course, be appropriate, but for a man who had diligently studied to prove his talents as a painter, the shows prevented him from concisely delivering the message of his new approach. The resulting confusion was predictable. The concluding sentences of the *New York Times* review of the second exhibition read, "Here [in *The Last Lull in the Fight*] attention is so occupied by the tragedy that the hard color passes unnoticed. In the brushwork of some of these pictures, however, one notes a broader handling." The reviewer generally praised the Western subjects, but the tone changed when he spoke of "an unusual composition," *Back of Big Oak.* He described the painting as "smooth water with the broad, flat leaves of an aquatic lily and tall spears of water grass, a man in canoe paddling forward, trees on the bank to the right and a hard blue sky." The reviewer then became harshly critical, stating, "Here there is no story to carry the picture, and the harshness of coloring which is Mr. Remington's weakness makes its full impression." These comments, which followed an encouraging review of the 1903 exhibition by Royal Cortissoz,

are not what Remington had hoped for. But his selection of work invited the comparisons.

The "unusual composition" described by the *New York Times* critic signaled yet another shift in Remington's thinking. For the first time he seemed willing to allow a north country subject to stand alone. Since his earliest days, Remington had sketched the Canton-Ogdensburg region, but he had never worked any of these ideas up to exhibition paintings. His small 1903 oil, *Boat House at Ingleneuk*, reverberated with his newly gained talents as a plein air painter. Not intended for public exhibition, it shows what technical strides had been made, for instance, from the 1887 work *Small Oaks*, which relied on detail to report the experience of his summer camp. He now realized the subject of a painting could be light and its effects, not how the boathouse was built or what was inside. Rarely had Remington demonstrated the confidence to paint water, but his striving for recognition as a painter necessitated his digesting the current styles. The reflective quality of water was a major theme of the leading Impressionist and Tonalist painters, thus Remington knew he had to learn how to handle it in his own paintings if he were to be accepted critically. Beginning in 1902 and 1903 his sketches succeed, and the shortcomings found in larger works such as *Back of Big Oak* were quickly eradicated, allowing Remington to create during the next year two of his greatest paintings.

The third Noé exhibition, held in March 1905, included only recent work. Consisting predominantly of the Western settlement series published by *Collier's* during the previous year, the collection allowed the viewer to comprehend Remington's current efforts. Among the finest pictures were *Pony Tracks in the Buffalo Trails*, a characteristic Remington cavalry subject, and *End of the Day*, a moody,

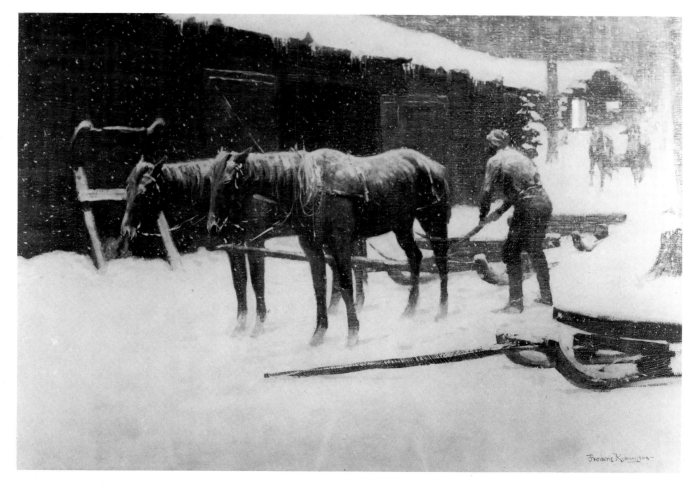

End of the Day

Pony Tracks in the Buffalo Trails

1904. Oil on canvas, 30¼ x 51¼"
Amon Carter Museum,
Fort Worth, Texas

The eighth picture in the cycle of the Louisiana Purchase depicted a column of troops led by scouts examining the trail for the recent tracks of Indian ponies.

The Outlaw (Christmas card
to R. Bertelli)

1905. Pen and ink on paper, 8 x 6"
Courtesy The R. W. Norton Art Gallery,
Shreveport, Louisiana

*Remington often included line drawings
in his letters to friends. Bertelli, owner of
the Roman Bronze Works, was close to the
artist, and his willingness to allow Rem-
ington's experimentation was rare for a
foundry owner.* The Outlaw, *shown in
this drawing, was intended to be support-
ed by one foot and would be a casting
problem. Thus, Remington's caption,
which reads, "R[emington]: 'Can you cast
him' B[ertelli]: 'Do you think I am one of
the Wright brothers'?"*

Attack on the Supply Wagons

c. 1905. Oil on canvas, 30 x 45½"
Dallas Museum of Art, anonymous loan

*The supply wagons for a column of sol-
diers always followed the brigade. If at-
tacked, their choice was to circle and fight,
or to flee and try to catch up to the troops.
Remington's choice of subject was natu-
rally the one providing the most action.*

nocturnal subject intended to conclude the series by representing a fully civilized frontier genre scene. Cortissoz, a Remington admirer, wrote to the artist regarding the exhibition, "so full of life they are, and oh! so rippingly painted!" and continued by asking, "if it isn't great sport to be alive and doing work like that, making something beautiful that no one else could make." Remington was very appreciative of the critic's acceptance because not all of Cortissoz's colleagues agreed. In a return note Remington said, "This painting game is a d___ long up-hill pull and at times we are inclined to set back in the breeching if someone don't say something nice. A good word at times is a lot of comfort." Remington emerged from this exhibition on a new plateau critically, but much of his best painting still lay ahead.

The Noé exhibition was not the only spotlight on Remington during 1905. A second, stronger light was cast on the artist by *Collier's* "Remington Number" published on March 18. The dedication of a national weekly to the career of an artist was a rare, if not unique, experience. The editors' plan was to capitalize on Remington's reputation, so for several weeks prior to its release the magazine published advertisements touting a retrospective look at the famous artist, his paintings, and his bronzes. The five major reproductions were available for purchase from the magazine, while the originals, including the masterful *Evening on a Canadian Lake*, were for sale at Noé. *Evening on a Canadian Lake* was similar in subject to *Back of Big Oak*, but it avoided the harsh coloring and lack of story. Created in the tradition of such great American genre painters as William Sidney Mount and George Caleb Bingham, this sensitively orchestrated canvas exemplifies Remington's compositional and tonal talents at their peak. The two hunters, accompanied by their dog, slowly make their way home at dusk and serve to represent the generations of hunters and trappers that helped to settle America's wilderness. Proud and confident, they guide their canoe along the reflected tree line, their heads turned toward the setting sun in order to give their faces full expression while silhouetted against the shadowed black shoreline. *Evening on a Canadian Lake* indeed strikes a universal chord.

As if Remington's ego needed another boost, he received a letter written two days before the publication of the special issue, formally requesting him to create a monumental bronze of a cowboy on horseback to be installed in Philadelphia's Fairmont Park. The Fairmont Park Art Association had a long and impressive record of commissioning significant works for its collection, thus Remington's success as a sculptor began to equal his renown as a painter. His desire was to produce a mounted cowboy accompanied by his pack horse, a project too rich for the Philadelphians' bankbook. Following a visit to the park, and the selection of a specific site, it was decided that he should create a cowboy reining his horse to an abrupt halt on a small bluff. The artist's enthusiasm, sustained by his own financial stability, allowed the Association to take advantage of him. The fee was a whopping $20,000, but all of it was ultimately spent on necessary studio improvements and Bertelli's foundry costs. Remington sensed this was an opportunity to guarantee his reputation, so for the next three years he was willing to invest a great part of his time and energy in this project.

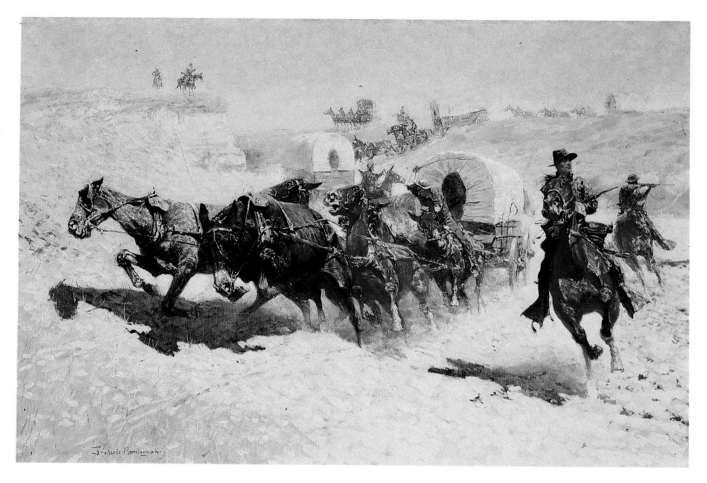

Attack on the Supply Wagons

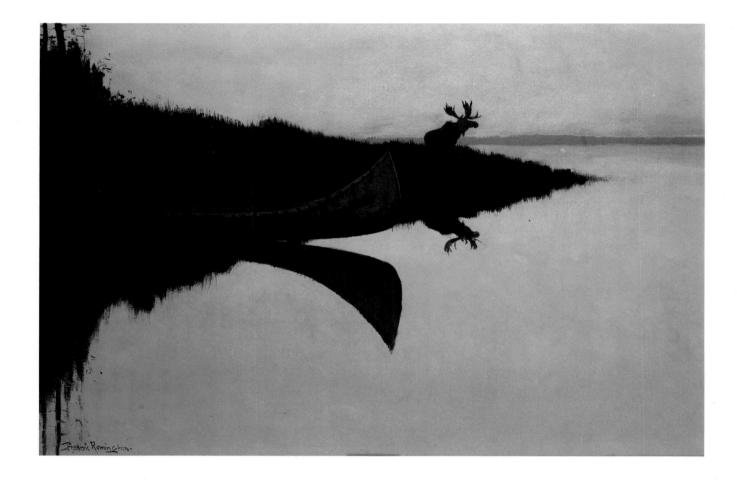

Coming to the Call

1905. Oil on canvas, 27 x 40"
Private collection

*During the second year of the Collier's
contract, the artist broke from his narra-
tive cycle approach and began to create in-
dividual paintings. This was the freedom
for which he had been struggling. The
success of the paintings executed in 1905
was applauded by Royal Cortissoz, one of
America's most important critics.*

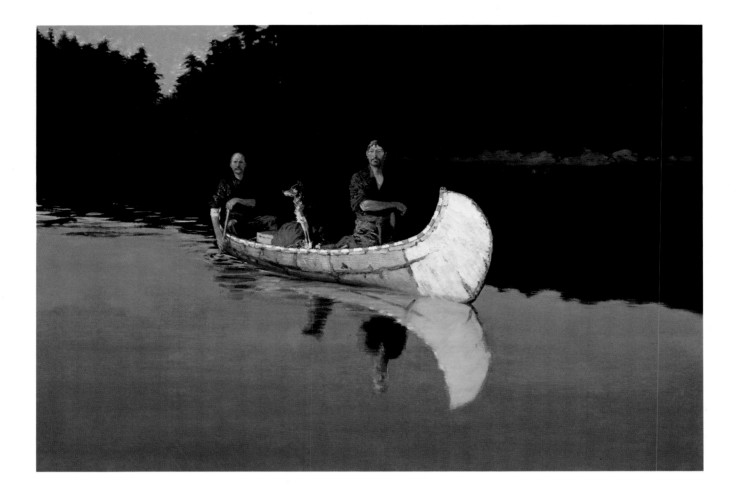

Evening on a Canadian Lake

1905. Oil on canvas, 27½ x 40″
Private collection

Evenings spent exploring around Inglen-euk in his own canoe provided Remington the opportunity for the study of nature, light, and color. A result was one of his greatest works—one that placed two men in harmony with nature—and among America's finest genre paintings.

The Cowboy

River Drivers in the Spring Break-Up (Breaking up the Ice in Spring)

1906. Oil on canvas, 27 x 40″
Courtesy Frederic Remington Art Museum,
Ogdensburg, New York

During the last years of Remington's life, the study of nature and its atmospheric qualities became his special interest. Close study and a continued interest in photography brought him an appreciation of the abstract qualities of a scene, as is evidenced here in the breaking ice.

Voluminous correspondence regarding *The Cowboy* exists between Remington and the Association's secretary, Leslie W. Miller, as well as between Remington and Bertelli. The letters allow for a detailed understanding of how work on the monumental sculpture progressed, while at the same time recording how well founded were the frugal reputations of "Philadelphia lawyers."

The monument was unveiled with tremendous fanfare on June 20, 1908, while Remington sketched and played with his dog, Sandy, at Ingleneuk. He had not lost enthusiasm for the project, but he felt the sculptor would only be lost in the event, and it was difficult to travel from Ingleneuk to Philadelphia. Even with all the hard work, *The Cowboy* did not achieve the greatness Remington desired. The Association had been concerned about the stiff-legged pose of the pony, which Remington knew was in fact the way a horse would stop. The pose was a distinguishing characteristic of the work, creating an advanced composition for an equestrian statue. Its shortcoming, really, was that the subject was simply not appropriate for Philadelphia, and the action depicted was not as stirring as the artist's best efforts.

The time taken to complete *The Cowboy* may, in part, be the explanation for the small contribution Remington made to *Collier's* during 1906 and 1907. With his series exploring the history of the Louisiana Purchase, Remington had attempted to fulfill his contractual requirements through a serial approach. Premiering in October 1905, the "Great Explorers" series appeared in *Collier's* through the following summer. The subjects ranged historically from Cabeza de Vaca through Zebulon Pike and Jedediah Smith. Only the fourth picture in the series, *Radisson and Groseilliers*, exists today, as the artist, dissatisfied with his ef-

The Cowboy

1908. Bronze, Roman Bronze Works,
unique cast, life-size
Fairmont Park Art Association, Philadelphia

Remington's only monumental bronze was commissioned by the Fairmont Park Art Association of Philadelphia. The sculpture still stands in the park. Special attention was paid to selecting the stone base, just as the artist's other sculptures utilized the detail or shape of the base as an integral part of the piece's overall statement.

Radisson and Groseilliers

forts, destroyed the other canvases following their publication. The same fate
awaited Remington's next series for *Collier's,* "Tragedy of the Trees." The prob-
lem was that he knew little about these subjects, thus his images were reversions
to illustration in an attempt to tell a specific story rather than to capture the emo-
tion. The *Radisson* picture was a success because the primary subject was the visu-
al delight of the calm, lily-covered water of the bay around Ingleneuk. The
explorers, transported by Indians in their canoe, are generalized and play only a
secondary role in the composition. Radisson and Groseilliers were the only ex-
plorers represented in the series who were relevant to the north country history,
which Remington certainly would have known, and this allowed him to place
them in the proper context. Also, Remington wanted to get these pictures behind
him, so that he could push on with his easel work. By late 1907, his matter-of-fact
philosophy was apparent to the editors, and especially to the new art editor, Will
Bradley, who was transforming the layout to conform to his preferred style—an
Art Nouveau approach which really did not allow for Remington's nineteenth-
century subjects. *Collier's* management chose not to renew Remington's contract
in 1908.

During his *Collier's* years the painter continued his out-of-doors studies as he
had since the summer of 1903, using all sorts of techniques, including photo-
graphs, color studies, sketches, and smaller finished works in order to master col-
or. While he was creating some mediocre works for publication, he was also
exhibiting paintings, especially nocturnes, which were the finest of his career.

Chippewa Bay

c. 1908. Oil on board, 12 x 18″
Courtesy Buffalo Bill Historical Center,
Cody, Wyoming

Feeling confident enough in his plein-air studies to sign them, Remington exhibited six in his one-man exhibition at Knoedler during December 1908. In addition to his Tonalist color approach, Remington successfully utilized a textured brushwork inspired by his Impressionist painter friends.

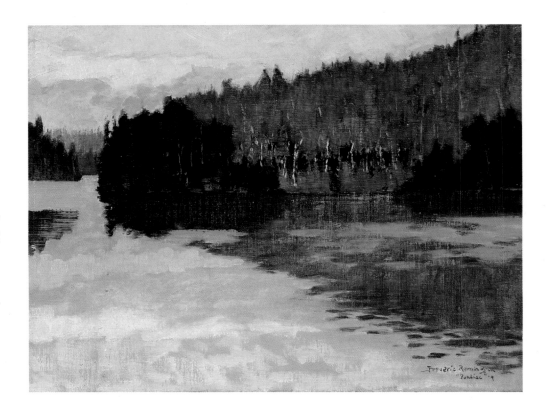

Pontiac Club, Canada

1909. Oil on canvas, 12 x 16″
Courtesy Frederic Remington Art Museum,
Ogdensburg, New York

John Howard, a lifelong friend, held a membership in a private hunting club in Pontiac, Canada. He lent the Remingtons his membership during the summer of 1909 and Frederic took the opportunity to paint outdoors. The fruits of his friendships with Childe Hassam, Willard Metcalf, and Robert Reid are all brought to bear in these marvelous oil studies.

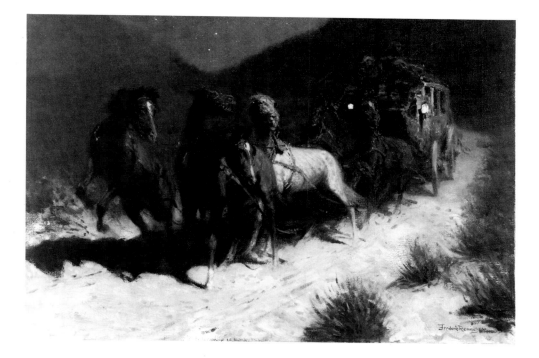

A Taint in the Wind

1906. Oil on canvas, 27⅛ x 40"
Courtesy Sid Richardson Collection
of Western Art,
Fort Worth, Texas

*Nocturnal pictures require reflective sur-
faces and special light sources in order
to be successful. Moonlight is the basic
source, but it can be augmented by light
sand, white horses, white hats, and in this
case, lanterns, which most likely would not
have been lighted under these circum-
stances. Remington's friend the Impres-
sionist painter Childe Hassam said in a
letter that this was the artist's finest work to
date.*

The attention given Remington during 1905 resulted in a contract offer from M.
Knoedler & Co., one of New York's most prestigious galleries. Beginning in
1906, he had an annual exhibition there each December, one to which the critics
had to respond because of Knoedler's importance. His first exhibit at Knoedler
included eleven pictures, two of which, *A Taint in the Wind* and *Against the Sunset*,
serve to show the painter's progress. The poetic *Taint in the Wind*, when com-
pared to the 1901 *Old Stage Coach of the Plains*, demonstrates his success with night
subjects. The soft light of the moon is properly captured in the new picture, cre-
ating an uneven sheen in the white sand of the roadway, echoed by the quickly
reduced vision toward the stagecoach. By moving the light source behind the
viewer, details are evident in a scene that is emotionally pitched to the instant
when the quiet ride is abruptly disturbed by something that alarms the team. The
moment provides Remington the opportunity to depict the horses in various
states of excitement, his forte. The choice of white sand and a white horse is a les-
son learned years earlier from Charles Rollo Peters, a master at providing reflec-
tive light sources in his nocturnal scenes. When it was created, *Old Stage Coach of
the Plains* was one of Remington's most advanced efforts, but compared to the lat-
er picture, there are no reflective light sources, forcing the painter to "overlight"
the picture; and, by putting the moon behind the subject, there is
no detail toward the viewer, resulting in black blocks of paint. Finally, the gentle-
ness of moonlight in *A Taint in the Wind* is expressed more abstractly through the
softer application of the paint itself and the slow curve of the road that unifies the
composition.

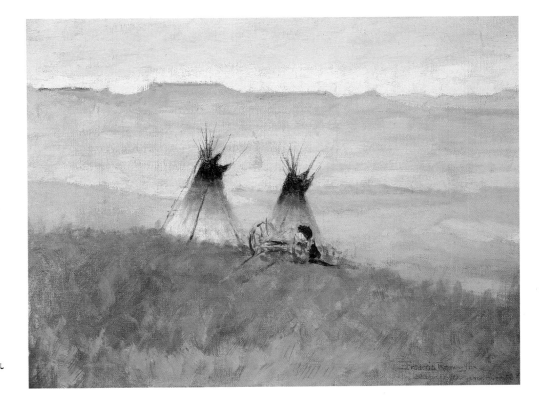

Against the Sunset is an exercise in color harmonies and perception. Reming-
ton's own color notes show he was concentrating on learning all the hues available
through specific pigments and how they interact. By choosing the instant at dusk
when there seems to be a universal light source, color remains perceptible in the
landscape and on the rider charging across the plain. The cowboy is no longer an
individual but rather a symbol, metaphorically placed in time. Remington cer-
tainly had not forgotten the Muybridge studies, as this horse appears to be lifted
directly from the photographer's publications. Royal Cortissoz praised the exhi-
bition in the press, citing the artist's progress with color, and pointing toward a
great future for the emerging painter. Childe Hassam, the quintessential Ameri-
can Impressionist painter, wrote to Remington that the show represented "all the
best things I've seen of yours for sure!" He continued, "No-body else can do
them . . . I was interested in the coach coming down the hill, the only thing to say
in criticism is your stars look 'stuck on' and your foreground cast shadows are a bit
black." This encouragement pleased Remington like none other. Hassam and
his wife had become friends of the Remingtons in recent years, the two painters
having met at the Players Club, a New York City organization founded in 1888 by
the actor Edwin Booth for actors, writers, and artists. Artist members, in addition
to Hassam and Remington, included Saint-Gaudens, John Singer Sargent, Wil-
lard Metcalf, Edward Simmons, John Henry Twachtman, Robert Reid, Ed-
mund Tarbell, J. Alden Weir, and Charles Rollo Peters.

As the above list demonstrates, the Players was the meeting place for Im-
pressionist painters in New York, as well as for representatives of the Tonalist

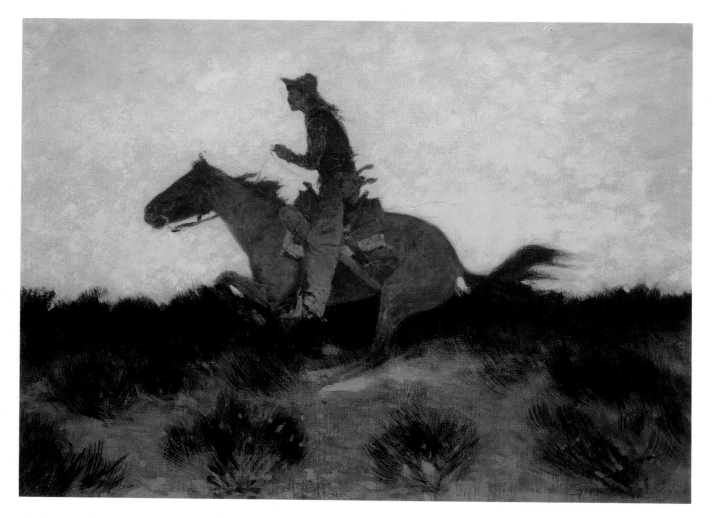

Against the Sunset

Willard Leroy Metcalf
(1858–1925)
Icebound

*Just prior to Remington's death, he re-
ferred to Metcalf as being the number-one
painter of the American landscape. Met-
calf's tonal approach to the landscape
combined with the shimmering brushwork
he used in his trees influenced Reming-
ton's plein-air pictures toward the end of
his career. Metcalf, like Hassam, be-
longed to the Players Club, which served
as a gathering spot for many of America's
Impressionist painters.*

movement, the second most popular landscape style in America. Remington was a regular visitor to the club and his acquaintances there had a tremendous influence on his stylistic changes following the turn of the century. All these painters had been trained in Europe, and during the 1890s they had brought back with them the latest in landscape styles. Weir, Remington's teacher at the Art Students League, and Willard Metcalf joined with Hassam in providing the greatest guidance to Remington. Acutely aware of his reputation as an illustrator, Remington wrote to Weir about the 1906 exhibition of the Impressionist group, The Ten. He chided his former teacher's work, *Hunting the Coon*, by saying, "The whole thing is rich and distinguished but you must be careful—it is perilously near a story. Art must rise superior to human interest—not to speak of coons." Weir's style had progressed from that of an academically oriented painter during the 1880s to a color-oriented, Impressionist painter. Metcalf, whom Remington would eventually proclaim the number-one American landscape painter, vacillated in his pictures between a subdued tonal approach and a more energetic adaptation of Impressionist techniques. Metcalf also turned to night subjects, a characteristic Remington would study closely.

The isms of art history are often too easily applied to artists of a particular period. Impressionism is an extremely familiar style today, having originated with the color experiments of Claude Monet during the 1870s in Paris, but during Remington's lifetime writers interpreted the term differently. As Elizabeth Broun noted in her study of the World's Columbian Exposition, Hamlin Garland was the first American to champion the style when he noted its prevalence at the fair. His book, *The Crumbling Idols*, lays out what he thought to be the three major qualities of "impressionistic or open-air painting." First, he thought such pictures were not an amalgamation of objects, but unified impressions of the scene. Second, the palette comprised raw colors, which utilized strong complementary pigments rather than color harmonies. And last, the subjects were derived from nature, not history, religion, or tradition. Garland's appraisal is much different from our contemporary, more scientific viewpoint. William Gerdts, writing on American Impressionism today, defines the style in terms of pure, prismatic colors applied with the concept of fusion to create a flickering, vibrating atmosphere. He sees the subjects of Impressionist pictures as being casual in nature, expressing a feeling of immediacy through a plunging perspective, a cropping of forms, and a sketchy finish. Despite these definitions, no artist blindly adheres to all the elements of a style. Weir, Metcalf, and even Remington borrowed from the Impressionist lexicon as they desired. Metcalf's adoption of Impressionist techniques occurred, according to Gerdts, during 1903–1904, also a crucial time for Remington. Metcalf's *May Night* (1906) was purchased by the Corcoran Gallery of Art in 1907 and influenced his colleagues to experiment with nocturnal subjects. Metcalf's first Impressionist-derived paintings were never allowed to become casual scenes. He held to structural compositions generally based on architectural elements. Cortissoz was a great admirer of Metcalf as he was of Remington, even calling Metcalf "the truly American Impressionist" because of his local subject selections.

Tonalism was an American style developed concurrently with the adoption of Impressionism. Exhibitions of Tonalist work have been organized by Gerdts and Wanda Corn during the past generation, resurrecting a term that had lain dormant after World War I. The two scholars disagree over who the major Tonalist painters were, but they agree on the style's merits, and that it had many adherents. Pictures such as those by Charles Rollo Peters were local in subject, yet strove for greater "spiritual" meaning than did most purely Impressionist pictures. The compositions were more finished and were created by building the painting with glazes that created color harmonies rather than by combining strong complementary colors. There were two approaches to Tonalist pictures according to Henry Ward Ranger, himself a Tonalist and an important propagandizer for the style: in one, a color dominated the picture, and in the other, "forms [were] perceived through an overall atmosphere," creating an evenness of color value. The Tonalists formed an organization in 1899, the Society of Landscape Painters, which had an annual exhibition at Knoedler until 1904.

That Tonalism and Impressionism were distinct styles was also clear in 1909 when Leila Mechlin wrote an essay, "Contemporary American Landscape Painting," for *International Studio Magazine*. Mechlin argued that many American painters borrowed from both styles. She wrote of Remington's favorite painter, Willard Metcalf: "The short stroke [of Impressionism] is also commonly employed by Willard L. Metcalf, who is likewise to be numbered among the foremost of American landscape painters. Light and air are to him matters of serious concern, but so also are form and motion. Unlike the majority of those who follow the impressionists' teachings, he cares not merely for the effect of sunlight but for the object upon which the sunlight falls, and paints not always in a high key." Mechlin's interpretation of Metcalf's work is helpful in understanding how Remington would have drawn upon contemporary trends for his own use. His collection, still housed at the Remington Art Museum, included work by both Hassam and Metcalf as well as the Impressionist Robert Reid and the Tonalist painters Bruce Crane, Edmund D. Lewis, and Julian Rix.

Remington wanted his work to be identified with that of his friends from the Players Club. He learned from them, attended their exhibitions, and even bought their paintings. This closeness increased when he and Eva decided in 1907 to buy property in Ridgefield, Connecticut, and build a grand house and studio. The Ridgefield area was home to many of these painters, among them Weir, Metcalf, and Hassam. In order to raise the funds, the Remingtons sold Endion and Ingleneuk and moved in May 1909. The couple's pride was evident when Fred's longtime friend General Leonard Wood visited them during the fall of 1909. Wood, who first met Remington in Arizona in 1886, was an inveterate note taker and correspondent. He recorded in his diary all the statistics of the estate, including the $40,000 price. He went on to say he "felt like a bull in a china shop on going into the room given me, as Mrs. Remington had evidently fitted it up for her best girl friends, as everything was in a delicate rose color." Following their experiences on the frontier and in Cuba, this account may not be entirely friendly to the artist's comfortable situation.

Childe Hassam (1859–1935)
Bedford Hills

1908. Oil on canvas, 22 x 26"
Collection Akron Art Museum, Ohio,
Bequest of Edwin C. Shaw

Childe Hassam's Impressionist style of quick brushstrokes and pure color served as a model for Remington as he struggled to lose his reputation as an illustrator after the turn of the century.

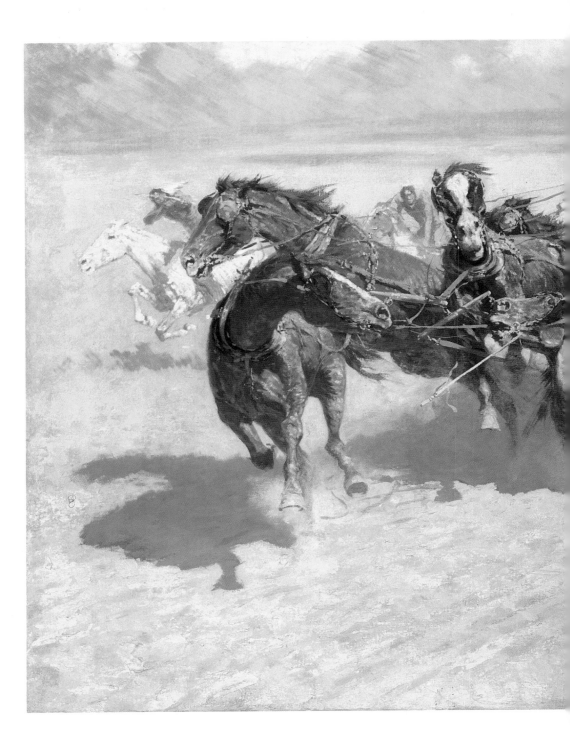

At this time Remington's nocturnal subjects primarily drew inspiration from Tonalist developments, while his daytime subjects borrowed from the higher-keyed style of his Impressionist friends. Remington's second Knoedler exhibition included a painting, *Downing the Nigh Leader*, that is almost a daytime version of *A Taint in the Wind*, exhibited the previous year. *Downing the Nigh Leader* was reproduced in *Collier's* and depicts a stagecoach under attack by a band of Indians who are attempting to stop the coach by killing the front left horse, or "nigh leader." The picture is typical of Remington's long line of action-packed

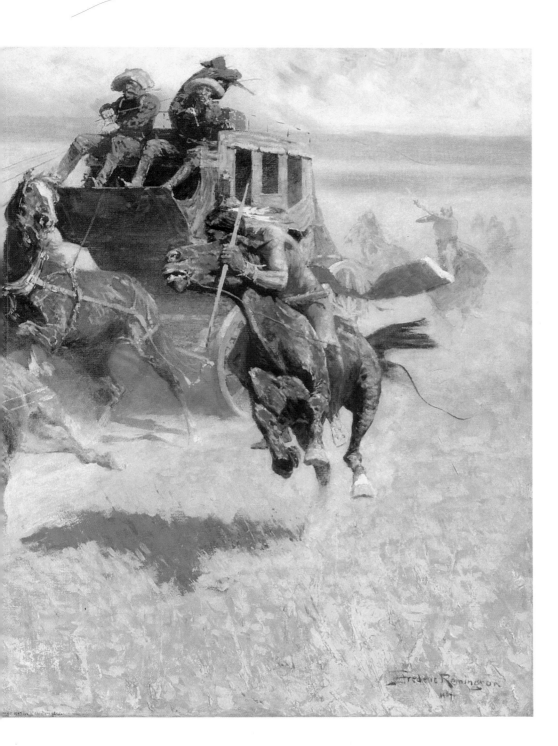

Downing the Nigh Leader

1907. Oil on canvas, 30 x 50″
Museum of Western Art, Denver

The success of Remington's nocturnes led contemporary critics to find in his daytime efforts too much glare and jarring colors. A Taint in the Wind, *painted the previous year, can be viewed as this picture's nocturnal complement.*

chase subjects, but it differs in its use of modulated colors, all from the same value range. The highlights of the horses are delineated with short, choppy brushstrokes, and the shadows contain no black. The critics viewed the coloration of this work and others like it as crude and glaring, still preferring the night pictures. The more tonal pictures tended to let the subject recede, avoiding narrative, while the daylight subjects remained visually aggressive. Remington had joked about this fine line in his letter to Weir, but solving this issue of perception would not have been easy for any painter. Ranger put it more succinctly in his

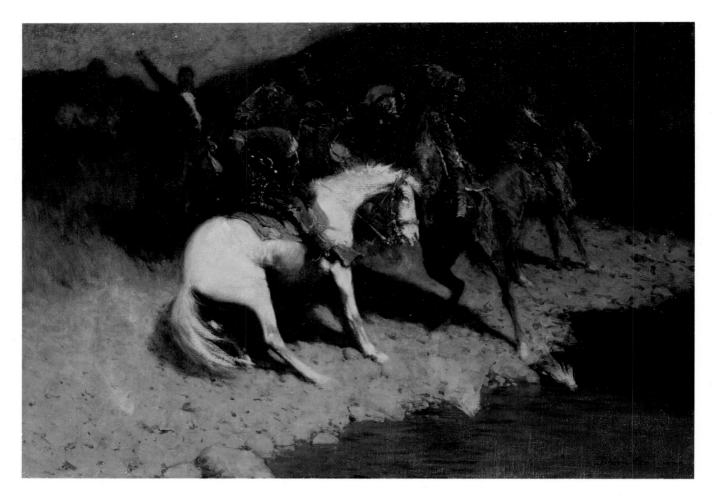

Fired On

The Sentinel

c. 1907. Oil on canvas, 27 x 36"
Courtesy Frederic Remington Art Museum,
Ogdensburg, New York

Disappointed by making only two sales from his 1907 New York exhibition, Remington was pleased at the same time to send this and one other nocturne to the Pennsylvania Academy of the Fine Arts for an exhibition arranged by Willard Metcalf, a member of The Ten.

"Art Talks," answering the question of what is a picture. He replied, "The genre school of painting, so popular a few years ago, came to an end because it was realized that story-telling was not the function of a picture." For most critics at this time the poetry of mood superseded the facts of an event.

Two other pictures from Remington's 1907 exhibition should be briefly noted. *The Sentinel* was selected by Metcalf to be included in an exhibition at the Pennsylvania Academy of the Fine Arts that same year, and *Fired On* was purchased after the exhibition by William T. Evans for his important collection of Tonalist pictures, which he donated to what is today the National Museum of American Art. Clearly, nocturnal subjects were the more interesting to contemporaries.

Throughout the decade Remington grew more sensitive to the problems illustration created in his work. In an effort to exorcise this evil from his oeuvre, he began destroying old pictures. According to his diaries, on February 8, 1907, January 25, 1908, and February 15, 1909, he burned canvases unworthy of his current stature. In all, over one hundred paintings were destroyed. A frustrated Remington was emphatic in his diary, "They will never confront me in the Future—tho' God knows I have left enough [pictures] go that will." Each burning occurred within weeks following his annual exhibitions at Knoedler.

Remington was free to devote more energy to his paintings once *The Cowboy* model was in Bertelli's hands for casting. His December 1908 exhibition reflected the situation with the inclusion of nineteen works, up from the twelve- and

Fired On

1907. Oil on canvas, 27⅛ x 40"
The National Museum of American Art,
Smithsonian Institution, Washington, D.C.,
Gift of William T. Evans

"Notice from Knoedler that W. d. [sic] Evans bought my 'Fired On' moonlight for the National Gallery at Washington," Remington noted in his diary for November 11, 1909. Evans's renowned collection of Tonalist and Impressionist pictures served as the core for what is now known as the National Museum of American Art. Cortissoz's review of the Knoedler exhibition declared the painting to be the artist's masterwork.

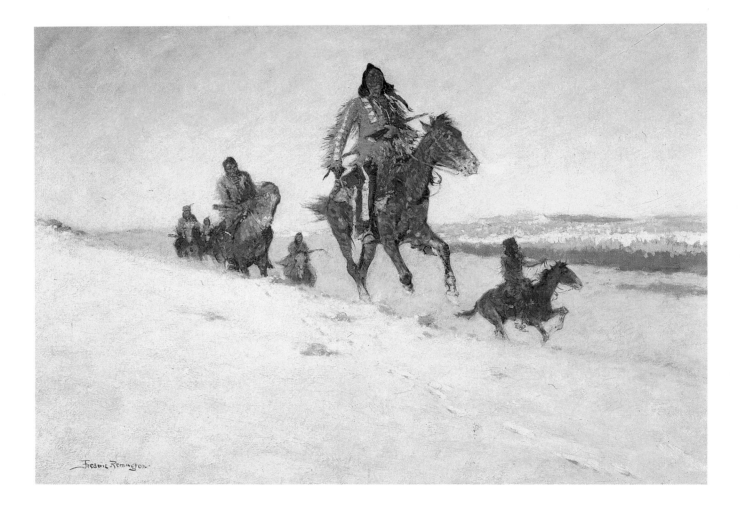

The Snow Trail

c. 1908. Oil on canvas, 27 x 40″
Courtesy Frederic Remington Art Museum,
Ogdensburg, New York

*Remington's admiration of his friend
Willard Metcalf's landscapes is nowhere
more evident than in this work, which
takes advantage of the cool blue light
reflected from shaded snow. The contrast
of the setting sunlight and the shadows
also creates the implied movement of the
Indians' horses.*

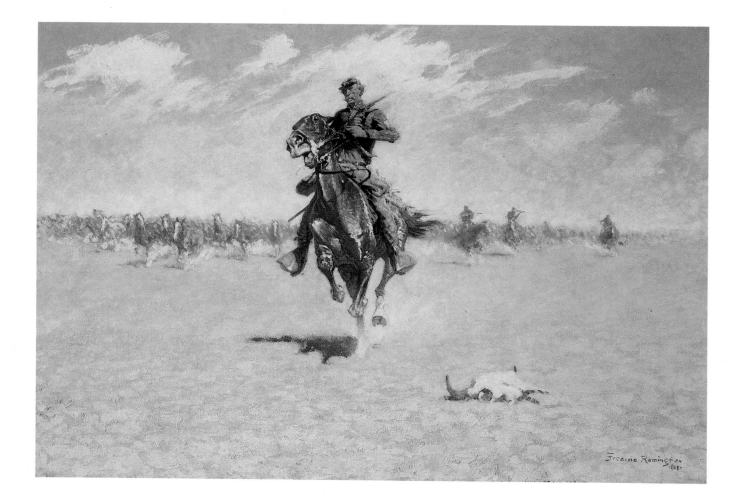

Cutting Out Pony Herds

1908. Oil on canvas, 27 x 40"
Museum of Western Art, Denver

Military subjects did not vanish from his work as Remington studied the landscape more closely. The shimmering, hot light of the plains is beautifully rendered through looser brushwork and by a strong color sense, using blues, greens, and golden sand color.

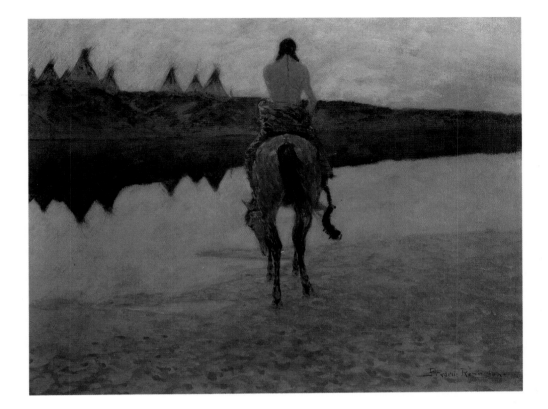

Indian, Horse and Village

1907. Oil on canvas, 20 x 26"
Courtesy West Point Museum, United States
Military Academy, West Point, New York

Since Remington had painted hundreds of works representing the United States Army and its exploits, one wonders why the artist gave an Indian subject to the United States Military Academy. The Indian on horseback represents our viewpoint as he watches the outlines of his village slip into darkness.

Apache Scouts Listening

1908. Oil on canvas, 27 x 40"
Private collection

During the artist's later years, he continued to draw Apache subjects from his early days in the Southwest. The subject is no longer a specific event; rather, it is the mysterious mood created by something implied outside the frame. The mood is heightened through the use of his favorite greenish tones.

eleven-piece exhibitions of previous years. The showing represented a breakthrough for the artist, including five pure landscape studies—the first he had ever exhibited. All five of the small works were pictures made during the summer at Ingleneuk. Remington's own language, recorded in his diary, mirrors his deepening interest in landscape and color. On January 11 he described the day: "Drove down along Farmington River and took a look at the hills—and they are interesting each way—up or down. The rushing river—a cold blue through the snow fields is fine. Lots of abandoned houses—very well built originally. Splendid winter day and good sleighing. Loafed after lunch until the sun was 'bout to set when I went across the lake and made a dandy study of snow with sun setting on it—a valuable note." It was rare for the artist to include such detail in his diary. He was trying to get back to the easel following the hard months of preparation for *The Cowboy*; his sketching helped, though he did not see it yet as an end in itself. A few days later he complained, "I sometimes feel that I am trying to do the impossible in my pictures in not having a chance to work direct but as there are no people [who paint] such as I paint its 'studio' or nothing. Yet these transcript from nature fellows who are so clever cannot compare with the imaginative men in long run." By June he was able to report, "painted in studio and I have discovered for first time how to do the *silver sheen* of moonlight." It is interesting that the discovery would come in the studio, although he was spending evenings outside studying the light late into the night. By the end of October Remington's friend Gus Thomas claimed the landscapes to be as good as anyone else painted. He

Apache Scouts Listening

Indians Simulating Buffalo

1908. Oil on canvas, 27 x 40"
The Toledo Museum of Art, Gift of
Florence Scott Libbey

The Plains Indians devised many methods to hunt the buffalo, including disguising themselves as bison in order to drift into the herds unnoticed. This painting depicts the use of this technique so as not to be discovered by a passing wagon train. A late picture, this work demonstrates how Remington applied aspects of Impressionism to his own style.

With the Eye of the Mind

1908. Oil on canvas, 27 x 40"
The Thomas Gilcrease Institute of American
History and Art, Tulsa, Oklahoma

The sensitive grouping of three Indian riders slipping into evening shadow personifies the artist's desire to relate the nostalgia of the Indians for their past life. Coordinating the earthen tones of evening with darting hints of yellow and blue demonstrates Remington's talents at their best and far overshadows the overt symbol of charging Indians seen in the cloud formations.

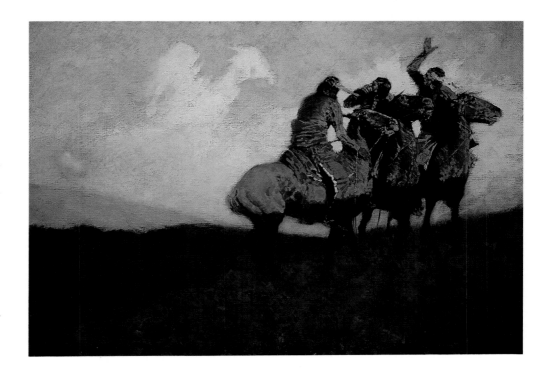

even went so far as to predict Remington would be a great landscape painter. Idle words from a playwright, although he had been correct in encouraging his friend's talent for sculpture thirteen years earlier.

The 1908 exhibition contained many of Remington's very best pictures; among them were *Apache Scouts Listening, The Snow Trail, The Stampede,* and *With the Eye of the Mind.* These works demonstrated the range that Remington had developed from his earliest days when he was interested only in subject. Excepting

The Stampede, the paintings expressed a disenchantment with the West, captured predominantly by Tonalist techniques. Metcalf's specialty of snow pictures was creeping into Remington's work with marked success. What the 1908 works best document is the artist's confidence in recording various lighting effects. In *Apache Scouts Listening,* Remington for the first time avoids an "acid" effect in the green tones by properly balancing the composition with blues. His deft handling of cool blue tones of the snow unified *The Snow Trail,* a scene of Indians galloping on horseback through snow-covered fields—not studied in the West, but in the East. Remington masterfully used atmospheric perspective to show the depth of the scene, and by reducing detail in each rider trailing the leader, the composition is woven into perfect balance. *With the Eye of the Mind* is one of Remington's most successful paintings due to a similar control of the setting sun against a group of three Plains Indian riders observing a similar image created by the clouds, an overt apotheosis of their culture.

It is in *The Stampede* that the artist tackled a particularly difficult situation. The picture was begun at least three times before the artist could write on May 31: "Worked on 'Stampede' and have made a dandy of it. I got the light that is unearthly—and the curious yellow glow of a rain storm, seen only at long intervals but not forgettable." Recording action was second nature to Remington, and here he combines the desperate acts of the cowboy faced with a stampede caused by a crisp crack of lightning with the atmosphere that created it.

When examined together, many of the 1908 paintings have prompted several writers to assert that Remington had reached a level of sophistication in his work equal to other American Impressionists. Granted, the summer landscapes demonstrate a dappled light effect, and the studio pictures demonstrated a greater bravura brushwork, but to proclaim Remington, even briefly, an Impressionist is not an accurate assessment of his work. It may be felt that to include him as an Impressionist is to proclaim him a superb American painter, as Impressionism today is one of the best-loved painting styles. This should not lead, however, to improper classification of an artist as talented as Frederic Remington.

Another 1908 painting, *Indians Simulating Buffalo,* has often been cited as the best example of the painter's adoption of Impressionism because of the dabbing brushwork that is used to depict the buffalo robes draping the two Indian riders, and the strong vertical blue and red lines used to build up the shadows beneath them. These are indeed Impressionist techniques, but the similarity stops there. Impressionism, like any painting style, is a language. To be fluent, one must be able to speak, think, and dream in a language. Remington's approach to painting was not as an Impressionist. For example, he often used previously prepared background canvases in which to draw in his figures, something no Impressionist would have done. The method disrupts the overall unity of a picture, which is evident in the artist's occasional inability to blend foreground, middle ground, and background. Remington was primarily a figure painter, by definition a problem for any Impressionist. Indeed, this drove Auguste Renoir from the French Impressionist camp and never really allowed Edgar Degas to enter.

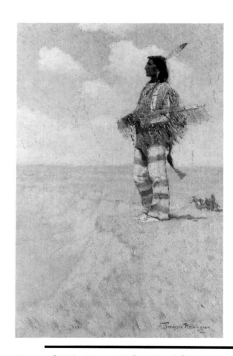

Last of His Race (The Vanishing American)

1908. Oil on composition board, 18 x 12⅜"
Yale University Art Gallery,
New Haven, Connecticut, Gift of
Mr. and Mrs. A. Varick Stout

In this small picture the artist returned to a theme he used throughout his career, that of the final moment of an era. Though brightly colored, the message is clear that the days of roaming the plains have ended and the future is uncertain.

Remington knew this; he even confided to his diary during January 1908, following a day of gallery viewing, "small canvasses are best—all plein air color and outlines lost—*hard outlines* are the bane of old painters." Such canvases as *Indians Simulating Buffalo, The Snow Trail*, and even *The Outlier* of the following year show that Remington's method was to build the figure through traditional techniques and then overlay the brushwork, thus creating the final effect.

Remington took great effort in creating *The Outlier*, an idea that took shape on July 6, 1909, and was completed on October 30, an extremely long time for Remington to work on one picture. He began it on several occasions, referring to the picture in his diary as "my old companion." Its completion brought fast compliments from his friend Hassam, who called it the best of Remington's pictures. The unity of this picture is perhaps unequaled by any other late painting; the tonality of the composition is beautifully balanced with the draughtsmanship, the brushwork itself helps to build the horses' form, and the subject has a universal appeal. By comparing *The Outlier* to the much earlier *Self-Portrait on a Horse*, painted around 1890, it is perhaps easier to discover the success of Remington's newer techniques. The self-portrait focuses total attention on the horse and rider by representing the ground and sky as flat areas of color. Except for the reflected blue light, every color in the composition is premixed and laid on the canvas to create a gray shirt or a brown boot. The goal of the work is to describe the integrity of the sitter and to demonstrate his talent as a draughtsman of horses. Very little emotion is present. *The Outlier* gazes not at the viewer but into the distance, setting the mood for a poetic interpretation of the reverie one experiences in isolation. The subject shares weight in the composition with the setting sun, a metaphor of the life this outlier would have known. There is no area of flat color, the ground cover is built up through fast brushstrokes, and the Indian's leggings are likewise a framework of various colors. The figure and the horse are still carefully drafted under the netting of the brushed colors Remington applied, unifying the picture and striking an emotional rather than factual chord.

Remington's 1909 exhibition was the most highly praised of his entire career. In addition to *The Outlier, The Buffalo Runners: Big Horn Basin, The Winter Campaign, The Gossips*, and *The War Bridle* were among the works singled out by critics for praise. Remington's enthusiasm fills his diary as the articles began appearing and his nervousness disappeared. Prior to any reviews he wrote, "The papers are certainly not good to me. I can get the 5th ave. crowd but not the insects of the art columns but cheer-up the pups will come." And come they did: "Remington's work is at once splendid in its techniques, epic in its imaginative qualities, and historically important in its permanent contributions to the records of the most romantic epoch in the making of the West," wrote one reviewer. The subjects were praised, the color was touted, and the draughtsmanship recognized by the various reviewers. "No American artist interests the people more than Remington does, and none is really better worth going to see," wrote another. Tremendously cheered, Remington penned in his dairy on December 9, 1909: "The art critics have all 'come down'—I have belated but splendid notices from all the papers. They ungrudgingly give me a high place as a 'mere painter.' I

The Stampede

1909. Oil on canvas, 27 x 40"
The Thomas Gilcrease Institute of American
History and Art, Tulsa, Oklahoma

One of the artist's most popular works, The Stampede was also the title of a bronze done the same year. Stampedes created by lightning and cracks of thunder forced sudden, chaotic action—a natural subject for Remington.

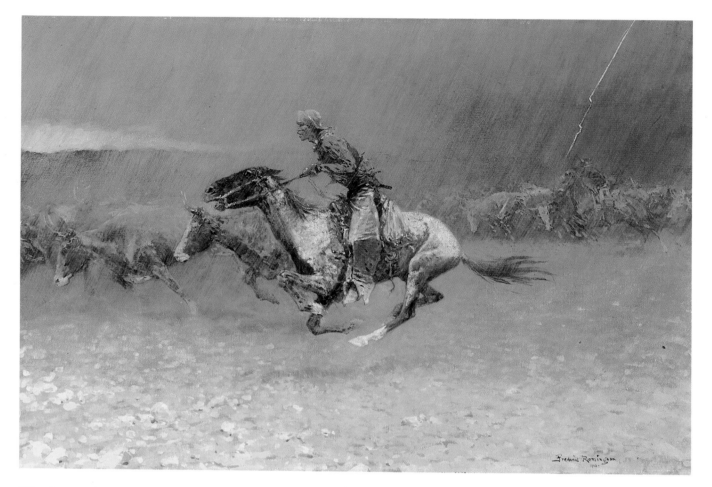

The Stampede

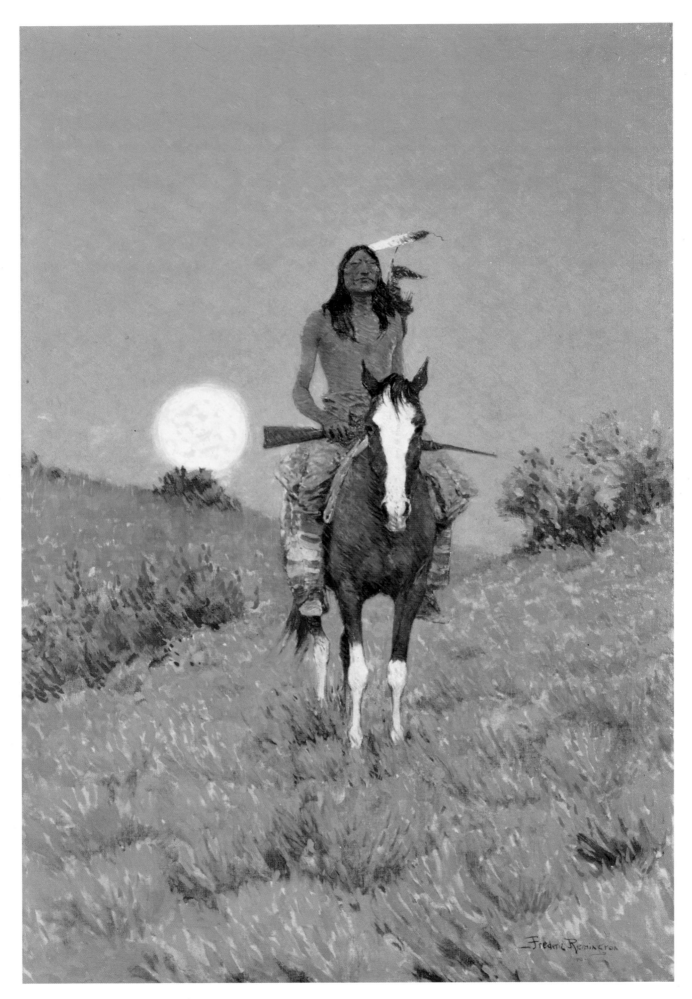

The Outlier

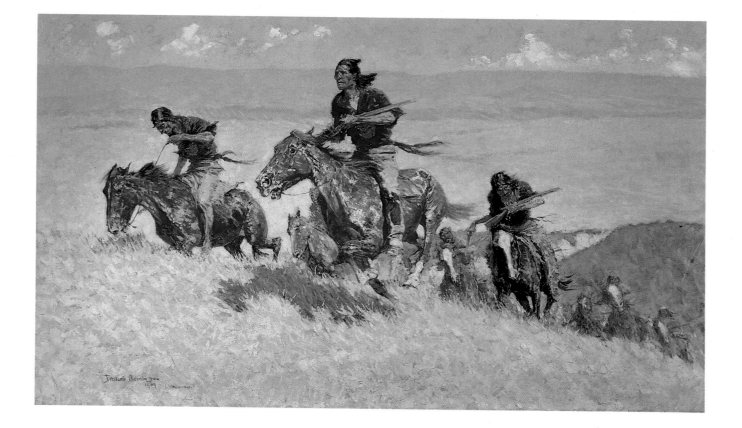

The Buffalo Runners: Big Horn Basin

1909. Oil on canvas, 30⅜ x 51½"
Courtesy Sid Richardson Collection
of Western Art,
Fort Worth, Texas

According to Remington's diary, he worked on this painting for months before he finally "pulled The Buffalo Runners *into harmony" on July 6, 1909. Unsold from the painter's last exhibition, it drew great praise from the critics for its combination of dynamic action, fluid brushwork, and harmony of color.*

The Outlier

1909. Oil on canvas, 40⅛ x 27¼"
The Brooklyn Museum
Bequest of Miss Charlotte R. Stillman (55.43)

"I will not be licked," Remington confided in his diary after laying in The Outlier *for the tenth time. Characteristic of his dogged approach to life and art, six days later Remington could write that the picture was praised by his friend Childe Hassam as "the best of my pictures."*

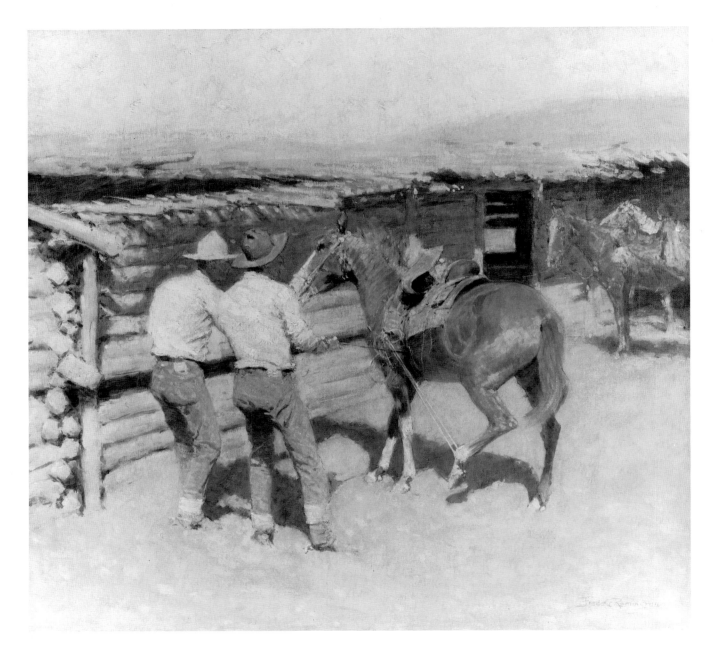

The War Bridle

have been on their trail a long while and they never surrendered while they had a leg to stand on. The 'Illustrator' phrase has become background."

Perhaps the most written-about picture in the exhibition was *The Winter Campaign*, a night scene, still the most praised by the critics and aficionados. One writer noted, "The indication of the figures of the men in the middle distance gathered around the fire is admirably done, and the whole effect is of a sincere workmanship and a strong feeling for characteristic sentiment." A second writer said the picture "expresses, as only Remington can, the oneness of feeling of animals and men in the face of nature's menace of death. Indeed, in all of Remington's pictures the shadow of death seems not far away. If the actors in his vivid scenes are not threatened by death in terrible combat, they are menaced by it in the form of famine, thirst or cold." By the time the exhibition closed on December 15, eleven of the canvases had sold, totaling over $5000. The loss of the *Collier's* contract could now be forgotten as the Remingtons had enough to live comfortably for a couple of years. Frederic was completely free to paint.

Writers are famous for overly dramatizing individual works of art. The equation of *The Winter Campaign*'s dismounted cavalrymen crowding around a winter night's fire with nature's menace of death was a romanticized concept that even Remington, who was used to puffery, would have found exaggerated. His goal was to communicate a sense of place by faithfully capturing the flickering

Wolf in the Moonlight

c. 1909. Oil on canvas, 20 x 26″
Addison Gallery of American Art, Phillips
Academy, Andover, Massachusetts

A wildlife subject is quite unusual for Remington, but the message is not. The yellow darts of the wolf's eyes, complemented by the stars, create an almost supernatural late-night scene.

The Winter Campaign

1909. Oil on canvas, 27 x 40″
The Rockwell Museum, Corning, New York

Described by a contemporary critic as a picture "reproducing with positive clairvoyance that indescribable bond which unites the men and their horses around the comfortable glow of the campfire," this work ranks as one of the painter's finest nocturnes.

qualities of the night fire, a universal symbol of protection. The writer's romantic comments did become somewhat prophetic when less than two weeks later Remington developed an acute case of appendicitis, then a life-threatening illness. On December 20 he noted in his diary, "While at work I was caught with intense pains in the belly . . . I got a hole through my guts later but it put me in a wounded man's fever and I went to bed." Following a brief respite, his condition worsened until Eva summoned a doctor from Danbury to examine her husband. The diagnosis was appendicitis, and a decision was made to operate immediately. The operation went smoothly, considering the patient's great bulk, and on Christmas Day Eva reported that Frederic was feeling quite comfortable. Later that day, his condition changed rapidly as peritonitis set in. The doctor was again sent for, but it was too late. Remington died the next morning.

At the age of forty-eight, Remington died at the apex of an incredibly productive career, having been a successful illustrator, reporter, novelist, painter, and sculptor. His images had been seen by millions of Americans, creating for them and future generations an articulate understanding of the American West during its waning years. Leonard Wood, whose equestrian portrait Remington had painted for his final exhibition, eulogized the artist in his diary: "His death will be a great loss, especially in all which pertains to a true portrayal of western life, as he has been the one man who has been able to put this subject in its true light before the people . . . His death leaves no one in any way capable of taking up the class of work he was doing."

The Winter Campaign

Afterword

FREDERIC REMINGTON died feeling a false sense of optimism. The critics' response to the twenty-three paintings exhibited at Knoedler from December 4 to December 15, 1909, was, in his mind, vindication for two decades of harsh criticism as an illustrator. The critics, many of whom had written of his mere storytelling and lack of color sense, were almost unanimous in their praise for this final exhibition. He died while these tributes were ringing in his ears. Often, when an artist dies at the height of a career, myths are built around his talents and potential. Remington did not escape this: he had achieved fame through his illustrations, and he had at the very end triumphed as a painter, equal to the best . . . Or had he?

His early fame quickly outweighed his late critical recognition due to the society of his day, and one successful exhibition did not provide a long-lasting counterweight. By examining the normal measures of an artist's place in history, one will discover Remington's problem. Patronage, collecting, historiography, and the influences of the artist upon colleagues and artists of later generations are the things by which one evaluates his lasting stature. This does not mean that Remington did not earn a prestigious place in American art history—he did. But it belies the confidence he himself sensed, as well as the idea that, had he lived, he would have become one of our best-remembered artists.

In the history of art, an artist who is an illustrator wears a "Scarlet I." Remington was fully responsible for the reputation he so despised later in his career. His goal as a high school student had been to become an illustrator, prompting him to attend Cornell College to study journalism and art, something that combined his own romantic longings of becoming an artist with his father's desire that his son follow in his path. Because Cornell lacked an art department, the young artist went to Yale College, where he quickly learned that art and journalism were not a realistic combination, which was underscored when he arrived at the Art Students League in 1886 to study painting under one of America's leading artists. Remington's desire for fame and success made him concentrate on illustration while at the same time pursuing the normal exhibition activities of an emerging artist. Unlike Winslow Homer, Henry Farny, and Willard Metcalf, he was unable to free himself from the commercial world at the proper time.

Remington may have been a victim of the times as well. His entry into the illustration world came when advertising was being introduced into publications, quickly transplanting subscription rates as the chief economic fuel for the indus-

try. Prior to Remington's era, illustrators like Homer, although known, were not promoted. *Harper's* unintentional success with the cartoonist Thomas Nast demonstrated to them what a star could do for the ledger sheets, thus the overblown puffery of Julian Ralph and Owen Wister, who wrote, "Remington is not merely an artist; he is a national treasure." The development of the mass media in concert with greater educational opportunities and a higher literacy rate during the latter years of the century broke down old barriers of class, tradition, and taste.

Remington's ability to socialize comfortably with the cavalrymen on the plains and the genteel folk at Endion is a paradigm for what has become the theory of "mass cult." The encroachment of mass culture put the genteel, educated upper class on the intellectual defensive. Their response was to isolate themselves either academically by imitating the great, or by withdrawing from confrontation and developing as an avant-garde. Mass culture demanded the qualities that Gilbert Seldes, a leading exponent of folk and popular arts, outlined in 1951: "[They] have much in common; they are easy to understand; they are romantic, patriotic, conventionally moral and they are held in deep affection by those who are suspicious of the great arts. Popular artists can be serious, like Frederic Remington, or trivial, like Charles Dana Gibson . . . one thing common to all of them is the power to communicate directly with everyone."

Dwight MacDonald, another important transcriber of the philosophy of mass culture, wrote in 1962: "In mass cult, everything becomes a commodity, to be mined for $$$$, used for something it is not, from Davy Crockett to Picasso. Once a writer becomes a name . . . the mass cult mechanism begins to 'build him up' to package him into something that can be sold in identical units in quantity." Considering MacDonald's comments, it becomes evident that Remington was on the cutting edge of a cultural phenomenon of which he was not aware but into which he happened to fit. MacDonald states that the two characteristics needed for success in a mass-cult world are that "the producer must believe in what he is doing," and that "[he] must have a good deal of mass man within himself." Again, Remington fits the description. He rode the wave of success and fame until it was too late—and he realized it. That is why he not only burned earlier paintings but also, on the day before he moved to Ridgefield to take his place among fellow painters, "burned up old photos. Rubbish from [undecipherable] and Harper rejects for years back."

Remington lamented that he left too much early material "out there," and it is indeed an important contribution to what critics and historians have said about his work since his death. The artist's reputation has always suffered. Though Royal Cortissoz, in his reviews, was encouraging to Remington during the artist's final years, his books did not continue the praise, nor did other contemporary art writers such as Samuel Isham, Charles Caffin, or Sadakichi Hartmann, who mentioned Remington as an illustrator and ignored his efforts as a sculptor. The situation had not changed by the 1940s when Oliver Larkin, Homer Saint-Gaudens, and Virgil Barker examined American artists for a new generation. More recent writers, such as John Wilmerding, Milton Brown, and Sam Hunter, have maintained their predecessors' posture. And, as art history has become more

specialized, Remington has fared no better. Writers on Impressionism and Tonalism have omitted Remington. His only work to be reassessed has been his sculpture. Only now is there some movement afoot to recognize properly Remington's best work, both two- and three-dimensional. Remington could not outlive the popularity of his illustrations, but art historians should be able to distinguish those works done on commission and on a deadline from more sincere' efforts. These, in turn, should be the efforts judged, not all 3000 works produced.

Remington's renown in his lifetime was largely due to the promotion of periodicals. Likewise, the patterns of his patronage are unlike those of other artists. Collectors are necessary to support artists, and quite often they can be the major factors in an artist's reputation. During his lifetime, the magazines were Remington's major patron, and, in turn, their promotion of collector prints, made possible by the progress in printing technology, made Remington's work accessible to everyone for as little as one dollar. Until 1903, Remington was his own dealer, and there were never true collectors of his work during his lifetime; nor did his work go into major private collections of American art. Only *Fired On* was purchased by a collector, William T. Evans, whose prestige would have helped the artist, but the purchase was made in December 1909. Both the Metropolitan Museum of Art and the Corcoran Gallery of Art bought sculptures directly from the artist, but these purchases seem not to have broadened interest in Remington's total output.

It remained for a later generation of collectors to assess the artist properly, an examination that came during the 1940s and 1950s. Amon Carter purchased his first work by Remington, *His First Lesson*, in 1935, leading to a burst of interest in the artist. Carter was a successful oilman from Fort Worth whose collections of Western American art now form the core holdings of the Amon Carter Museum in that city. A close friend, and collecting adversary, of Carter's was Sid Richardson, also a wildcat oilman. Like Carter, he admired Remington and Charles Marion Russell and sought to acquire the best of each painter's work. Several paintings in this publication, including *Self-Portrait on a Horse*, *The Buffalo Runners: Big Horn Basin*, and *Apache Medicine Song*, were purchased by Richardson even though he claimed that when Carter bought *A Dash for the Timber* he himself would be priced out of the Remington market. For many years, the Sid W. Richardson Collection was on loan to the Carter Museum, but today it has its own facility in downtown Fort Worth. Yet another Texas collection, that of the Hogg brothers of Houston, was made at this time, and today it is in the Museum of Fine Arts in their home city. Two other oilmen, Thomas Gilcrease and R. W. Norton, acquired sizable Remington holdings during these same two decades, and their collections are now in institutions bearing their names. Gilcrease was an amazing acquirer of books, documents, paintings, and sculptures describing what he defined as "Westering America." He purchased over 8000 works of art and 41,000 Indian artifacts in less than a twenty-year period, and he could be said to be the Remington collector with the broadest taste—which is still rather narrow. Key pictures in this Tulsa institution are *Missing* and *The Stampede*. Norton, an oil

investor from Shreveport, built holdings of several dozen works by Remington, especially very early pictures and sculptures.

The impact, and lack thereof, of these Southwest oil barons is important in understanding the position Remington has gained in American art since his death. The artist would feel great satisfaction knowing that hundreds of thousands of people view his greatest works each year in these institutions. In fact, over 30 percent of the illustrations in this volume, representing the very best of Remington's efforts, come from the five collections noted. But none of them was built in a major art center, and none of the five men was noted as a connoisseur of American art. Thus, Remington has always stood apart from the American art community, as have most Western American artists. The collecting by these oilmen, and by several other persons on a smaller scale, has been explained as their having seen in their own activities the same wide-open freedom that Remington saw in the West. There is much truth to this statement.

Unfortunately for Remington's reputation, his work was never acquired by "serious" collectors of American painting. Vast collections of American Impressionist material have been assembled during recent years, but no Remington examples are in these collections. Just as the major writers on the subject have ignored Remington, so, too, have curators. Even the 1980 exhibition "Connecticut and American Impressionism" omitted Remington, an apparent rejection of the notion that Remington became an Impressionist late in his career.

Upon Remington's death, his widow held much of his estate together and made a strong attempt to stop the further production of bronzes by instructing that the molds be destroyed. Eva outlived her husband by nine years, and upon her death, a sizable collection of paintings, sculptures, sketchbooks, and other archival material was transferred to the Ogdensburg Public Library. These holdings today are at the Frederic Remington Art Museum. This time, geography is the strike against the artist because of Ogdensburg's isolation.

It was not until Harold McCracken, a prolific American outdoor writer during the 1920s and 1930s, took up an interest in Remington's career that a biographical attempt was made. Eva had earlier attempted to convince Wister to write a biography of her husband's career, but he never complied. During the 1940s and 1950s, McCracken, too, assembled a great amount of Remington material and brought interest to the artist through sporting publications. He gained an in-depth knowledge of the Remington Art Museum collection, and when the studio collection of late landscapes and archival material was sold to the Buffalo Bill Historical Center in Cody, Wyoming, he became that museum's director. Remington had spent time during his last years in Wyoming, so the many field sketches he produced there, as well as many artifacts from the region's Native American tribes, found a proper home in this great institution. Under McCracken's leadership, and that of his successor, Peter Hassrick, scholarly endeavors regarding Frederic Remington's work have taken place. Sound books and exhibition catalogues have been published, but they have concentrated on the artist's biography, not on his art.

If an artist is ignored or abused by critics, curators, collectors, and historians,

other artists themselves may make or restore a reputation. Unfortunately, Remington's influence was felt chiefly by those who painted the American West. He had a great impact largely on such American painters as Charles Schreyvogel, Charles M. Russell, N. C. Wyeth, and Maynard Dixon, and on lesser artists of the same milieu. Even today, his spirit and that of Russell are philosophical guideposts for the popular Cowboy Artists of America organization. Finally, during his last years, Remington was a follower, not a leader; therefore he could not have influenced younger, more experimental artists.

Beginning with the prehistoric cave painters of southern France, mankind has always needed the visual arts to express itself and leave its record. For thousands of years, the audience for "art" was, in fact, the entire population. Beginning in the eighteenth century, artists began to respond to a more specialized audience, while the wider population had its own artists who only infrequently "crossed over," artists such as William Hogarth in eighteenth-century England, or Honoré Daumier a century later in France. Remington should be viewed as one of those artists whose audience was the wider public and whose subjects and style responded to that public's taste and to its need to have its history recorded. Art historians, collectors, and curators must change some of their viewpoints in order to recognize the importance of Remington's art.

Whenever art historians judge art on the basis of its ability successfully to reflect and interpret a society, an artist such as Frederic Remington will be understood and enjoyed as he should be.

Chronology

1861	October 4: Born to Seth Pierre and Clara Sackrider Remington in Canton, New York
1873	August: Moves to Ogdensburg, New York; Seth Remington appointed Collector of the Port
1875	September: Enrolls at Vermont Episcopal Institute, Burlington
1876	June 25: General George Custer and his men slaughtered in the Battle of Little Big Horn
1876	September: Enrolls at Highland Military Academy, Worcester, Massachusetts
1878	September: Enrolls at Yale College School of Art, attends three semesters
1880	February 18: Seth Pierre Remington dies
1881	August–September: Vacations in Montana Territory—his first trip to the West
1882	February 25: *Harper's Weekly* publishes first illustration (redrawn by staff)
1883	March: Buys sheep ranch near Peabody, Kansas
1884	March: Moves to Kansas City; invests first in a hardware store, then in a saloon; October 1: Marries Eva Caten in Gloversville, New York; couple returns to Kansas City
1885	September: Moves to Brooklyn, New York
1886	March–May: Attends Art Students League, New York June: Travels to Arizona, Mexico, and New Mexico
1887	April: Travels to North Dakota, Montana, Wyoming, and western Canada; exhibits for the first time at the American Watercolor Society and the National Academy of Design
1888	February: Illustrations appear in Roosevelt's serialized articles for *Century Magazine*, later published as *Ranch Life and the Hunting Trail* March: Wins Hallgarten and Clark awards at National Academy of Design exhibition May–July: Travels to Arizona, Texas, and New Mexico
1889	July: Wins silver medal at Paris International Exposition
1890	April: Buys home in New Rochelle, New York; one-man exhibition and sale at American Art Galleries of the American Art Association December 30: Defeat of Sioux at Wounded Knee
1891	June: Elected associate member of National Academy of Design
1893	March: Travels to Mexico for *Harper's* September: Meets Owen Wister in Yellowstone; on return trip to New York visits World's Columbian Exposition, Chicago
1895	July: First book, *Pony Tracks*, published October 1: First sculpture, *Bronco Buster*, copyrighted November: Second exhibition and sale at the American Art Galleries of the American Art Association
1897	December: Exhibits forty works in Boston exhibition
1898	May: *Crooked Trails* published June: Travels to Santiago, Cuba, to cover Spanish-American War for *Harper's* and *New York Journal*
1899	April: *Harper's Weekly* releases Remington; begins illustrating for *Collier's*
1900	March: Begins casting sculpture with Roman Bronze Works, New York May: Buys summer home at Ingleneuk, New York; summers there every year
1901	September: *Bunch of Buckskins*, portfolio of color lithographs, published; Theodore Roosevelt becomes 26th president upon the death of William McKinley December: Exhibits at Clausen Gallery
1902	May: Owen Wister's *The Virginian* published

1903	April: Begins showing with Noé Gallery, New York
	May: Signs four-year contract with *Collier's*
1905	March 16: Receives commission for *The Cowboy* from Fairmont Park Art Association, Philadelphia
	March 18: *Remington Number* published by *Collier's*
1906	December: Begins showing with Knoedler, New York
1908	November: Buys property for new home and studio in Ridgefield, Connecticut
1909	Janurary: *Collier's* contract terminated; exhibits work at Doll and Richards Gallery, Boston
	December: Exhibition at Knoedler well received by critics
	December 26: Dies of peritonitis following emergency appendectomy

Selected Bibliography

BILLINGTON, RAY ALLEN. *Frederick Jackson Turner: Historian, Scholar, Teacher.* New York: 1973.

BROUN, ELIZABETH. "American Painting and Sculpture in the Fine Arts Building of the World's Columbian Exposition, Chicago, 1893." Ph.D. dissertation, University of Kansas, 1976.

COLLIER'S: THE NATIONAL WEEKLY. *Remington Number.* March 18, 1905.

CRAVEN, WAYNE. *Sculpture in America.* Newark, N.J.: 1968.

CROWLEY, WILLIAM, with essays by David Tatham and Atwood Manley. *Artist in Residence: The North Country Art of Frederic Remington.* Exhibition catalogue, Frederic Remington Art Museum. Ogdensburg, N.Y.: 1985.

DARY, DAVID. *Cowboy Culture.* New York: 1981.

DIPPIE, BRIAN W. *Looking at Russell.* Fort Worth: 1987.

———. *Remington and Russell: The Sid Richardson Collection.* Austin: 1982.

EMERY, EDWIN, AND EMERY, MICHAEL. *The Press and America: An Interpretive History of the Mass Media.* Englewood Cliffs, N.J.: 1978.

FREDERIC REMINGTON ART MUSEUM, Ogdensburg, N.Y. Frederic Remington Papers.

GERDTS, WILLIAM H. *American Impressionism.* New York: 1984.

GERDTS, WILLIAM H., AND SWEET, DIANE. *Tonalism: An American Experience.* Exhibition catalogue, Grand Central Art Galleries. New York: 1982.

GOETZMANN, WILLIAM H., AND GOETZMANN, WILLIAM N. *The West of the Imagination.* New York: 1986.

HARPER, HENRY J. *The House of Harper.* New York: 1912.

HARRIS, NEIL. *The Land of Contrasts 1880–1901.* New York: 1970.

HASSRICK, PETER H. *Frederic Remington: Paintings, Drawings and Sculpture in the Amon Carter Museum and the Sid W. Richardson Foundation Collections.* New York: 1973.

———. *Frederic Remington: The Late Works.* Exhibition catalogue, Denver Art Museum. Denver: 1981.

JUSSIM, ESTELLE. *Frederic Remington, The Camera and the Old West.* Fort Worth: 1983.

KEYES, DONALD D. *The Genteel Tradition.* Exhibition catalogue, Winter Park, Fla.: 1985.

KORZENIK, DIANA. *Drawn to Art: A Nineteenth Century American Dream.* Hanover, N. H.: 1985.

MCCRACKEN, HAROLD. *Frederic Remington: Artist of the Old West.* Philadelphia.: 1947.

———. *The Frederic Remington Book: A Pictorial History of the West.* Garden City, N.Y.: 1966.

MacDonald, Dwight. *Against the American Grain: Essays on the Effects of Mass Culture.* New York: 1962.

Maxwell, Perriton. "Frederic Remington—Most Typical of American Artists." *Pearson's Magazine,* October 1907: p. 403.

Missouri Historical Society, Saint Louis. Powhatan Clarke Papers.

Samuels, Peggy, and Samuels, Harold. *Frederic Remington: A Biography.* New York: 1982.

Samuels, Peggy, and Samuels, Harold, eds. *The Collected Writings of Frederic Remington.* Garden City, N. Y.: 1979.

Shapiro, Michael Edward. *Cast and Recast: The Sculpture of Frederic Remington.* Exhibition catalogue, The National Museum of American Art. Washington, D.C.: 1981.

Shapiro, Michael Edward, and Hassrick, Peter H., with essays by David G. McCullough, Doreen Bolger Burke, and John Seelye. *Frederic Remington: The Masterworks.* Exhibition catalogue, Saint Louis: 1988.

Taft, Robert. *Artists and Illustrators of the Old West 1850–1900.* New York: 1953.

———. *Taft Papers, Frederic Remington Journal.* 1886. Microfilm. Kansas State Historical Society, Topeka.

Taylor, Lonn, and Maar, Ingrid. *The American Cowboy.* Exhibition catalogue, The Library of Congress. Washington, D.C.: 1983.

Thomas, Augustus. *The Print of My Remembrance.* New York: 1922.

The United States Military Academy. *Frederic Remington: The Soldier Artist.* Exhibition catalogue, West Point, N.Y.: 1979.

Utley, Robert M. *The Indian Frontier of the American West 1846–1890.* Albuquerque, N. M.: 1984.

Vorpahl, Ben Merchant, ed. *My Dear Wister: The Frederic Remington—Owen Wister Letters.* Palo Alto, Calif.: 1972.

White, G. Edward. *The Eastern Establishment and the Western Experience: The West of Frederic Remington, Theodore Roosevelt and Owen Wister.* New Haven, Conn.: 1968.

Ziff, Larzer. *The American 1890s: Life and Times of a Lost Generation.* New York: 1966.

Photograph Credits

The author and publisher wish to thank the museums, galleries, libraries, and private collectors who permitted the reproduction of works of art in their possession and supplied the necessary photographs. Photographs from other sources (listed by page number) are gratefully acknowledged below. E. Irving Blomstrann: 68; Buffalo Bill Historical Center: 66 top, 146; Wayne Cozzolino: 122; Rick Gardner: 140 top; Tom Jenkins: 38; Library of Congress: 16, 23, 27 top and bottom, 28, 34; James O. Milmoe: 36, 149; Frederic Remington Art Museum: 40; Jim Strong, Inc.: 60; Jerry L. Thompson: 74, 104, 105, 110.

Index

Page numbers in *italics* refer to illustrations